MICHAL ROVNER

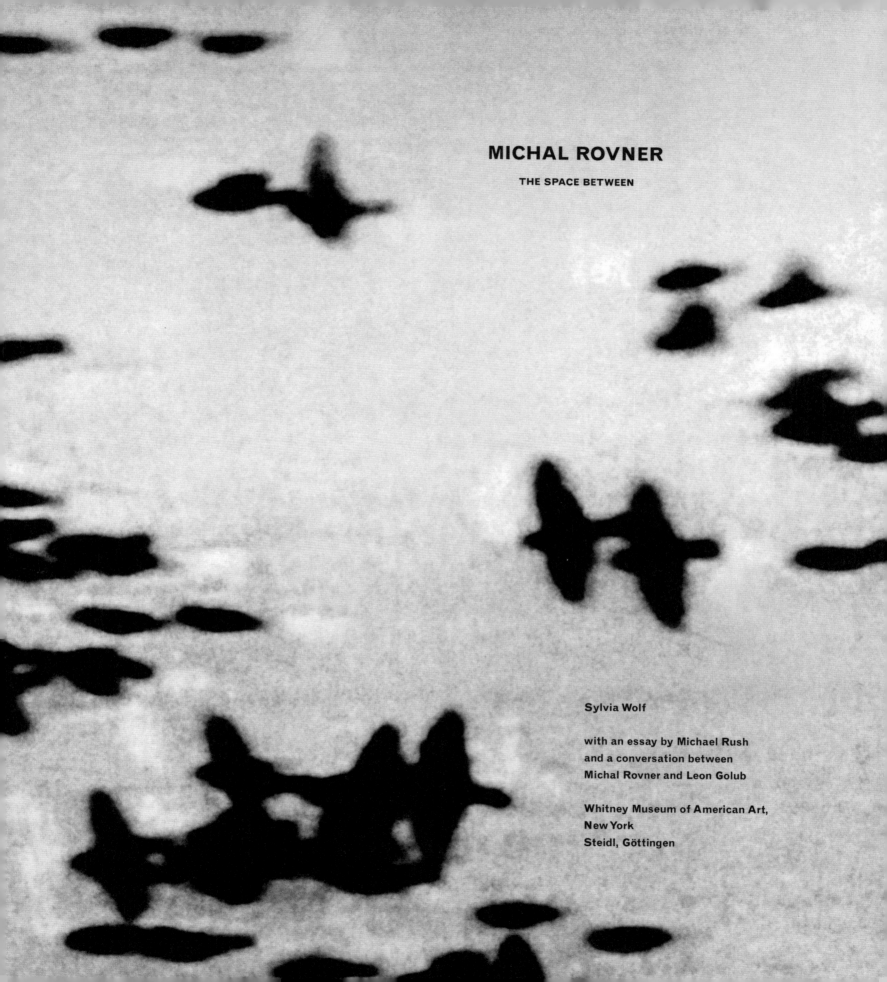

MICHAL ROVNER

THE SPACE BETWEEN

Sylvia Wolf

with an essay by Michael Rush
and a conversation between
Michal Rovner and Leon Golub

Whitney Museum of American Art,
New York
Steidl, Göttingen

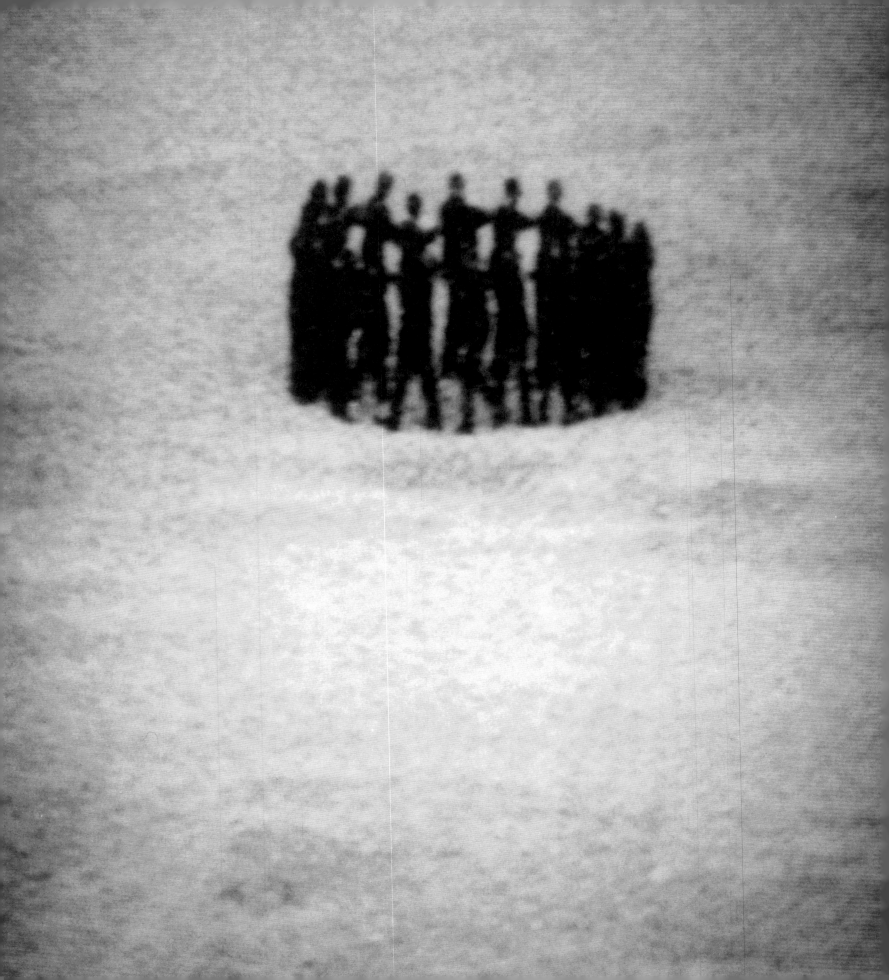

CONTENTS

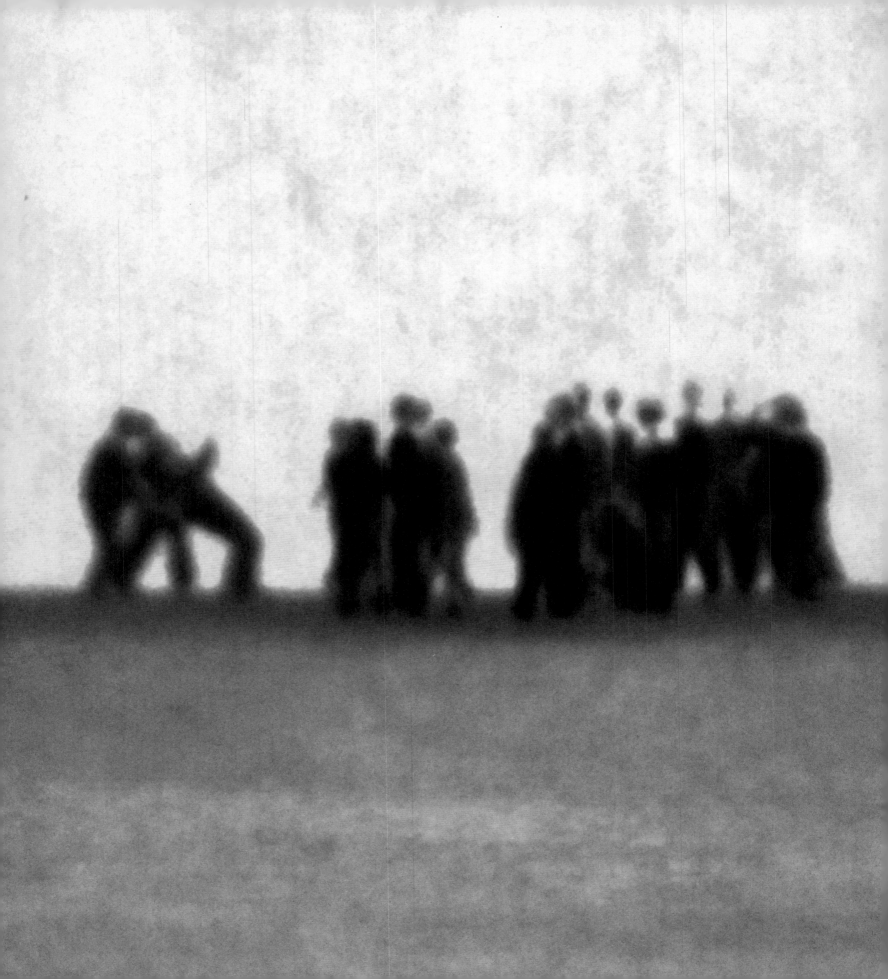

FOREWORD

MAXWELL L. ANDERSON

American art, and thus the Whitney, increasingly draws the world into its embrace.
With Michal Rovner, the Museum continues a long-standing tradition of collecting
and presenting the work of artists born outside of the United States but living
and working here. Arshile Gorky was among those who helped define the Whitney's
consistent engagement with artists from abroad; like Gorky, Michal Rovner imports
a body of work and a worldview that we all stand to gain from, inflected with
a freshness of vision and technique.

Rovner's potent but subtle iconography is of this place and this time. As we in
the United States struggle to understand our place in a shifting global community,
she provides a visual language that rewards careful examination. Her imagery,
by turns abstract, calligraphic, and painterly, makes us confront nature, armed
conflict, and the solitary individual. Her point of departure is never obvious,
nor is our destination. Instead there are universal themes and haunting visual
appeal in everything she makes.

Michal Rovner had an initial presentation at the Whitney through the *2000 Biennial
Exhibition*. Sondra Gilman Photography Curator Sylvia Wolf has championed
Rovner's work for more than a decade, and has made a compelling case for Rovner
as a primary figure in the arts today. Her advocacy is matched in the present
publication by a thorough grounding in the achievements of the artist, which will
serve as a lasting testament to Rovner's contributions.

I join Sylvia Wolf in thanking those whose generous support made this exhibition
a reality, including in particular The Israel National Lottery Council for the Arts;
the New York-Israel Cultural Cooperation Commission, a joint venture of the State
of New York, George E. Pataki—Governor, and the State of Israel; and the Elizabeth
Firestone Graham Foundation. I owe special gratitude to Whitney Museum trustees
Melva Bucksbaum and Raymond Learsy; and to the National Committee of the
Whitney Museum of American Art.

Works of art should not be required to help us make sense of the world around us.
But when they do, as in the case of the photographs, videos, projections, and
installations of Michal Rovner, we are all the better for it.

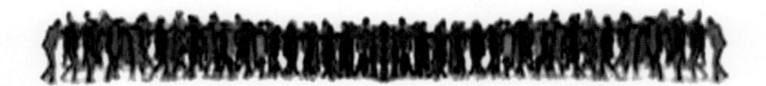

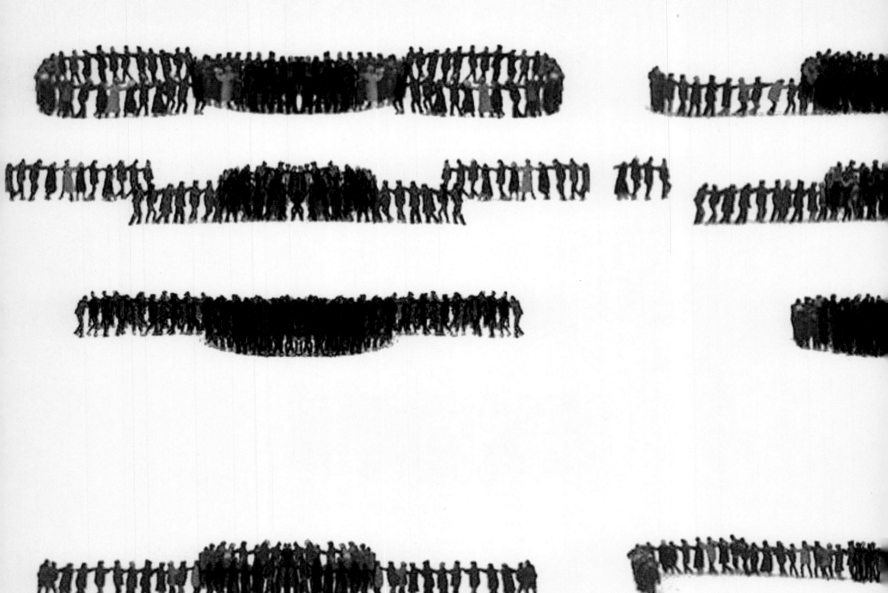

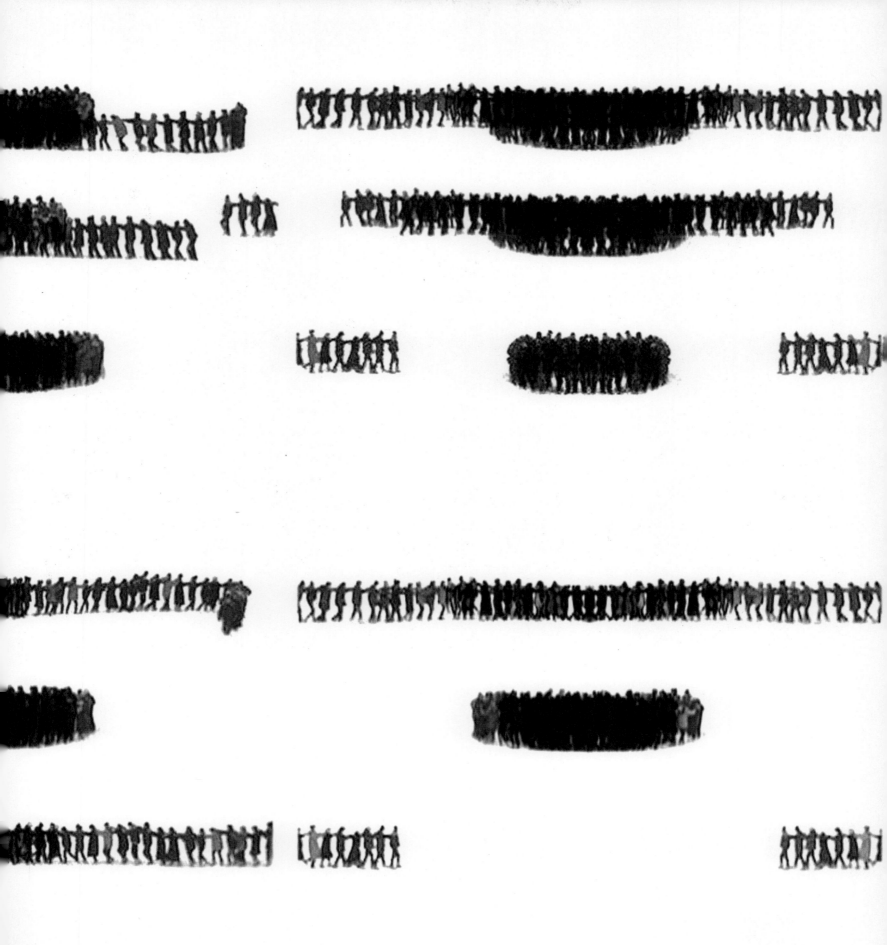

1

Plate 1
Untitled, 1981

THE SPACE BETWEEN

SYLVIA WOLF

Just off the road between Tel Aviv and Jerusalem, Michal Rovner owns a small farm in the Valley of Ayalon, the site of a sequence of brutal battles recounted in the Bible that featured death, miracles, and the righteousness of God.[1] Today, the region is farmland. Rovner's square, one-story house is situated on six acres of land, with fruit trees on one side and an artichoke field behind. After the harvest, butterflies skim the overturned earth and hawks soar above, looking for prey. Beyond the field, low sandstone hills speckled with olive trees can be seen in the distance, behind a scrim of particles blown in from the desert that refract light and diffuse things near and far. Drained of color and contrast by the relentless sun, the landscape looks like an overexposed photograph. The ground is parched. No clouds provide shadows, and one single tree offers shade from the bone-dry heat. "This place is my element," Rovner says, "These are the ingredients that make me who I am."[2]

When Rovner says "place," she is not specifically referring to Israel as a nation, and yet the landscape, the ancient history of the land, and the territorial wars that have marked it during her life have had an impact on her art. Indeed, much of her subject matter and many of her themes are drawn from her country of origin. Even so, she makes it clear that she could not have become an artist had she not left this place. Since 1987, when she shifted her principal residence to New York, Rovner has straddled two realities. On the Israel census she is listed as a farmer, and in the United States she is listed as an artist. A large portion of her imagery is shot in Israel, but the editing and printing of her final works takes place in her studio in New York. There, Rovner works hard to remove her imagery from allegiance to any particular place or time, as though the distance she creates between her art and reality provides a safe territory from which she can take a closer look at issues of identity, memory, and existence. We, however, may gain a broader understanding of Rovner's art and of the thematic threads that bind her career if we take a closer look at her personal history and at selected aspects of her cultural background. Though the art itself is not about Rovner's bicultural experience, it benefits from the duality, the complexity, and the contradictions that characterize a life lived in two worlds.

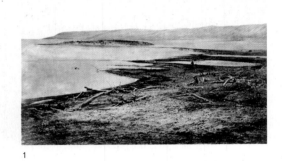

Michal Rovner was born in Tel Aviv in 1957. Her mother, Ruth, came to Israel from Germany in 1933. Her father, Jacob (Jack), an engineer in the construction business, is a descendant of the first Russians to settle in the land of Israel in the late nineteenth century.[3] Rovner is the youngest of three children, five years younger than her brother, Oded, and eight years younger than her sister, Daphna. Raised in a secular household in a small neighborhood on the outskirts of Tel Aviv, Rovner is a *sabra*. This nickname for native Israelis comes from a small cactus fruit that is tough on the outside but sweet on the inside. At once forceful and charming, Rovner fits the description. Her determination manifested itself, even as a child, in an uncanny ability to marshal the efforts of others.

Nothing early on signaled that Rovner would become a visual artist. Dance was her first passion. In her mid teens, she was a classical and modern dancer—good enough, her teachers thought, to be a principal dancer in a major company someday. Rovner stopped dancing at age eighteen, when she began her two-year mandatory service in the Israeli Defense Force. But her understanding of movement and choreography would emerge years later in her video and photographic art. In the army, Rovner held administrative positions and was posted close to home out of sympathy for her family, following the death of her brother, Oded, in a car accident on his way home from the army three years earlier. After Rovner finished her army service, she joined her boyfriend, amateur photographer Arie Hammer, in building Tel Aviv's first professional darkroom with space for photographers to rent, which opened under the name Camera Obscura in 1978.

Photography in the land of Israel has a slim history.[4] Few pictures made before the turn of the century represent the life and experience of native inhabitants. Most nineteenth-century images were made by Western photographers traveling through Egypt and Palestine to record views of ancient architecture or exotic landscapes for European consumption (fig. 1). From 1900 to 1948, the year Israel declared its independence, photographs functioned primarily as propaganda for Zionist causes and to draw Jewish settlers to the land of Israel (fig. 2).[5] The 1950s and 1960s saw a rise in participation in collective farm settlements, *kibbutzim*, that were cooperatively owned and run by their members. Enthusiasm for life on the *kibbutz* made its way into photography, with pictures that celebrate the communal efforts of people at work on building projects or in the field. Among Rovner's earliest recollections of photography are the portraits of pioneering farm families that accompanied heroic stories of settlement in school textbooks.

By the 1970s, the ranks of Israeli photojournalists had grown, and reportage for the printed press flourished. In 1977 the Israel Museum developed the country's first curatorial department of photography and began collecting photographs by Israeli and international artists. Publication of the vanguard monthly magazine *Monitin* (Reputation), which began in 1978, included high-quality photographic reproduction

Figure 1
Frances Frith
The North Shore of the Dead Sea, 1857

Figure 2
Shmuel Yosef Schweig
Ha-Noar Ha-Oved (Working Youth), 1926

and innovative features on culture, fashion, art, and liberal politics (fig. 3).[6] Around this time, a number of young photographers who had been trained in Europe and the United States immigrated to Israel and added a cosmopolitan atmosphere to the photographic community. It was in this climate of growth and international influence that Hammer and Rovner founded Camera Obscura.

Rovner knew nothing about photography when she agreed to become a partner in the venture, and she had no interest in becoming a photographer. But since she was investing time, effort, and money in the photo lab, she thought she should at least learn the principles and terminology of the art. So, in 1981, in addition to her studies in cinema, philosophy, and television at Tel Aviv University, she took a photography class at Camera Obscura. Rovner's teacher, Simcha Shirman, saw potential in her photographs and urged her to continue studying photography. Later that year, Rovner left Tel Aviv University and enrolled in Bezalel Academy of Art and Design in Jerusalem, Israel's renowned school of visual arts.[7] Also in 1981, Rovner and Arie Hammer married and moved to Jerusalem.

Among the images Rovner made in her first years of involvement with photography were pictures of isolated stone houses, surrounded by a barren landscape, seen from a high and distant vantage point (pl. 1). "I climbed to the top of Herodium, the artificial mountain King Herod built near Bethlehem around 23 B.C.E. At that time, Herodium was the last point I could reach before entering Arab territory. I watched the houses through a telephoto lens. Although I was able to get close to them optically, they remained at a distance, mysterious and remote."[8] This image is the first of many Rovner would make over the years in which she created visual immediacy through physical distance from her subject. To make the photograph, Rovner underexposed the negative and purposefully printed it low in contrast with deep, dark tones: there are virtually no highlights. In another image from the same

3

4

Figure 3
Monitin (Reputation),
cover of first issue,
September 1978

Figure 4
Michal Rovner
Untitled, 1981

5

6

7

Figure 5
Michal Rovner
Untitled, 1983

Figure 6
Michal Rovner
Untitled (Nahalal), 1984/85

Figure 7
Michal Rovner
Untitled (Nahalal), 1984/85

time, scruffy desert vegetation resembles the grain of her later images (fig. 4). Both pictures contain the mysterious intensity that would emerge in her mature work. Although these photographs were taken in her first year at Bezalel Academy of Art and Design, they were not made for class. To school assignments, Rovner responded differently.

The education Rovner received at Bezalel was a classical one. Emphasis was placed on photographic tradition as it had evolved in Europe and the United States, with courses in art and photo history taught by Nissan N. Perez, curator of photography at the Israel Museum in Jerusalem and by Mordechai Omer, current director of the Tel Aviv Museum. In slide lectures and in books, Rovner saw the work of Henri Cartier-Bresson, André Kertész, Margaret Bourke-White, and Walker Evans. She was captivated by the way Etienne-Jules Marey's nineteenth-century motion studies extended time and action, and by how the monochromatic soft-focus landscapes of Alvin Langdon Coburn looked like spatial abstractions.

Of all the photographs Rovner saw, Robert Frank's images from his 1972 publication *The Lines of My Hand* had the greatest impact. Born in Switzerland, Frank is best known for his unheroic portrait of postwar America published in the United States in 1959 as *The Americans*. Rovner greatly appreciated Frank's seminal book, but it was the autobiographical nature of *The Lines of My Hand*, in which Frank looked at his own life through black-and-white photographs, that was most moving to Rovner. A few of Rovner's early 35mm photographs, which are atmospheric in feeling, reveal Frank's influence (fig. 5). Other images reflect an interest in social documentary photography. Pictures Rovner took around her husband's family farm, for instance, highlight a common theme in Israel—the struggle of its inhabitants to cultivate the land. Subtle in tonality and handsome in design, the photographs give evidence of Rovner's proficiency with exposure, composition, and printing (figs. 6–7). It is a measure of Rovner's talent and of her quick absorption of photography that these resemble well-made pictures by a number of sensitive and accomplished photographers. Missing, however, is the distinct personal vision of her earlier desert photographs. By adopting the popular practice at Bezalel, Rovner seems to have stepped into another person's closet and tried on their clothes. The size fits just fine, but the cut is wrong.

As is customary at the undergraduate level in art schools around the world, Bezalel students were required to develop a concept for a body of work and then articulate their aesthetic and technical choices in group critiques. This teaching method is designed to help students evolve into mature artists, responsible for the content and form of their art. Rovner, however, found the rigor and discipline of a structured academic environment oppressive. By the time she graduated with a bachelor of fine arts degree in 1985, she had lost enthusiasm for making pictures. It was not until a year after she graduated that Rovner found a meaningful subject and picked up the camera again.

AT HOME ON THE FARM

The subject that brought Rovner back to photography was the farmhouse she and Arie bought in 1985 in the farm community of Kefar Shemu'el, which Rovner now calls her home in Israel. The house was a concrete, single-story, box-shaped structure mounted on blocks, with a low roof and metal shutters to keep out the heat. Two windows were symmetrically placed on either side of the front door, like the eyes and nose of a mask. A walkway followed a straight line from the road to the front door. The simplicity of the place reminded Rovner of a dictionary illustration of a house or a child's drawing of home.

When Rovner first saw the house, there was little to it; there were few trees and no houses nearby, only two sheds leaning precariously in the backyard. And yet there was something magnetic about the place. In the first years she lived on the farm, Rovner took pictures of the field, recently planted with artichokes (fig. 8), and made numerous images of the house itself (fig. 9). In some of the photographs, the structure looks like a toy house—a box with a triangle for a roof. In others taken after dark, the house looks ominous, with windows glowing in the ink-black night. Rovner embellished one photograph by drawing a donkey, trees, and a pathway leading into the landscape behind the house. The number of pictures Rovner took of this subject signals her fascination with the theme. We sense a person imbuing a structure with importance and potential. In fact, Rovner compiled many of the photographs of the house and garden for her husband, and gave them to him in an album as a gift of hope. As she explains, "There was a serious communication, a dialogue between me and the place . . . a willingness to engage in another world. People get engaged to be married, but they can get engaged in cleaning the house too. We all have a desire for engagement with a subject. That subject then becomes a door that opens onto something else."[9]

8

Figure 8
Michal Rovner
Untitled, 1985

22

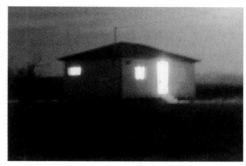

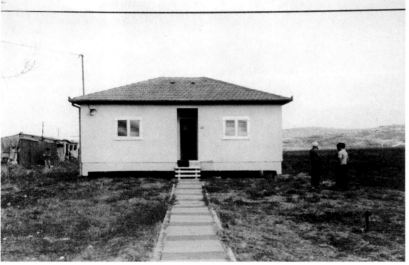
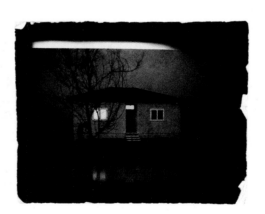

9

Figure 9
Michal Rovner
Images from a photographic album
of Rovner's farmhouse in Kefar
Shemu'el, 1985/86

10

While photographing the house, Rovner also took pictures of her dogs and the birch sapling in the backyard (figs. 10–11). She centered her subjects in the picture frame and isolated them from any distracting background, transforming something ordinary into something emblematic. In the photograph of the birch tree, she also paid homage to the challenges and defiance entailed in making a desert into a habitable place, and she made reference to the efforts she and Arie were making to cultivate their own land. They planted olive trees along the road, rose bushes in front of the house, and fruit trees along its side.

Within a year of her move to the farm, Rovner began photographing in color. At first she used natural light. But when she longed for a broader palette, she put filters made for theatrical lighting fixtures on an electronic flash so she could paint with light of many colors. With a Polaroid SX-70 camera and a color-filtered flash, she photographed the birch sapling again. Taken at dusk, the combination of waning daylight and tinted flash yielded eerie, unnatural colors that made the tree shudder with electric energy (figs. 12–14). Because film reads the color of light differently than our eyes do, Rovner never knew at the time of the exposure what kind of image would emerge. This piqued her curiosity and fueled her investigation. She took dozens and dozens of Polaroids, and then rephotographed them and enlarged them in a series of highly varied pictures.

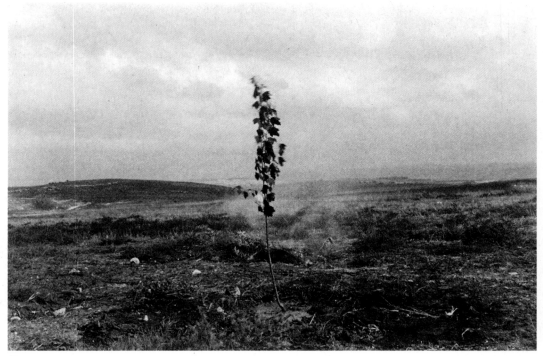

11

Figure 10
Michal Rovner
Untitled, 1985/86

Figure 11
Michal Rovner
The Tree, 1985/86

24

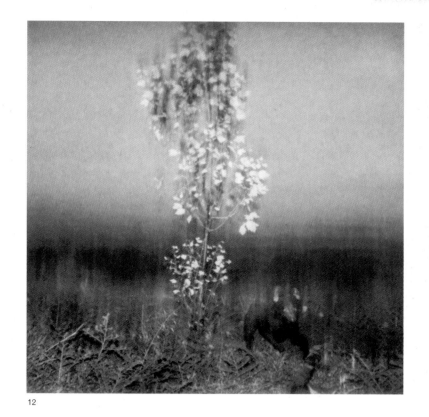

12

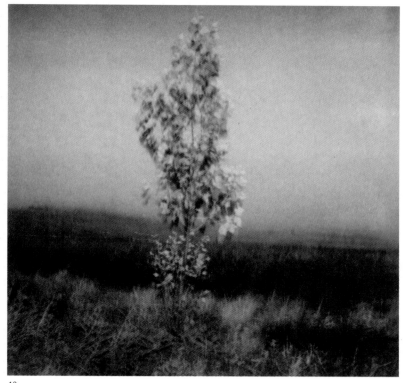

13

14

Figures 12, 13, 14
Michal Rovner
The Tree, 1986/87

The difference between Rovner's black-and-white photographs of the tree and her color renditions indicates a distinct shift in her ability to find a voice of her own with photography. In a series of photographs she took in 1986/87 of her black mutt Stella, she further articulated her interests. Here Rovner isolated the dog against a solid-colored background, a device she would use again and again to separate her subject from any reference to the real world. In these photographs, the dog is by turns agitated, sleeping, or alert (figs. 15–16). Positioned off-center, in flat, even light, the dog assumes sculptural form. Rovner thinks of these pictures as emotional seismographs. They bear the stamp of an aesthetic that would evolve in the years ahead—one characterized by a lack of detail, a certain degree of abstraction, a single subject pictured multiple times, and a highly subjective use of color.

Color photography is taken for granted today as a tool for photographic artists, but in the mid-1980s, when these images were made, the widespread use of color photography for artistic expression was little over a decade old. Before then, color photographs were limited primarily to the commercial domain. Cost, awkward processing methods, and chemical instability were three reasons for this. In addition, color was too rooted in the real for many fine-art photographers (with a few exceptions, most notably Eliot Porter and Harry Callahan). Artistic expression was associated with transformation, and there seemed to be an intrinsic artistry to seeing the world in black, white, and shades of gray. When Conceptual artists in the 1960s and 1970s adopted the camera to make flat-footed documents of their ideas or performances, many opted for color film precisely because of its non-art status. At around the same time, film and paper manufacturers were marketing new and improved color products targeted to a growing population of serious amateur photographers. Much as the amateur use of the box camera at the turn of the last century yielded unrefined but exciting compositions, the images made by the Conceptualists piqued the curiosity of documentary and fine-art photographers, and opened the door to new form.

It was not long before these photographers began considering color as a viable subject in and of itself. In the 1970s, art schools added color photography courses to the curriculum and students responded with high enrollment. Patience was required to make consistent color prints. The slightest shifts in chemical temperatures could dramatically affect the hues in the final print, and colors varied between batches of paper. Reminiscent of the early days of photography, a certain amount of alchemy was involved in color printing. Even so, growing numbers of

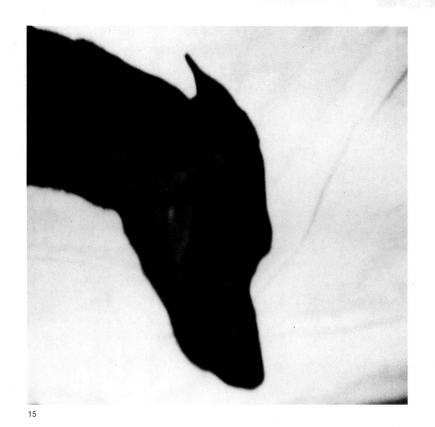

15

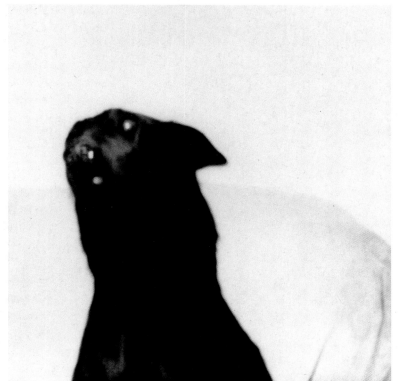

16

Figure 15
Michal Rovner
Sinking Dog, 1987

Figure 16
Michal Rovner
Rising Dog, 1987

students struggled with the toxic and time-consuming work. While some photographers used color to make images that recorded the physical world with greater accuracy and realism, others made a virtue out of breaking the rules of color photography by using daylight film with fluorescent lights, or tungsten film in daylight. The results were unnatural colors that could only be recorded by the camera. It was in this spirit of testing the medium and perception itself that Rovner took color photographs of the tree behind her house.[10]

Rovner's color prints were made at Camera Obscura, where she continued to work and occasionally taught photography classes. In less than a decade, the lab had turned into a national center for the study and practice of photography, film, and video. Camera Obscura had entered into a course credit exchange agreement with Pratt Institute of the Arts and with the School of Visual Arts, both in New York. Over three hundred students were enrolled, and fifty teachers were on the payroll. Visiting artists from around the world came to give workshops, including Robert Frank in 1983 and Lee Friedlander in 1985. One of the ways students learned about photographic history and contemporary photographers was through the booming market in photographic books. With plans in the works to build a library at Camera Obscura, Rovner traveled to New York in 1987 to buy books. This was Rovner's third trip to New York. As on previous visits, the city struck her as buzzing with an intensity that felt vital and real. She was impressed with the ambitions and accomplishments of the artists she met, who focused their time and energy on individual achievement—in contrast to the emphasis in Israel on family and community. But most of all, she was inspired by the richness of the cultural scene and by the degree to which art was taken seriously by Americans. A few months after she went back to Israel, she made the decision to devote herself to a life as an artist and, in the late summer of 1987, she moved to New York.

A COMMITMENT TO ART AND LEAVING HOME

When Rovner left Israel to settle in New York, she left her family, her farm, her marriage, and her work at Camera Obscura. Nearly thirty, she had been pursuing her own artistic interests for little more than a year. But she felt that in order to find the time and concentration needed to develop her art, she had to leave home. The photographs she took around the farm before she left, including an image of her husband's shirt drying on the laundry line and a picture of her beloved pet donkey, are misty, melancholy images that seem to anticipate her loss (figs. 17–18). "I was canceling one lifetime, one lifestyle, one life form in favor of creating a new one which did not yet exist."[11] The photographs she made after the move to New York suggest that with independence came a sense of isolation. When not working at her part-time job in a rental darkroom, Rovner lived in a small sublet apartment on West Third Street and arranged toy figures against photographs she had either taken or found. In one, titled *People in the Earth*, five plastic bridegrooms, laid on top of one of her early desert landscapes, seem to be tilting or falling out of the frame (fig. 19). In another image, a female figurine stands on a hill with her back turned to an airplane that descends in her direction at a raking angle (fig. 20). These offer the first examples of flying and falling, themes that would appear again and again in her work.

A self-portrait Rovner made in the winter of 1988, in the basement apartment she rented on Christopher Street, provides a clue to the ambivalence she felt toward her new freedom (fig. 21). As a child, Rovner had a black raven for a pet. In New York, she rented a stuffed raven from a taxidermist. Though she attempted to make a photograph in which she was at one with the bird—a picture that would give form to her urge to be free—the two appear to struggle. In this scenario,

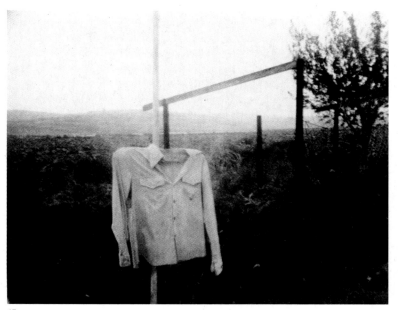

17

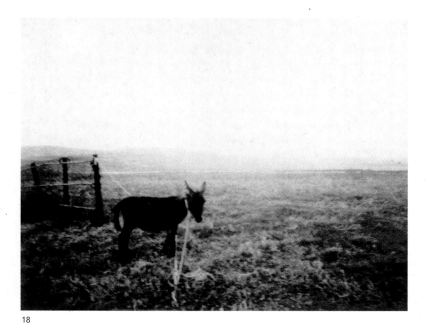

18

Figure 17
Michal Rovner
Arie's Shirt, 1987

Figure 18
Michal Rovner
My Donkey, 1987

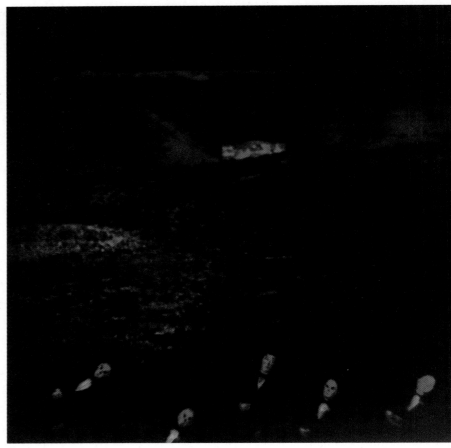

19

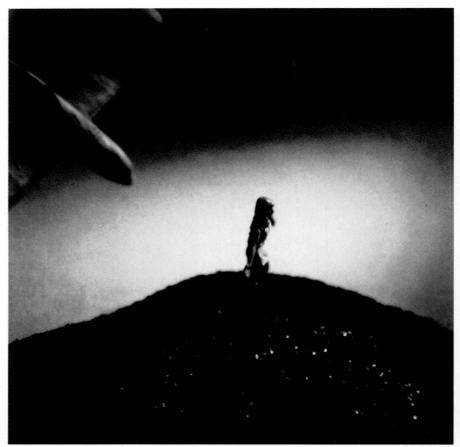

Figure 19
Michal Rovner
People in the Earth, 1987

Figure 20
Michal Rovner
Woman and Airplane, 1987

20

Rovner could be either player: the bird who wants to escape captivity or the keeper who will not let go. In addition to a raven, Rovner bought a dead rabbit and lamb from the local butcher shop and arranged them on colored backdrops. One appears to soar through the air, while the other looks like road kill (fig. 22).

These first photographs made in New York reflect Rovner's longing for what she had left behind and her search for artistic independence in photography. They also suggest a currency with other contemporary photographic production. In the 1970s and 1980s, several photographers moved away from picturing the existing world. Rather than looking outside for something to photograph, they went into the studio and constructed scenes in front of the camera. For them, photography was an act of invention. In 1977 David Levinthal produced a series of images, titled *Hitler Moves East: A Graphic Chronicle, 1941–43*, that used a camera's shallow depth of focus on toy soldiers, rendered in monochromatic blue-gray, to mimic the gritty nature of war photography (fig. 23). In the late 1970s, Laurie Simmons used doll figures to comment on female domesticity in a post-1950s world of feminism and social change (fig. 24). Where Levinthal's images have the look of actual reportage, Simmons's pictures are obviously artificial. Both artists employ children's toys to make bittersweet comments on grown-up topics, and both ask viewers to suspend their belief in photography as a medium rooted in reality.

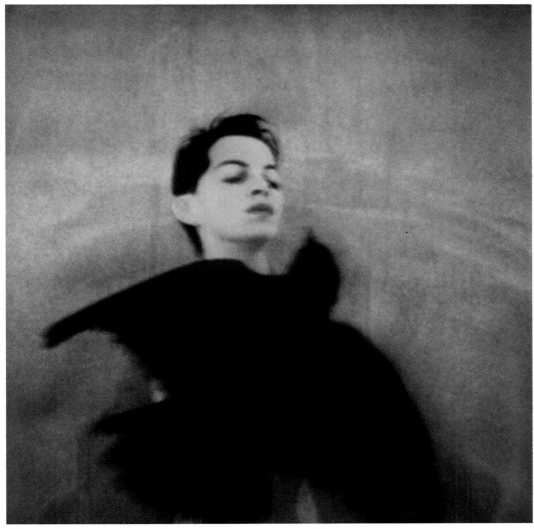

Figure 21
Michal Rovner
Me and the Bird, 1988

While Rovner does not recall knowing the work of Levinthal or Simmons when she made her studio still lifes, she remembers being urged by photographer and film-maker Robert Frank to see exhibitions of new art. Frank and Rovner had become friends when Frank had visited Israel as part of Camera Obscura's visiting artist program in 1983. It is Frank whom Rovner credits with inspiring her to be an artist. When Rovner moved to New York, Frank became a mentor of sorts. He recommended books and movies, and he introduced her to friends and associates, including Walter Keller, editor of the publishing company that later produced Rovner's first monographic book, *Ani-Mal*.[12] Rovner, in turn, assisted Frank in editing, with curator and historian Phillip Brookman, the third edition of his book *The Lines of My Hand*.[13]

Frank also asked Rovner to cowrite some of the scenes, and assist in the selection of the cast, for *C'est Vrai! (One Hour)*, a sixty-minute, unedited film made in 1990, set in New York's Bowery district, for the French television station La Sept. In 1991 Rovner worked with Frank on the script of *Last Supper* and acted as director's assistant during the film's shooting. *Last Supper* concerns a book-signing party set in an abandoned lot in Harlem, which the author never attends.[14] Using documentary footage shot in the neighborhood, interspersed with the scripted drama, Frank crossed the line between what is staged and what is real. That sense of uncertainty, of looking at the world and not knowing if what you see is real or fiction, is a characteristic found in many of Frank's films, and one that would emerge as a prominent feature in Rovner's work.

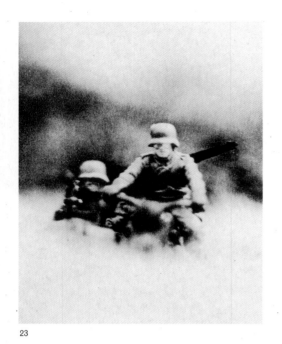

23

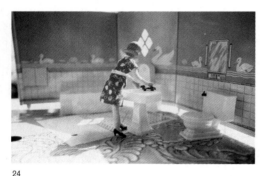

24

Figure 22
Michal Rovner
Flying Lamb, 1988

Figure 23
David Levinthal
Untitled, 1977, from the series
*Hitler Moves East: A Graphic
Chronicle, 1941–43*

Figure 24
Laurie Simmons
First Bathroom/Woman Standing, 1978

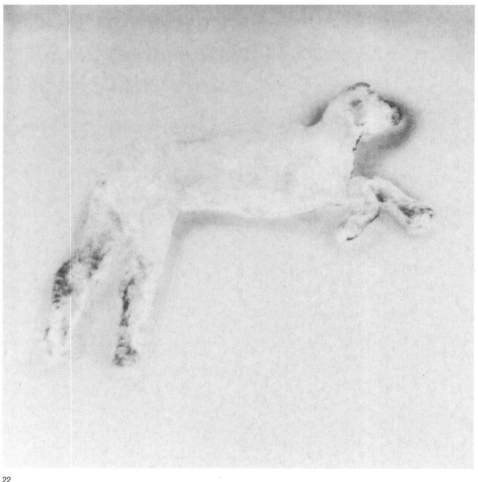

22

OUTSIDE-IN

Roughly two years after arriving in **New York**, **Rovner** began to look outside the confines of her **New York** studio for things to photograph. **By 1988 Rovner** and **Hammer** had divorced, and **Rovner** used the farm as her base to return to Israel two or three times a year. **On** one of these trips, in **1990, Rovner** was on her way to the **Dead Sea** when she saw the **Bedouin** house, made of corrugated tin and set on a hill in the distance, that would be the subject of her photographs for the next two years.

Her first view of the house was from the back, where there were no windows, doors, or pathways. Though she later discovered entrances on the other side, it was the desolate loneliness of the house's back view that **Rovner** pictured again and again. When she photographed the house that first day, it was the image of the structure, more than the house itself, that captivated her (she used **Polaroid** film, allowing her to see the pictures right away). She spent hours shooting the structure over and over, making long exposures and jiggling the camera to disrupt the focus. Once back in her studio in **New York**, she selected the **Polaroids** she liked best, rephotographed them for enlargement, then added unnatural color in the darkroom. In one picture, the house is shrouded by a lavender fog, while in another it radiates with fiery orange energy (pls. 2–4). The final photographs are over twelve times as large as the original **Polaroids**, and the house in them bears little resemblance to the original structure.

The initial titles **Rovner** gave to the pictures—*Floating House* and *Radiant House*—contain adjectives similar to the ones she had given to her studio still lifes, and the houses do appear to float, radiate, and fall.[15] Unlike the photographs she had taken of her farmhouse, these images relate to an internal idea of shelter, not to a personal attachment to a new home. When they were exhibited at the **Tel Aviv Museum** in **Rovner's** first museum exhibition in **1990**, some viewers saw a correlation with the watertowers of German photographers **Bernd** and **Hilla Becher** or with the haystacks of Impressionist painter **Claude Monet**. To this, **Rovner** replied that her intention was not to create a typology of a particular form or to show the effects of changing light and atmospheric conditions. Instead, her houses are intended to reflect a more subjective expression of the idea of house and home. What she did have in common with **Monet** and the **Bechers** was a tireless fascination with her subject. **Rovner** was prepared to continue photographing

the house indefinitely, but with the outbreak of the Gulf War in 1991, her effort ceased. Right after the Gulf War, she made a new series of images based on pre-existing photographs of the subject (see pls. 13–20), but when she revisited the site in 1992 the house was gone.

The conflict in the Persian Gulf was the fourth war that threatened the security of Rovner's family. Michal was nine years old during the Six-Day War of June 1967, when Israel launched preemptive attacks on Egypt, Syria, and Jordan, which had joined in a pact to invade Israel. She was fifteen years old in 1973 during the Yom Kippur War, when Egypt and Syria attacked Israel on the holiest day of the Jewish religious calendar. She was twenty-four when Israel invaded Lebanon in 1982. When the Gulf War began, Rovner was thirty-three.

Although Israel did not participate in military action during the Persian Gulf War, the country was in danger. Rovner, then in New York, watched from the outside as Israelis sealed themselves in their homes against missiles that the world feared carried toxic chemical gases. Five of the houses on the street where she grew up were destroyed by Scud missiles, and her parents' house was hit and badly damaged, though no one was hurt. With eyes glued to the TV—which Rovner considers a lens of another sort—she watched as soldiers marched across Iraqi sands and fighter planes locked targets in their sights. She was both anxious and fascinated by what she saw. Like many viewers, she felt dislocated by how sterile the high-tech weaponry and the highly controlled reporting made the war seem. "Precision bombing," as it appeared on TV, looked more like a video game than an actual attack.

Responding to an impulse to make art out of her concern, Rovner made Polaroid images from television coverage of the war. How ironic, she thought, that as a building was being bombed, it went from being something to being nothing, right before her eyes on TV, whereas the Polaroid image she made of that bombing went from being nothing to being something as it developed. Using the same method she had employed with her pictures of the Bedouin house, Rovner rephotographed the Polaroids, then enlarged them and added color in the darkroom (pls. 5–12). She selected hues based on her emotional response to the subject. A picture of a soldier raising his arms in surrender is drained of color, while another of a V-shaped formation of soldiers is an acid, computer-screen green.

Rovner further distanced these pictures from the actual event by giving them the series title *Decoy*. "A decoy is a visual temptation," Rovner explains, "It is camouflage, and it is a trap used to draw someone into danger."[16] She knew that the images of Iraqi troops on American television had been sanitized for general consumption and were already several layers removed from the original reality. In the past, photographs of war have featured heroic achievement and human suffering in often graphic detail. Rovner's pictures, by contrast, are non-specific. As in the television coverage of Desert Storm, the combatants are never clearly identified—this could be any war, any place. To Rovner's eye, the Gulf War represented a general state of threat more than a topical event. Consequently, she felt no compunction about taking one of the works in the series, a four-part piece picturing a line of soldiers colored gray-blue (pl. 8), and reconfiguring it four years later in a different size, color, and orientation, and with a title referring to her 1995 trip to China (pl. 11).

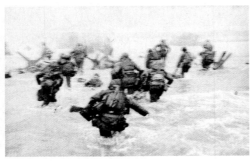

25

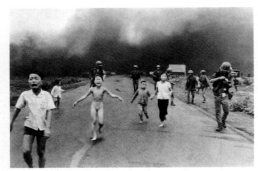

26

Few photographs came out of the **Gulf War** that were not sanctioned by the allied governments, and none pictured the drama of battle as seen, for example, in **Robert Capa**'s photographs of the 1944 **Omaha Beach** invasion (fig. 25) or of **Huynh Cong (Nick) Ut**'s image of a naked girl fleeing a napalm attack in **Vietnam** (fig. 26). More than in any previous military conflict, photographers were tightly restricted in their access to battle areas and conflict. When picture opportunities were provided, little of consequence resulted. In the absence of imagery of hand-to-hand combat, it was almost as though the war did not happen.[17]

In time of war, artists have traditionally responded with powerful emotion and images, ranging from the painfully particular, as in Francisco de **Goya**'s *Disasters of War*, to the enigmatic, as in **Robert Motherwell**'s abstract *Elegies*. In **Israel**, a handful of photographers made works in response to the **Gulf War**, but these were mostly pictures of people wearing gas masks in bomb shelters or of the "safe rooms" people set up in their homes. The limited response to the war by Israeli photographers may be due to Israel's position as vulnerable bystander, a strange and unfamiliar status for a nation that had undergone multiple wars in the forty years since its statehood.[18] It may also be a sign of an artistic community that is more focused on establishing an international identity than on making art out of national events. Finally, it may be a result of the distancing effects of a war that was, on the one hand, empty of images of human engagement and, on the other hand, omnipresent—broadcast live on **CNN** twenty-four hours a day. In a poignant example of the surreal collapse of time and space she experienced during the **Gulf War**, Rovner remembers watching **CNN** from her studio in **New York** and recounting the news by phone to her parents in Israel who had taken refuge at her farm.[19] From thousands of miles away, she told them what was happening nearby.

Figure 25
Robert Capa
D-Day, Omaha Beach, near Colleville-sur-Mer, Normandy Coast, June 6, 1944, 1944, from the series *Images of War*

Figure 26
Huynh Cong (Nick) Ut
Children Fleeing a Napalm Strike,
8 June 1972

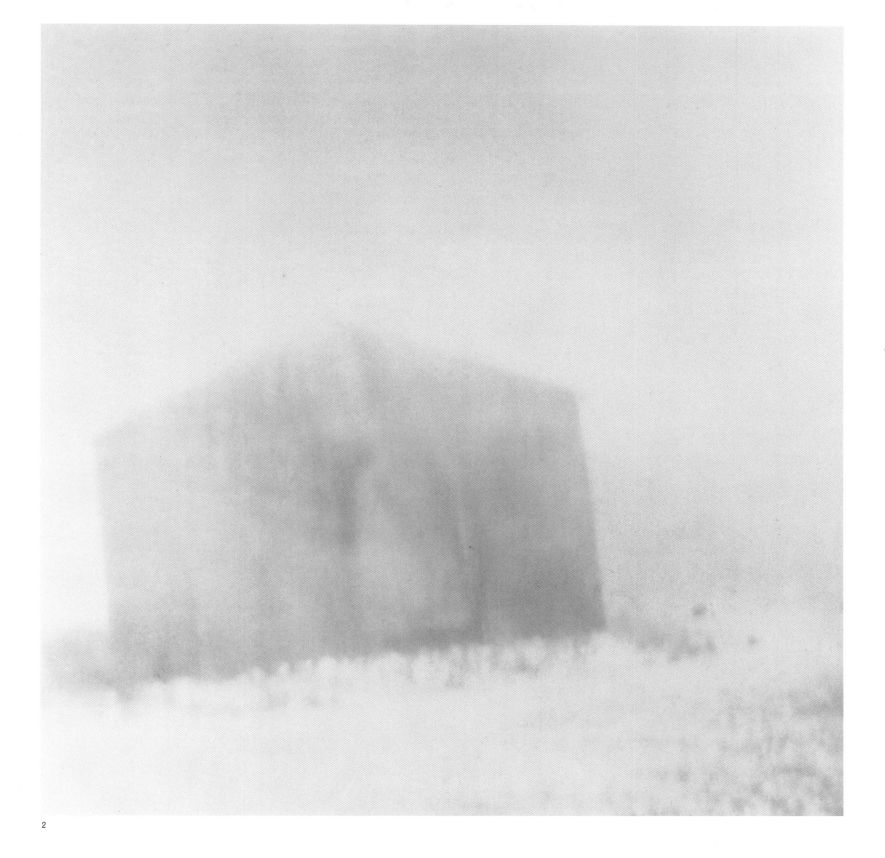

2

Plate 2
Outside #3, 1990

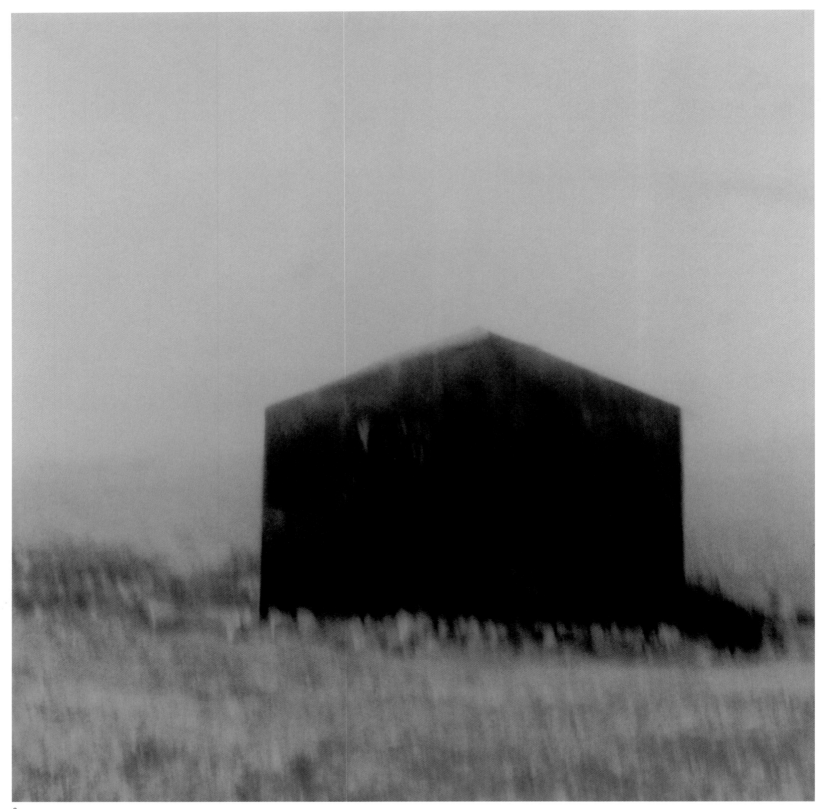

3

Plate 3
Outside #13, 1990

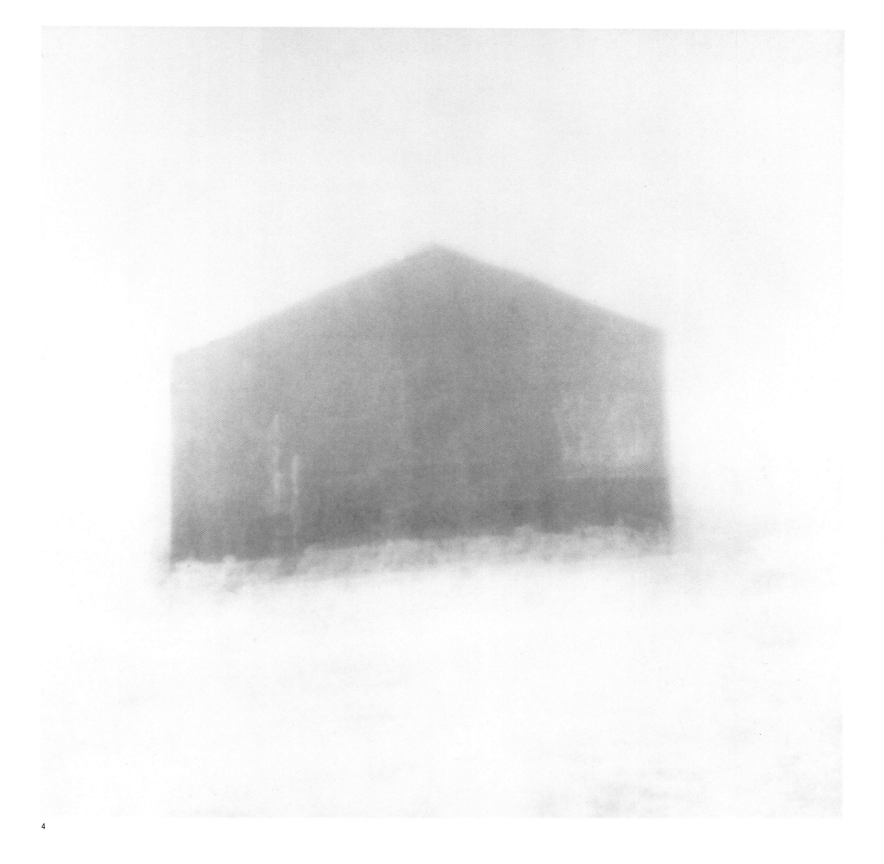

4

Plate 4
Outside #5, 1990

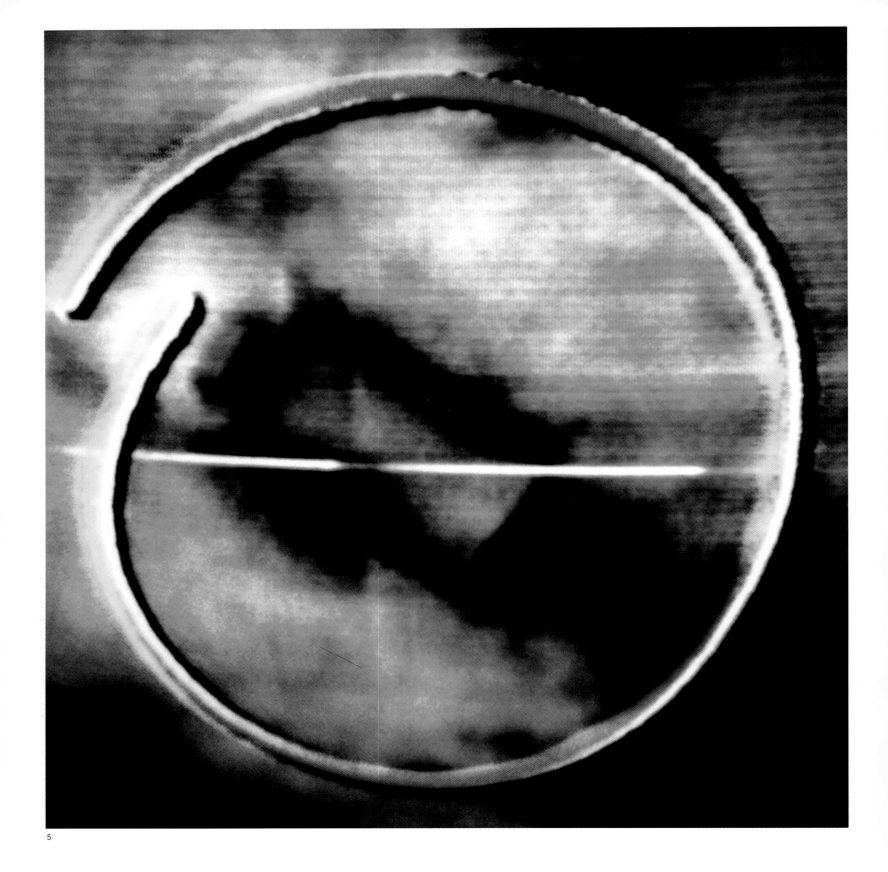

5

Plate 5
Decoy #2 (Target), 1991

6

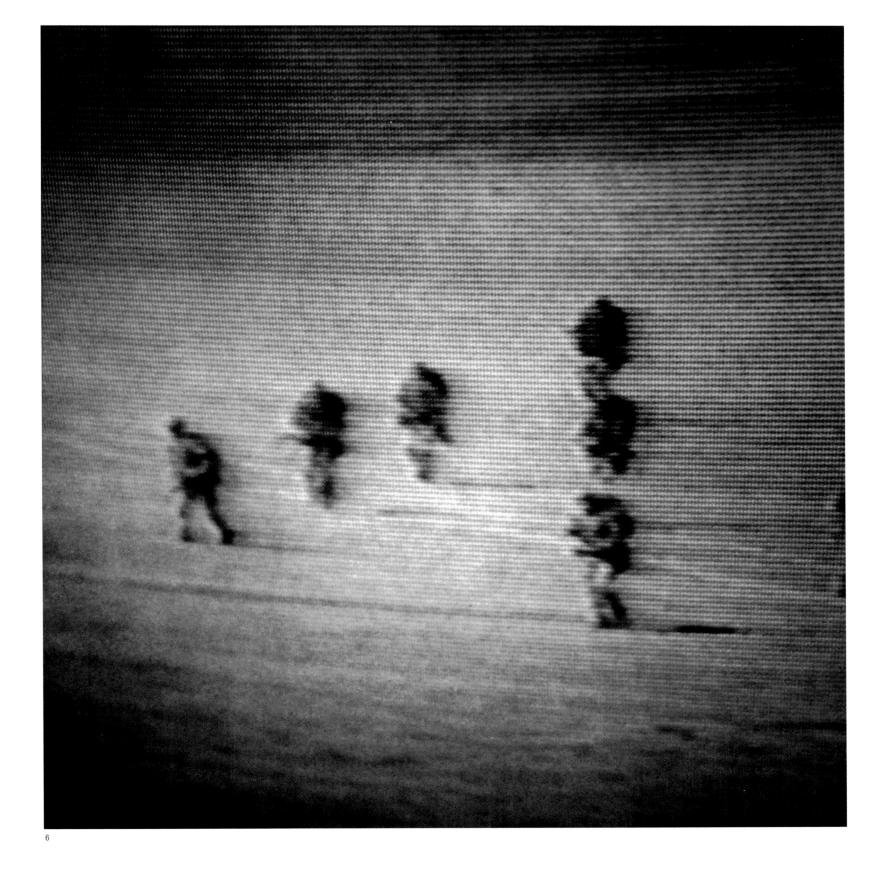

Plate 6
Decoy #3, 1991

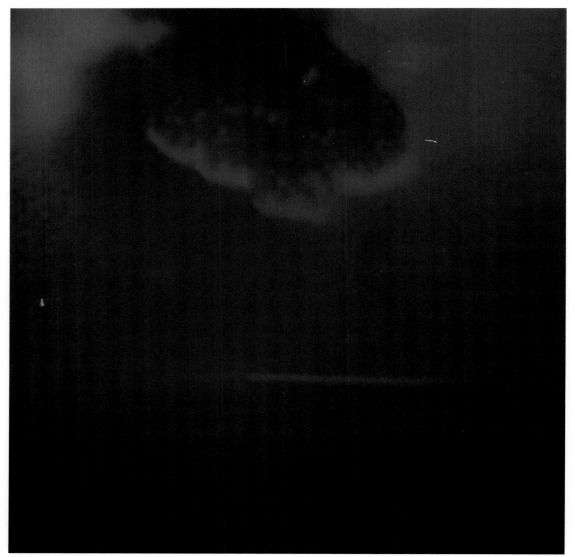

7a

7b

Plates 7a–c
Decoy #7, 1991

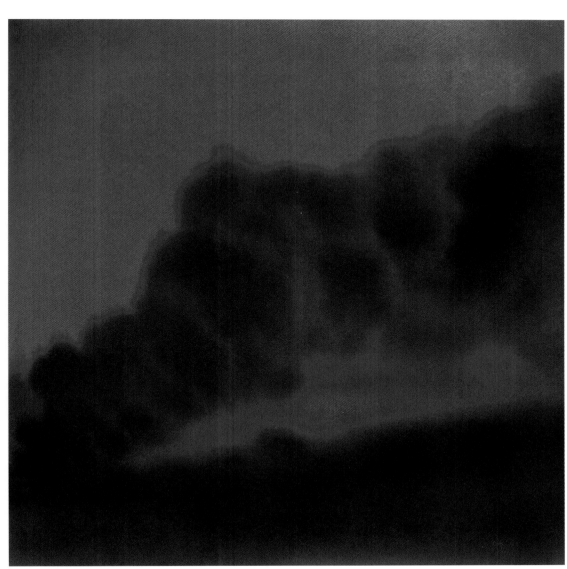

7c

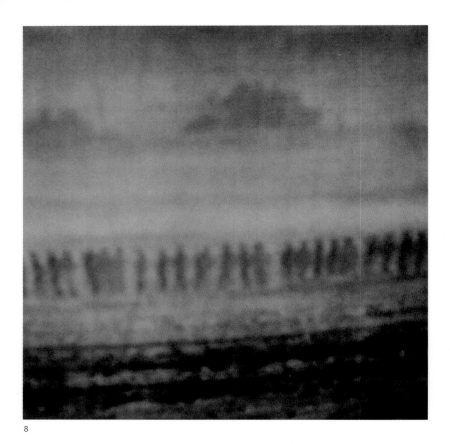
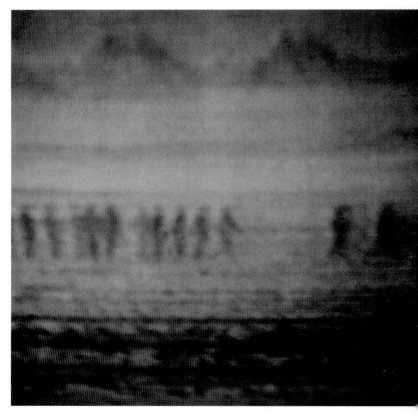

8

Plate 8
Decoy #6, 1991

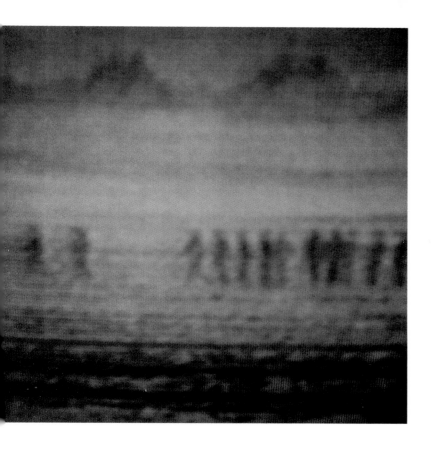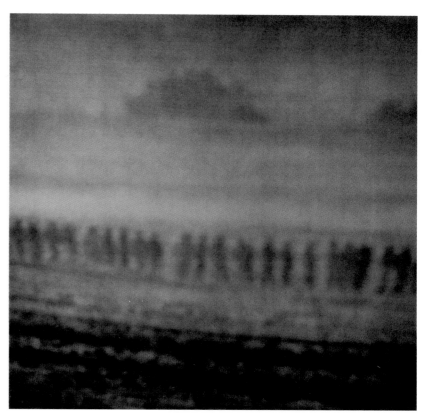

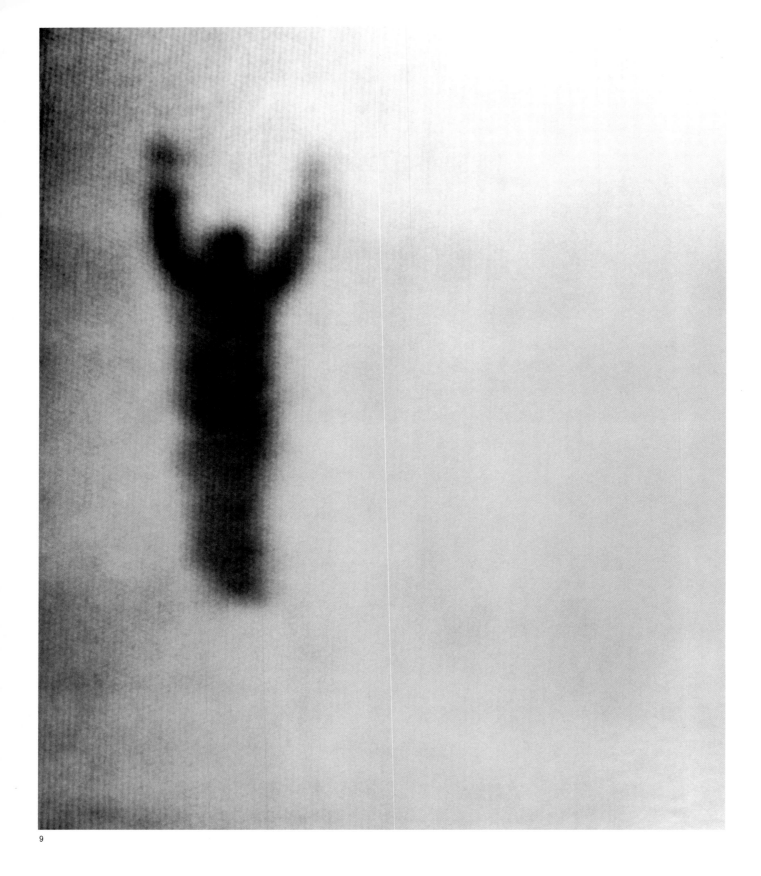

9

Plate 9
Decoy #1 (Man 1), 1991

10

Plate 10
Decoy #29 (Map), 1991

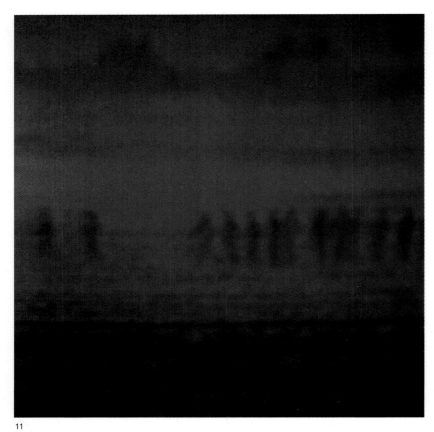
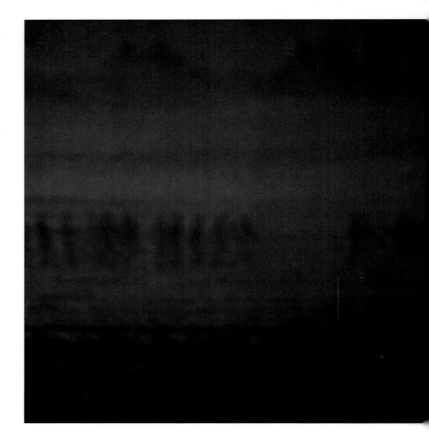

11

Plate 11
China, 1995

12a

Plates 12a–c
Decoy #16, 1991

12b

12c

When the Gulf War was over, Rovner returned to the subject of the Bedouin house with somber resolve and made a new series from Polaroid pictures she had taken during earlier visits to Israel. She re-photographed them in black and white, then added muted grays and browns in the darkroom (pls. 13–20). This series is heavier in emotional tone, more funereal than the earlier set. The later images are also meant to be seen as a group, unlike the series of the same subject Rovner had made in pastel colors before the Gulf War. When several of the photographs in the later series are seen together, as these are, the house becomes animated. It trembles in one frame, then lists to the side in another. In a third image the house seems poised to take flight. From picture to picture, the house changes position in the frame as Rovner moves near or far. Though the basic shape remains the same, the image of the house is ever-changing, unstable. "This later series is about repetition, change, transience, and contradiction," Rovner says.[20] The two groups, however, are united by the series title *Outside*.

Rovner did not make any of these photographs with a historical reference in mind. Nevertheless, the pictures may be seen in light of her nation's history. One of Israel's nicknames is "The National House," a reference to the country as safe haven for the world's Jewish population. Yet the wars and conflict that recur between Israel and the Arab nations that surround it prove that the national house is located in a volatile neighborhood. Until Israel and Egypt opened relations in 1979, an Israeli could not travel by land to another country: there was no going outside of its borders. For a nation no larger than the state of Massachusetts (roughly eight thousand square miles), this is both a geographical and a psychological restriction.

13

14

17

18

Plates 13–20
Michal Rovner, from the series,
Outside, 1990/91

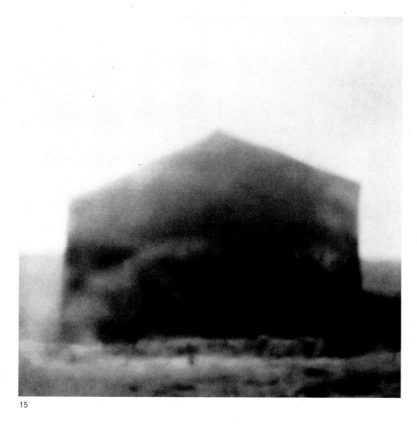

15

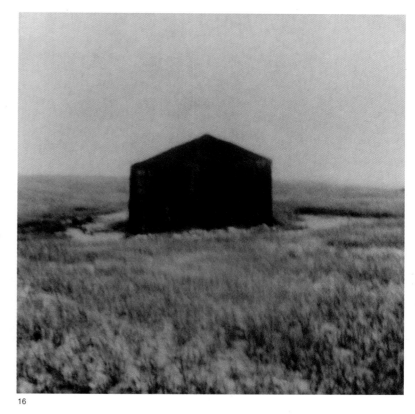

16

19

20

Today Rovner is an outsider to some degree in both Israel and America. When in Israel, her days are mostly spent with family, or photographing and filming. Her time in New York is primarily spent processing imagery she has made elsewhere, producing final works, and preparing for upcoming exhibitions. This remove from the site of image-making is crucial to Rovner. It gives her the needed distance to see her film and video footage apart from its source, which facilitates the creation of new form. In both New York and Israel, Rovner has assistants who help her with the mechanics of her artistic production, including the editing, mounting, framing, and shipping of works. But no one shares her process. Unlike the street photographers of the 1960s, who enjoyed a camaraderie as they roamed the streets of New York, Rovner is essentially a loner. This is due, in large part, to the nature of her work—a solo enterprise that takes place first in Rovner's head, in what she calls a "clear vague picture," then in the ambiguous place where imagination and intention come together as the artist's principal partners. It may also be a function of her circulation between two worlds. Depending on the year, Rovner can spend as little as two weeks in Israel or as much as three months. In 1992 she went to Israel to begin a third series of photographs of the Bedouin house, but when she got to the spot along the highway where it had been, it was gone. While the loss was great, it freed her to continue on the road to the Dead Sea, where she had been headed two years before when the house caught her eye.

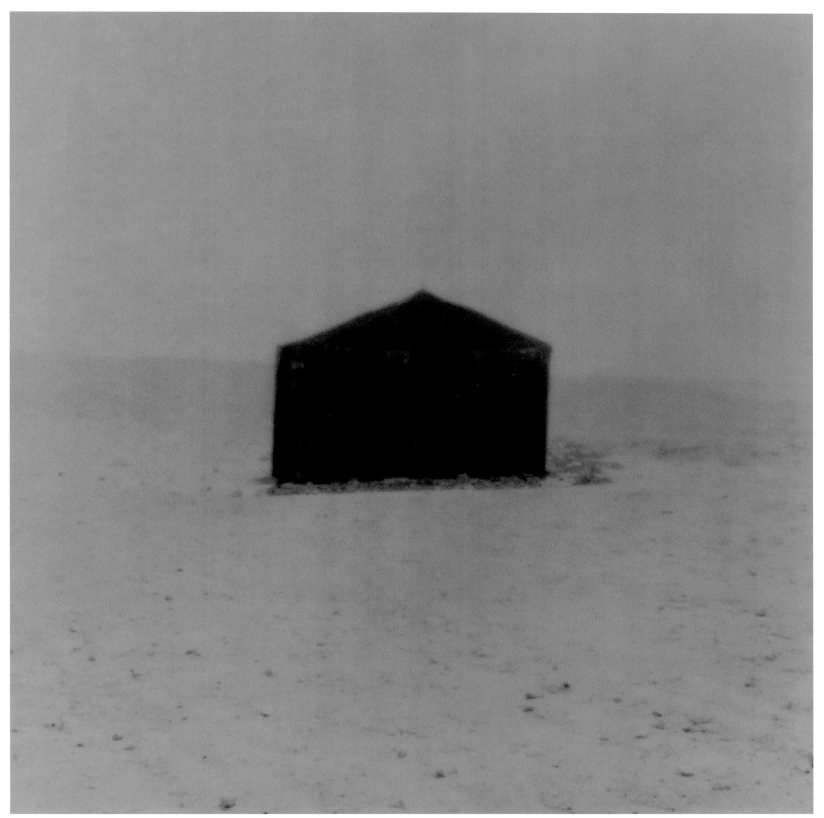

Plate 13
Outside #11, 1990/91

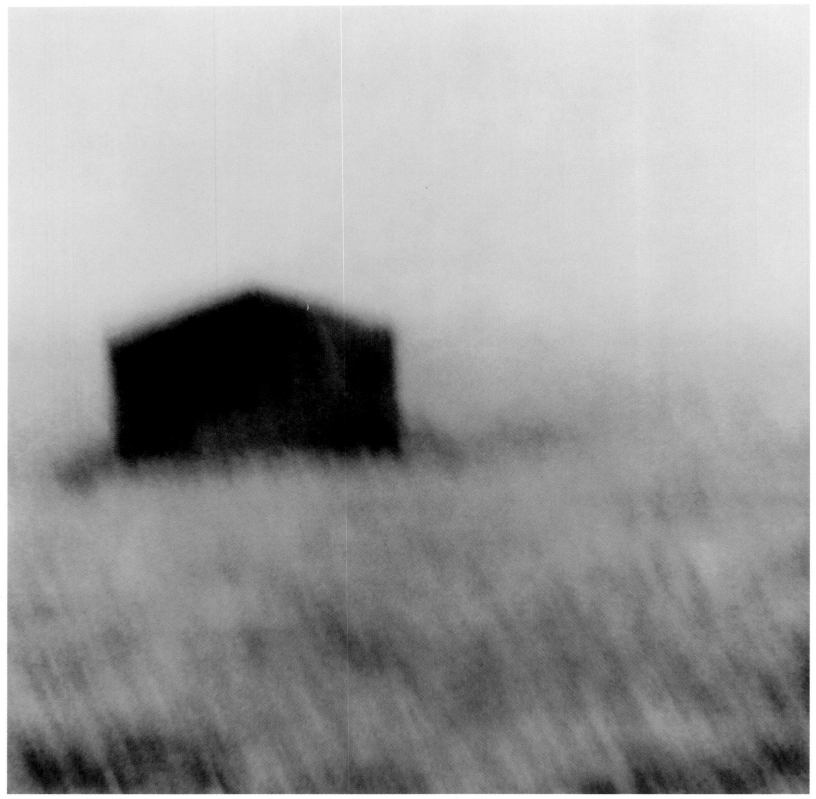

14

Plate 14
Outside #1, 1990/91

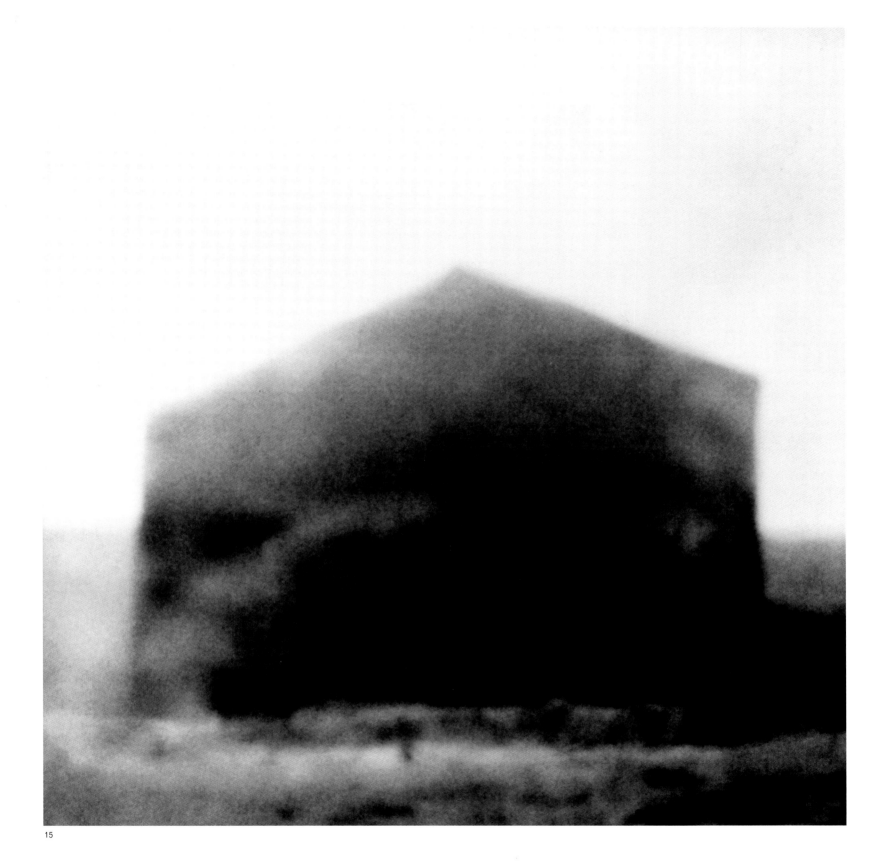

15

Plate 15
Outside #3, 1990/91

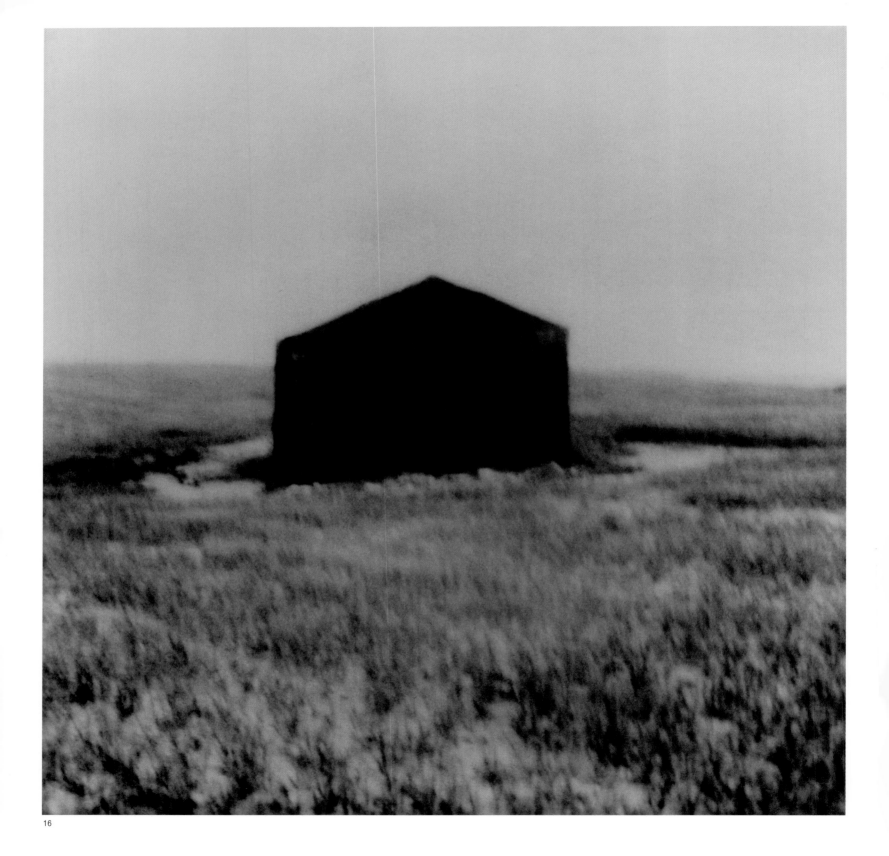

16

Plate 16
Outside #4, 1990/91

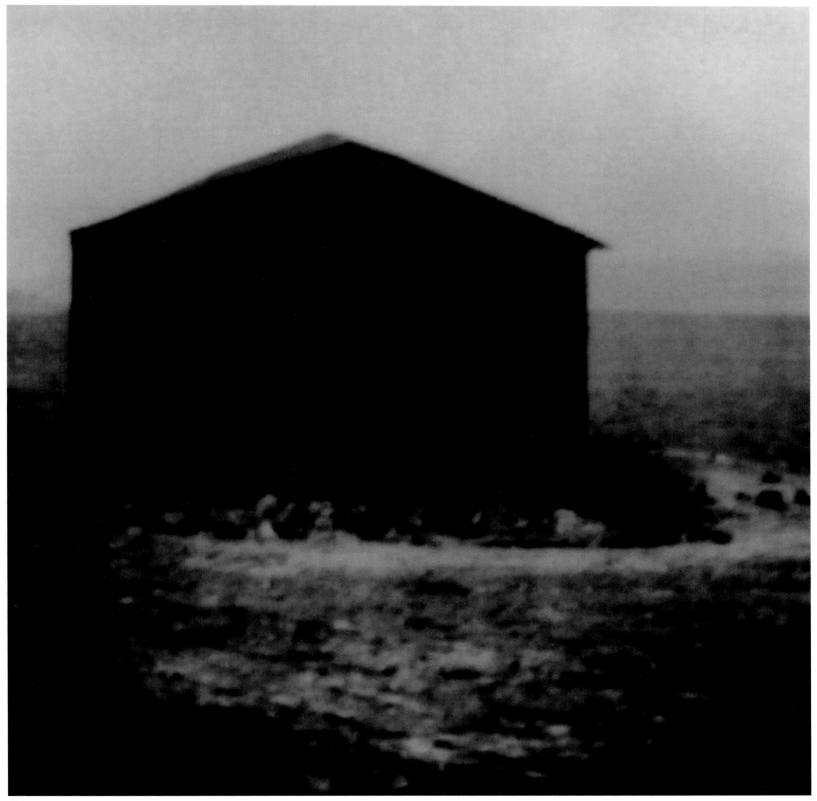

17

Plate 17
Outside #20, 1990/91

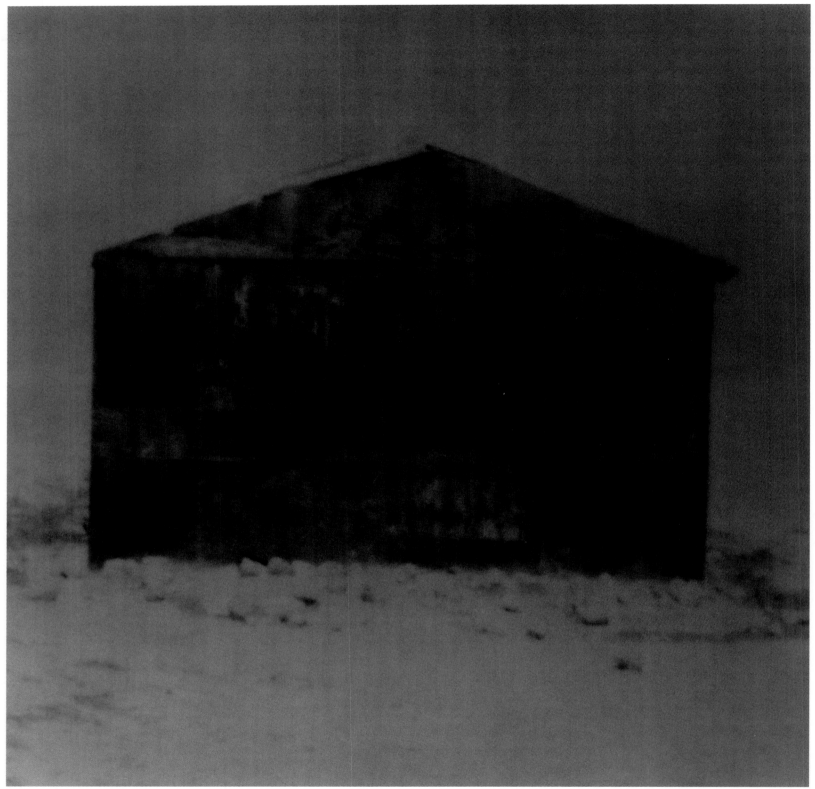

18

Plate 18
Outside #9, 1990/91

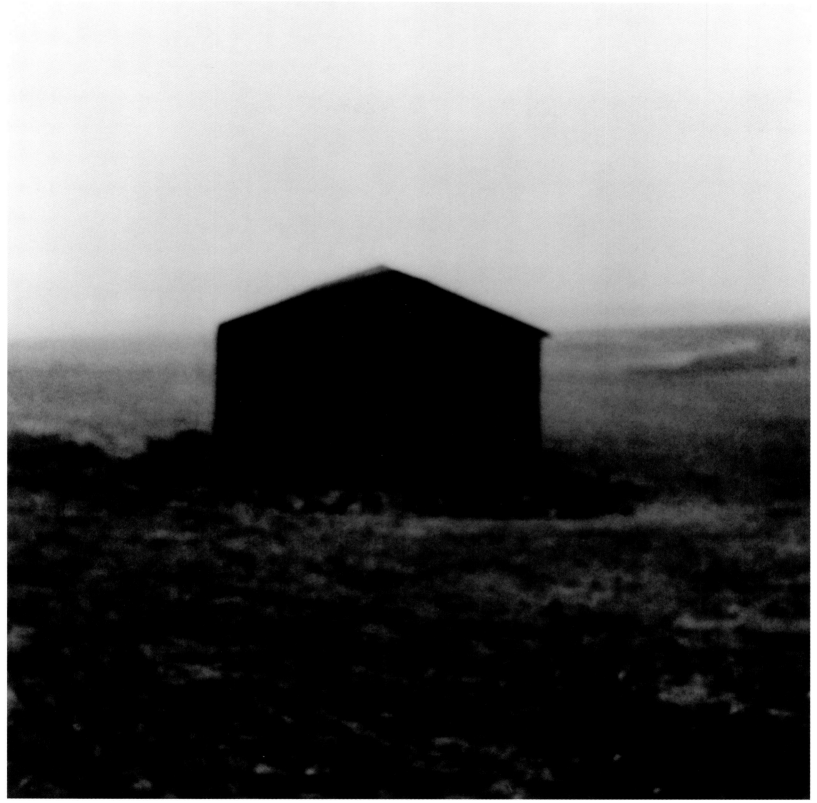

Plate 19
Outside #10, 1990/91

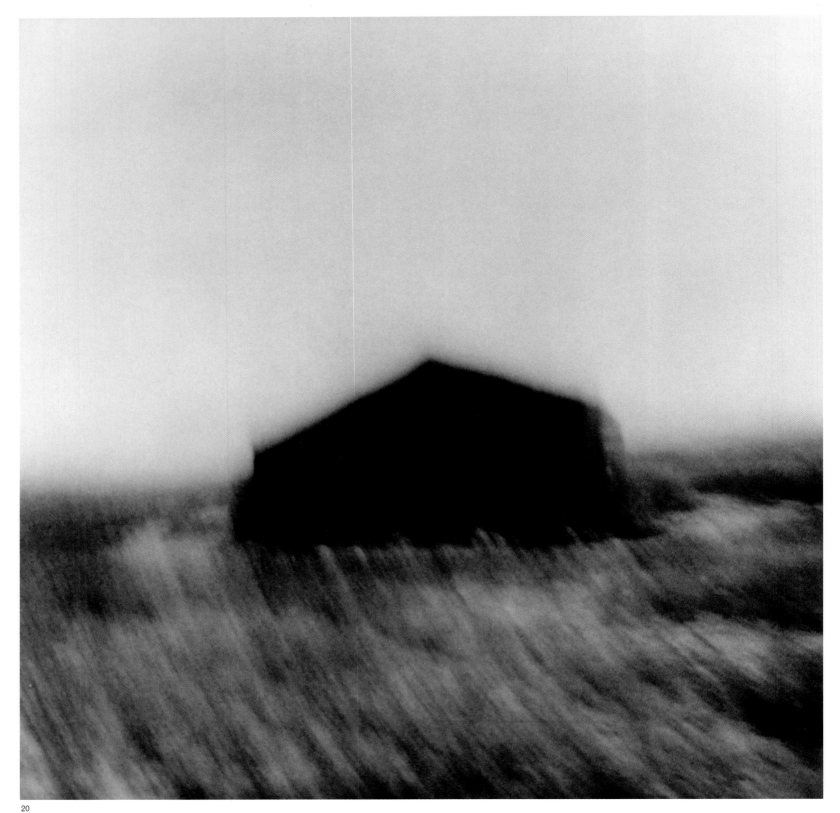

Plate 20
Outside #12, 1990/91

A SHIFT TO NO PLACE

Because of its intensity and stillness, the **Dead Sea** is one of Rovner's favorite places on earth. Landlocked by the deserts of Israel and Jordan, it is a place of extremes. More than thirteen hundred feet below sea level (four hundred meters), it is the lowest place on earth. The air is heavy with the smell of sulfates and bicarbonates, and the heat is merciless. Nothing lives in the saline sea and no vegetation grows on its banks. Due to the **Dead Sea's** high salt content, bathers who seek the medicinal powers of the mineral-rich water float like corks in a bathtub. This was the perfect setting for the pictures Rovner had in mind. She had photographed her mother and father in the water on a previous trip, and found that the water provided a neutral ground against which a figure appeared to be removed from the world of details (figs. 27–28). To model for her this time, she hired lean, teenage boys with close-cropped hair, wearing flesh-colored swimsuits, to float in the water at her command. With characteristic charm and will, she coaxed her models out of their boyish self-consciousness and directed their actions from the shore.

From the photographs taken at the **Dead Sea**, Rovner produced two bodies of work. One, like past series, was made with a **Polaroid SX-70** camera (pls. 21–25), which Rovner favors for its instantaneousness. "I think of photography like correspondence," Rovner says of darkroom photography. "You send a letter and you wait for a response, but the mail is slow. With the immediacy of Polaroid, you don't have to wait. You see it and can respond right away."[21] Standing on a chair to raise her above the water—thus eliminating the horizon line—Rovner photographed the floating bodies at dusk and by car headlights at night. Later, she re-photographed, enlarged, and tinted the images in the color enlarger. The final prints are moody and atmospheric. One figure (pl. 21) resembles an ancient Cycladic figure that stands tall and erect, "magnanimous to correspond with Heaven," as Milton described human posture in *Paradise Lost*.[22] Others, on their backs, rise and hover above the saturated bath of color Rovner created in the darkroom.

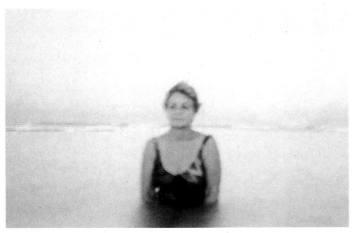 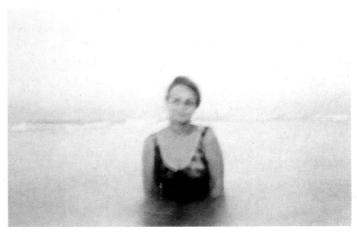

27 28

Figures 27–28
Michal Rovner
Untitled, 1985/87

29

30

Figure 29
Edward Steichen
The Pool, 1900

Figure 30
Allan McCollum
#73A and *#73B*, 1985,
from the series
Perpetual Photo

A second series of pictures was shot concurrently, using a video camera, from the seventh and tenth floors of a hotel along the seashore (pls. 26–29). "I was looking at the same thing from two different perspectives, two different viewpoints, two different languages," Rovner remarks.[23] As with her early black-and-white photographs of a house in Herodium (pl. 1), Rovner worked from a physical distance in order to achieve a visceral immediacy in her imagery. To make the prints, she selected frames from the videotapes, amplifying them dozens of times to produce gritty, grainy images in which human presence is only vaguely discernible. Unlike her photographs made from Polaroids, there is no original still image for these works. Everything is fabricated during the process of enlargement. But as with Polaroid, making images in video offers immediate review. While the first set of pictures is gentle in its haunting spirituality, with figures that have volume and a space that is full of color and suggestive of depth, the video-generated photographs are tougher, more ominous. Figures are reduced to dark silhouettes, and the grainy texture of the images creates a flat field. Even the colors are threatening: viscera red and gunmetal gray. The images resemble reconnaissance pictures that have been enlarged over and over to get at one minuscule detail of the larger scene—that detail acting as evidence of something sinister or tragic occurring at the time of the exposure.

Rovner gave the entire **Dead Sea** series (both Polaroid and video images) a title from a field of study called "game theory." With origins in mathematics, the theory codifies the behavior of decision makers when engaged in a game, conflict, military action, or economic negotiation.[24] Areas of study within game theory include "two-person games" and "three-person games," in which individuals are observed and evaluated as they determine the best course of action in anticipation of the response of their opponent. Strictly speaking, a one-person game does not contain the essence of game theory because there is no unpredictable opponent. But if nature is characterized as lending uncertainty to a person's decisions, then a game is, indeed, implied. In the photographs from *One-Person Game Against Nature*, **Rovner** challenged nature with figures that float and fly, and in so doing, she defies gravity. She also altered the physical nature of her figures by softening their mass and imbuing them with an ethereal presence.

Rovner's figures floating in the **Dead Sea** came at a time when the artist was exploring new ways of looking at the world. Rovner has never been particularly religious, but she is interested in various philosophical and spiritual schools of thought. When in New York, she took Tai Chi and studied with a Chinese master of martial arts. In 1995 her inquiry into Eastern religion culminated in a visit to China, where she spent three weeks with a group of Chinese and American students of Qigong, an ancient practice of postures, exercises, breathing techniques, and meditation that is designed to improve mental and physical health. China moved Rovner as a nation of hardship. "Individual life there is not considered the most

critical thing," she remarks. "In that hardship, they find ways to elevate them-selves through martial arts—by making the body stronger—and they commune with the sun and the moon. They feel strengthened and protected by the cosmos."[25] This idea was inspiring to Rovner, as was the Qigong practice of meditating on light and envisioning things beyond tangible reality. She also found poetry in the Chinese attitude toward the Tao itself:

> Infinite and boundless, it cannot be named
> It belongs to where there are no beliefs,
> It may be called the shape of no-shape,
> It may be called the form of no-form.[26]

The intangible was a feature of Rovner's photographs from the very beginning, but it reached its height with the Dead Sea pictures, in which human forms hover weightlessly as "shapes of no-shape" and "forms of no-form."

While Rovner's diffusion of a recognizable form produces images that are thor-oughly her own, she is not alone in this practice. The diffused image has long been a conceptual and expressive tool in photography. In the late 1880s and 1890s, when Pictorialist photographers sought to achieve the status of high art for their images, they did so with a soft-focus aesthetic believed to be a truer, more subjective artis-tic expression than the camera's unflinchingly accurate transcription of detail. By using photographic processes that suggested a painterly effect, as exemplified by the gum bichromate prints of Edward Steichen (fig. 29), the Pictorialists chal-lenged photography's marriage to the documentation of fact.

Nearly a century after the Pictorialist movement began, artists used the diffused image to comment on the glut of photographic images in contemporary culture, and to explore perception itself. In 1985 Allan McCollum made black-and-white photographs as part of a series called the *Perpetual Photo*—grainy, illegible enlarge-ments of works of art hanging on the walls of television studio sets. Much as Rovner had done with TV footage of the Gulf War, McCollum shot directly from the TV screen to highlight the disjunction between the real thing and its image, creating works that are several times removed from reality through photographic reproduction (fig. 30). In 1986, Los Angeles–based photographer and printmaker Robert Heinecken made inkjet prints of well-known news anchors from photograms taken off the television screen. In one chalk-textured print, Connie Chung's face radiates with saturated circus colors (fig. 31). This image can be seen as a prece-dent for Rovner's own photographic response to the homogenized television cover-age of the Gulf War five years later.[27]

Nature, too, has been a subject of diffused image-making. Starting in 1987, Ellen Brooks rendered idyllic scenes—a garden lush with colored flowers, for instance—in what looked like half-tone printing dots, computer pixels, or the swollen grain of a photographic enlargement (fig. 32).[28] As part of a postmodern critique of photog-

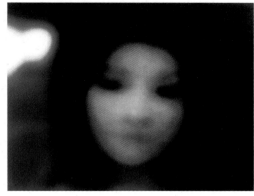

31

32

Figure 31
Robert Heinecken
Connie Chung, 1986

Figure 32
Ellen Brooks
Garden Slice, 1987

33

34

raphy's hold on realistic representation, Brooks's images offer a counterpoint to traditional forms of landscape photography that celebrated nature through images made with large-format cameras that were rich in tone and crisp in detail. More recently, Uta Barth, with whom Rovner exhibited at the New York gallery Wooster Gardens in 1994, has made photographs in which no particular subject is the point of focus (fig. 33).[29] Barth's images, in particular, raise questions about how we see and what kind of information we expect from a photograph. In her remarks about her photographs, Barth summed up the questioning spirit of much contemporary art that takes the medium itself as a point of reference: "We all expect photographs to be pictures of something. We assume that the photographer observed a place, a person, an event in the world, and wants to record *it*, point at *it*. . . . The problem with my work is that these images are really not of anything in that sense, they register only that which is incidental and peripheral to the implied *it*."[30]

Rovner's own diffusion of photographic detail is employed in an effort to get at something more real than the accurate depiction of a subject. She cites painting as a source of inspiration, and admires the canvases of German artist Gerhard Richter that have photographs as source material and that resemble out-of-focus pictures (fig. 34). Though Rovner's images bear a resemblance to painting, she finds it important to begin with something real. First, she records a subject on either photographic film or videotape, gathering evidence in what is a classic photographic or filmic action. Then, she inserts her own thinking, her own interpretation, making associations and stripping away details. In the end, the subject is no longer the same as it was in the beginning. It has lost its referential meaning. It is now both less and more than it was in its original form. Seeing less, we imagine more.[31]

Figure 33
Uta Barth
Ground #42, 1994

Figure 34
Gerhard Richter
Waterfall, 1997

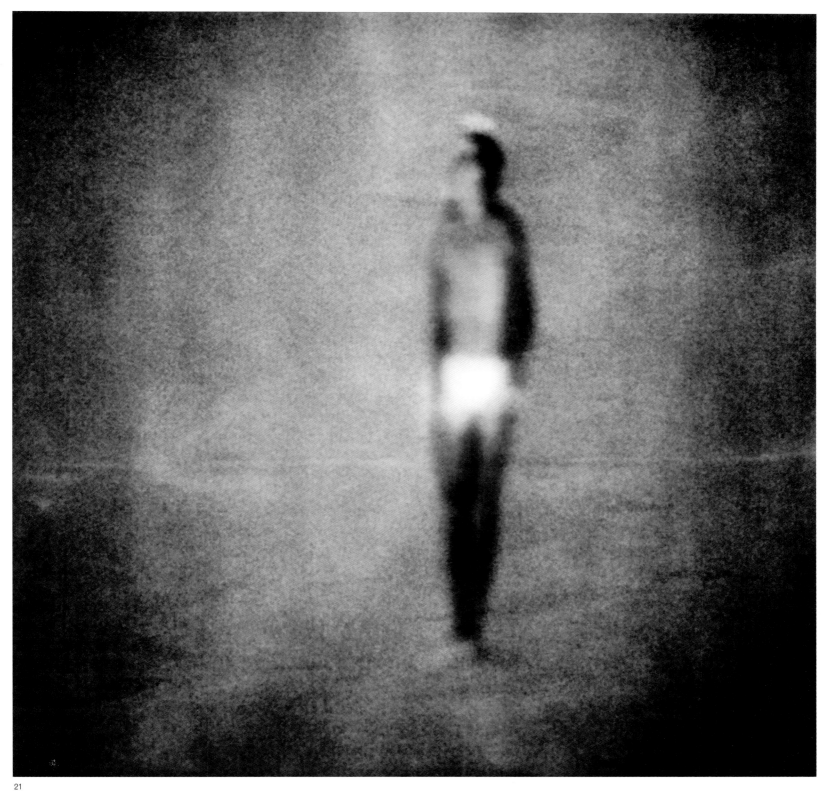

Plate 21
One-Person Game Against Nature #5, 1992

22

Plate 22
One-Person Game Against Nature #6, 1992

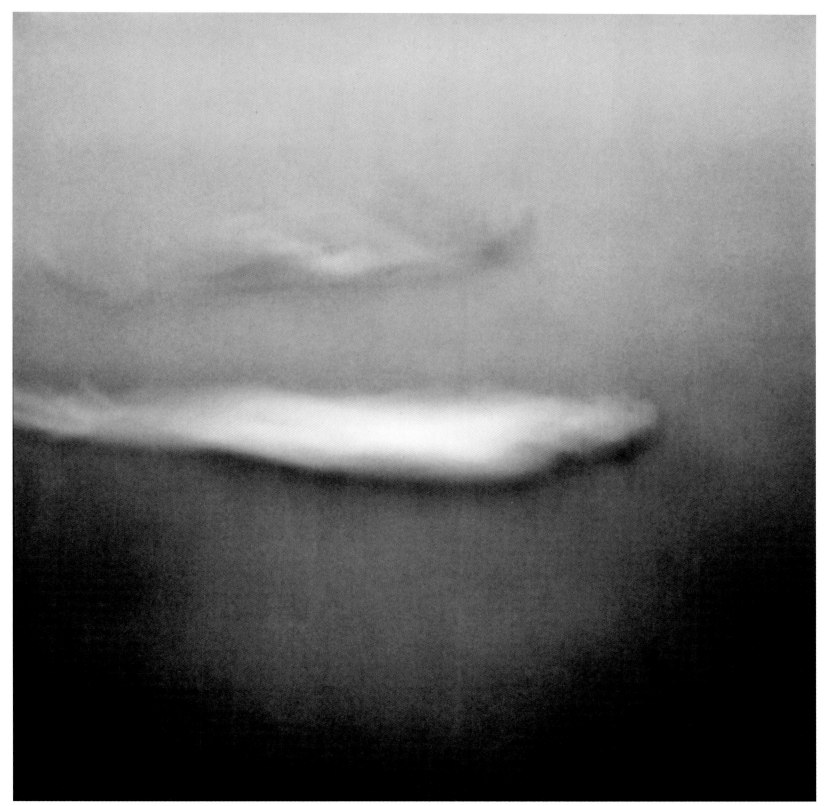

23

Plate 23
One-Person Game Against Nature #7, 1992

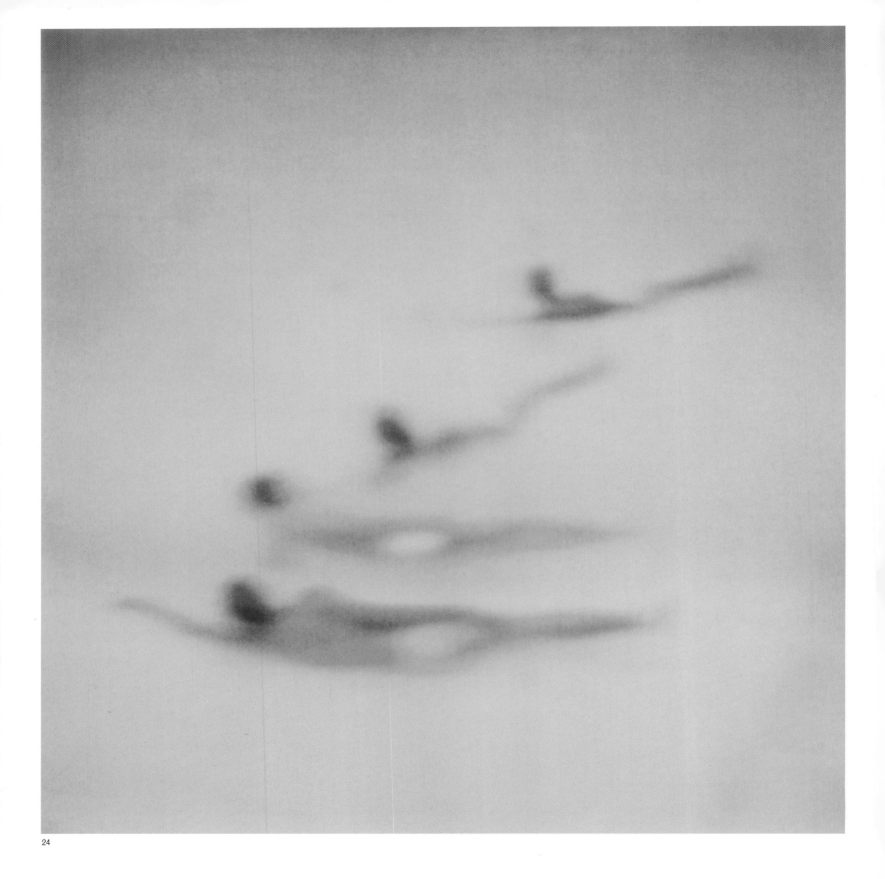

24

Plate 24
One-Person Game Against Nature #22, 1992/93

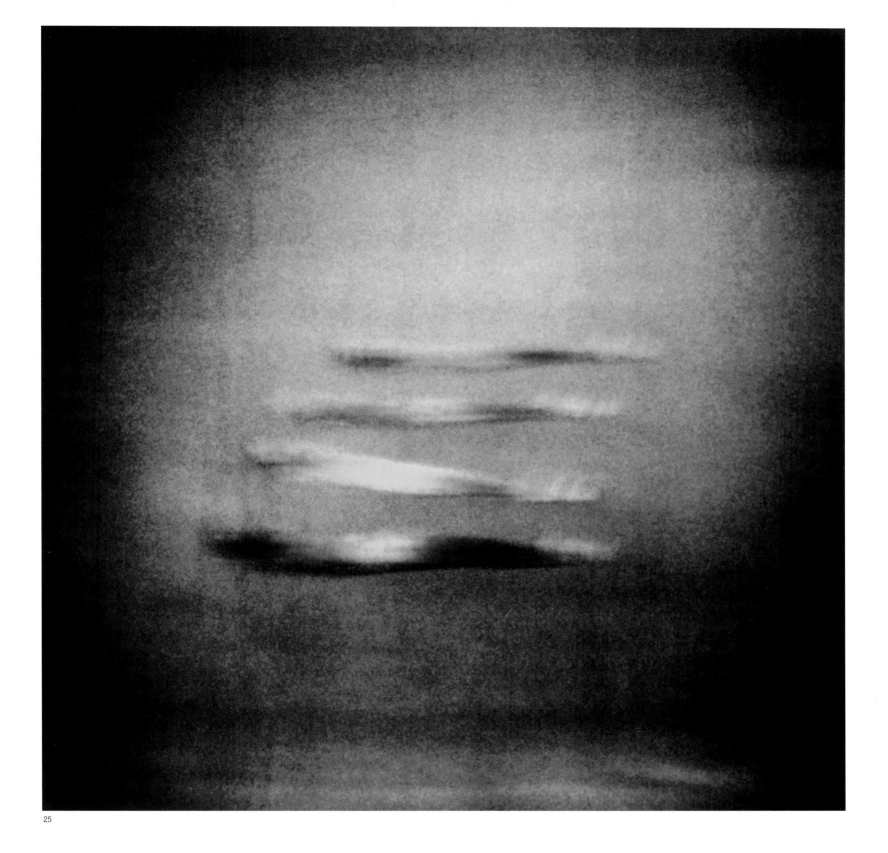

25

Plate 25
One-Person Game Against Nature #45, 1993

26

Plate 26
One-Person Game Against Nature #30V, 1993

27

Plate 27
One-Person Game Against Nature #6V, 1992

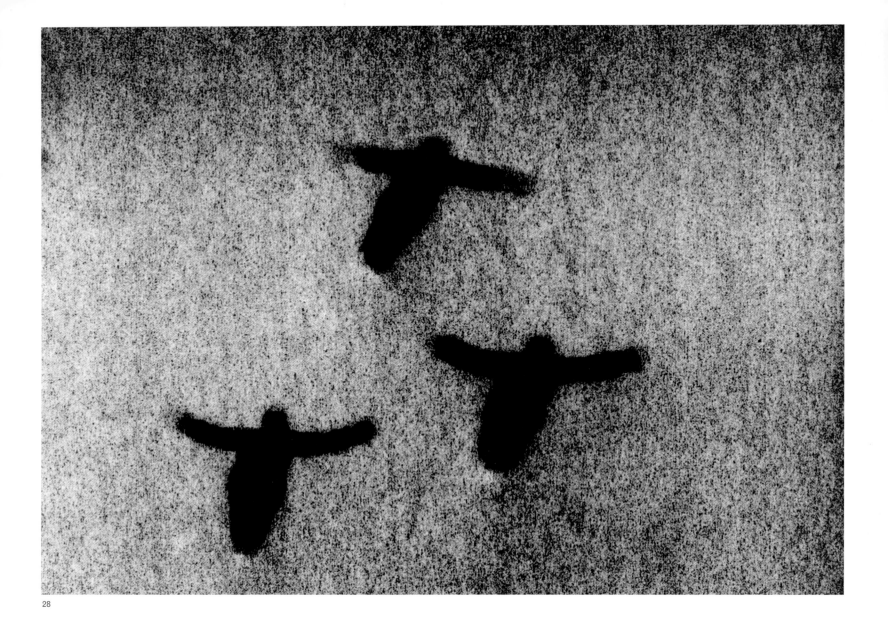

28

Plate 28
One-Person Game Against Nature #10V, 1993

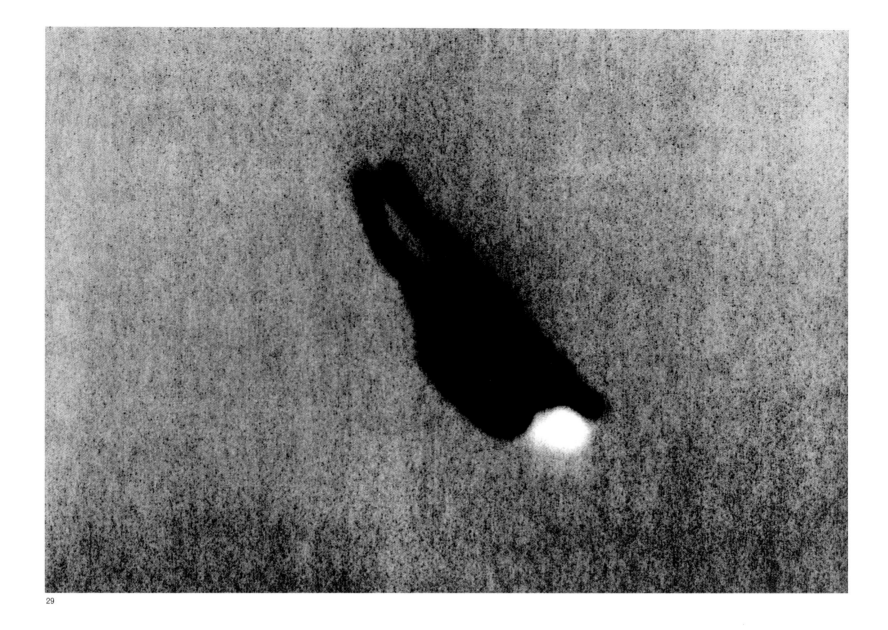

29

Plate 29
One-Person Game Against Nature #9V, 1993

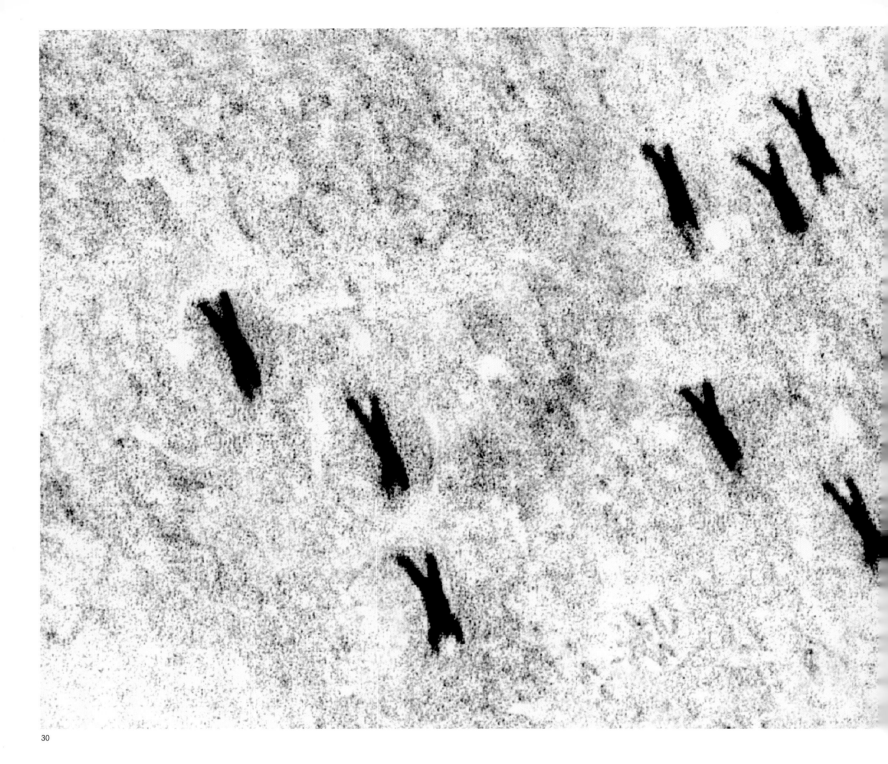

30

Plate 30
All That, 1995

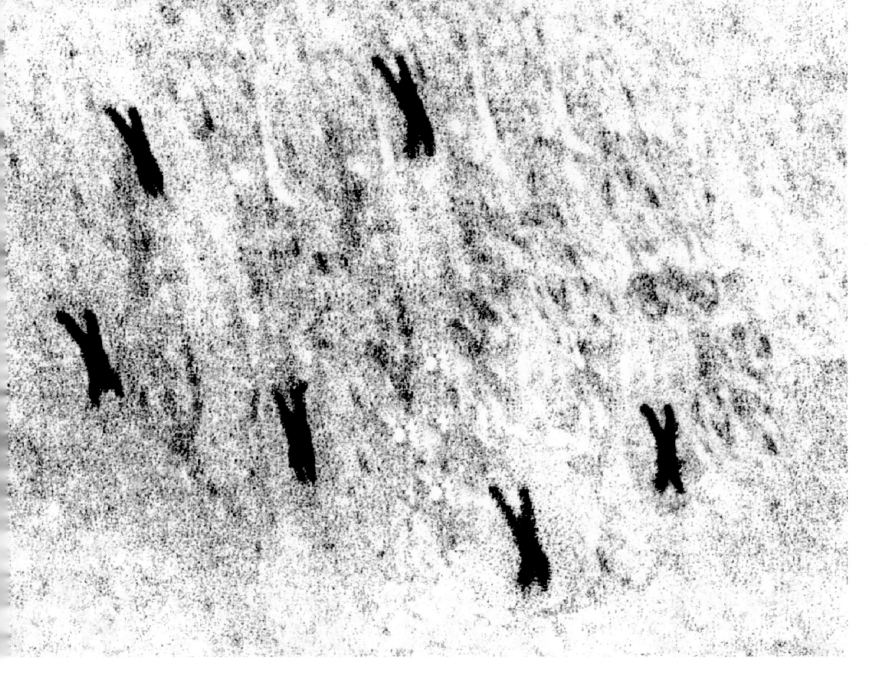

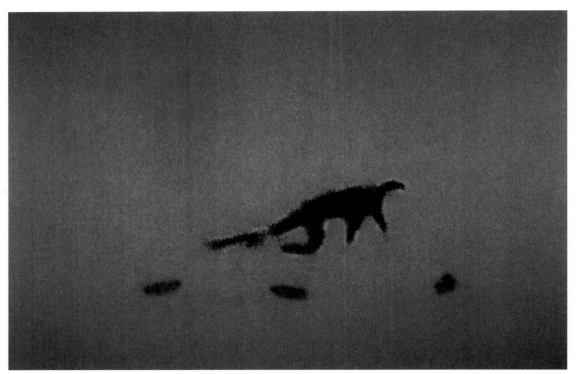

31a

31b

Plates 31a–c
Red Field, 1995

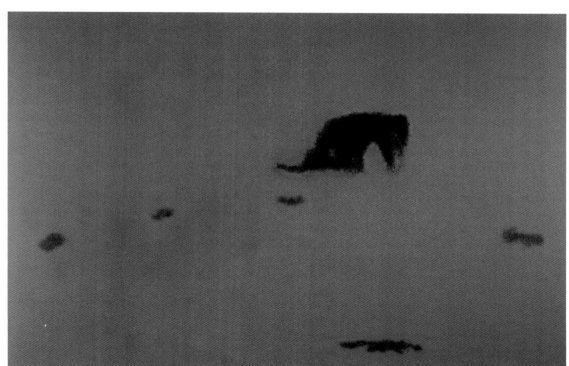

31c

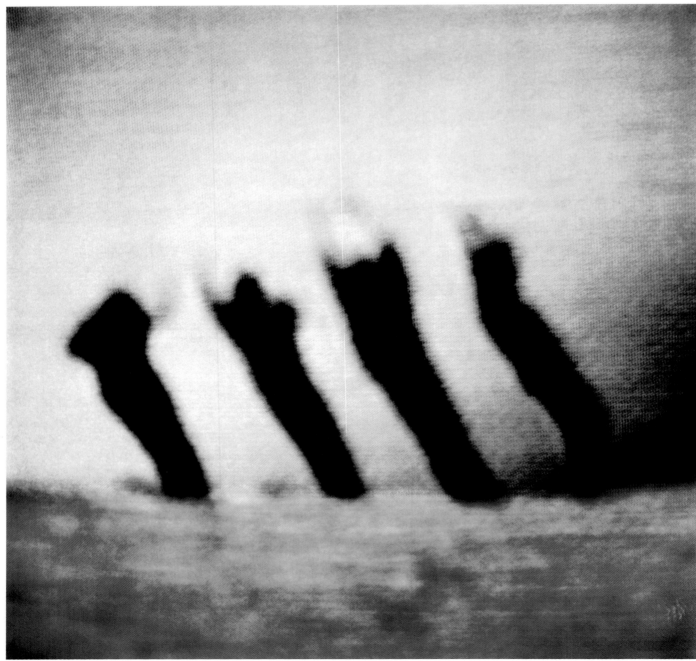

32

Plate 32
Force, 1997

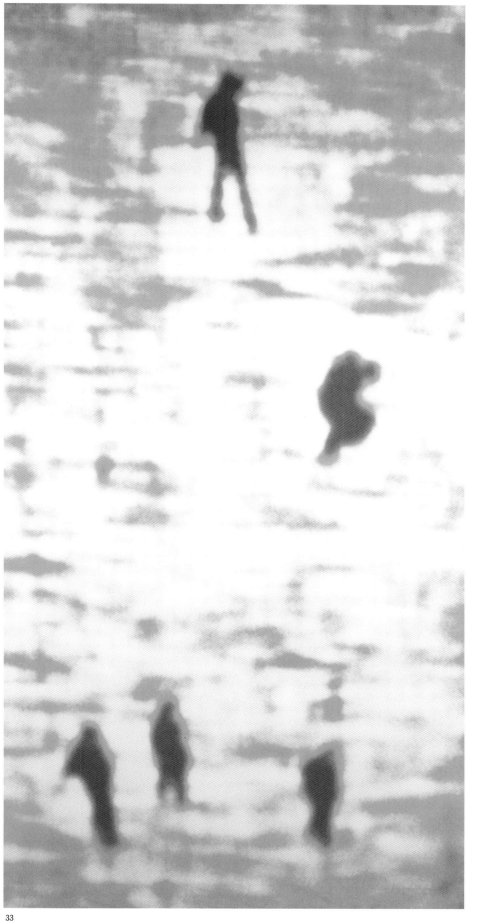

Plate 33
Heat #1, 1997

34

Plate 34
Land, 1997

As Rovner became more ambitious in the composition of her pictures, she became increasingly engaged in orchestrating greater numbers of people. She also left the Dead Sea and chose as backdrop the dry expanse of the Israeli desert. The resulting photographs are of figures struggling against heat, wind, and desert sands in stories of primal behavior and evolution. A sense of isolation permeates the work. Figures rarely interact or even show recognition of one another. Here Rovner's early training in dance can be seen in her understanding of body posture as expressive of ideas. In *All That*, made in 1995 (pl. 30), Rovner positioned fourteen men and women, dressed in black clothes, lying on a hillside in the desert. To get a flat, aerial perspective, she stood on a hill at a distance and directed their movements by walkie-talkie, much as she had for the video-generated works made at the Dead Sea. Once back in her studio, she reduced the details, heightened the grain and contrast, enlarged the image to nearly four by seven feet, and colored it the flat, opaque, navy blue typical of an architectural blueprint. The piece resembles a territorial map, with sites or targets marked by *X*s. It could also be an abstract painting or a microscopic sampling of chromosomes.

In another image made in 1995, titled *Red Field*, a lone black figure rises out of crimson sands and drags first one leg, then another, as it crawls across three frames (pl. 31). The vibrant color evokes the heat of a barren land and the intense effort with which the figure tries to move, despite what appears to be crippling exhaustion. "The works I was making at this time are about individuals obeying or acting in response to forces outside themselves," Rovner explains.[32] In particular, her figures appear to be struggling with the elements, which may be easily envisioned as metaphors for the forces of politics, fate, God, or any number of other powers that drive human behavior. In *Heat #1*, five figures are positioned against a vivid yellow, vertical field, in which ripples of white quiver like heat waves (pl. 33). In *Force*, four faceless, ageless, sexless figures lean in the same direction, as though performing in a modern dance piece or weathering gale-force winds (pl. 32).

The Epic of Gilgamesh, a tale over four thousand years old, would make a compelling companion piece to these photographs. The final chapter of the epic tells the story of a Sumerian prince, who, sickened by grief over the loss of a beloved friend, embarks on a journey in search of a magic plant said to restore life to the dead. As he traverses a desert, survives a flood, and races against the sun, we see the archetype of the hero on a quest, striving for superhuman achievement against impossible odds. Ultimately, the prince secures the plant, only to have it stolen by a serpent (an underworld figure even then). With this final loss, Gilgamesh appears to relinquish his pursuit of immortality and he returns to his people, where he is reported to have ruled as a compassionate king for more than 126 years.[33] Though Gilgamesh is an individual hero, with distinct strengths and flaws, his story is

meant to represent the drive, will, and fallibility of all human beings. Hard and unyielding, he is softened by friendship and humbled by his quest. Only when he accepts mortality, can he truly become king.

The Epic of Gilgamesh was first recorded by Mesopotamian poets around 2100 B.C.E., predating Homer and the Bible by over a thousand years. Its themes, however, are strikingly contemporary. With its tales of friendship, grief, and the desire to overturn the forces of nature and turn back time, it testifies to the enduring nature of certain human characteristics. It also positions the landscape as a testing ground and a place of transformation. Throughout history and across cultures, human beings have gauged their courage and compassion in relation to nature, and the landscape has been their field of inquiry. "A man is nothing but the landscape of his homeland," wrote Hebrew poet Shaul Tchernichovsky.[34] In Rovner's works, the landscape of Israel is a powerful force—one aspect of the landscape, that is. Israel contains a wide range of topography, from forested hills to fertile valleys to the coastal plain along the Mediterranean. Rovner has chosen to work in the Negev Desert, the dry, arid, sandstone expanse, sparsely inhabited by Israelis and Arabs, that occupies the southern half of Israel.

For much of the year, there is little rainfall in the Negev Desert and the light is relentless. Because the space is vast and uninterrupted by vegetation or other landmarks, it is difficult to gain a precise sense of scale and distance. Goats, sheep, and camels standing on a hillside blend into the landscape, until they move, and then the ground itself seems to awaken, only to settle again when the animals come to rest. In this landscape, mirages appear. Figures or structures with little contour, clarity, or color materialize out of nowhere, as they seem to in Rovner's

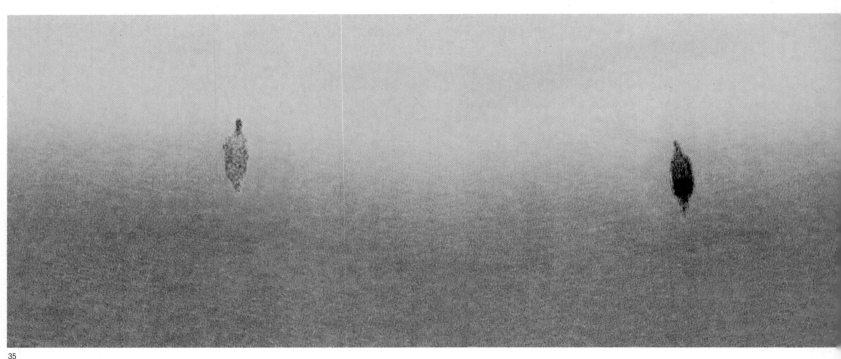

35

Figure 35
Michal Rovner
Labyrinth, 1997

photographs, and hover weightlessly above a khaki-colored ground (fig. 35). The ground itself undulates from the optical illusion of heat waves. In one of Rovner's photographs, an expanse of sand is pictured in four parts, the space between them resembling plot lines on a farm or the crosshairs of a gun sight (pl. 34). The concept of field is implied as a spatial construct, as an agricultural unit, and as contested territory.

The compositional elements of Rovner's pictures may be seen in light of the topographic characteristics of the desert. Often her subject is centrally placed and shown in silhouette to articulate its outer dimension or shape. There are rarely any suggestions of spatial depth. Houses, figures, or soldiers float on a flat field of color. In the desert regions of Israel, the color palette includes two principal hues— sky blue and sandstone. Rovner's images include blue, on occasion, and every imaginable variation of beige. These colors are not intended to describe Rovner's country of origin, but they certainly emerge from the place. Much as Netherlandish painting is particular to a latitude, as well as to an art-historical time, so is Rovner's aesthetic indebted to the landscape and climate of Israel.

Leaving home, however, was what allowed her to see the landscape with fresh eyes and to use it with purpose. Within five years of moving to America, Rovner had made a significant body of work with footage shot in Israel and processed in New York. In 1993 she had her first solo museum exhibition outside of Israel, at the Art Institute of Chicago. In 1994 she was included, with Shimon Attie, Abelardo Morell, and Jorge Ribalta, in the *New Photography 10* exhibition at the Museum of Modern Art, New York. Also in 1994, her work was featured in a solo exhibition at the Israel Museum in Jerusalem and in gallery shows in Paris, London, and three other cities in the United States.

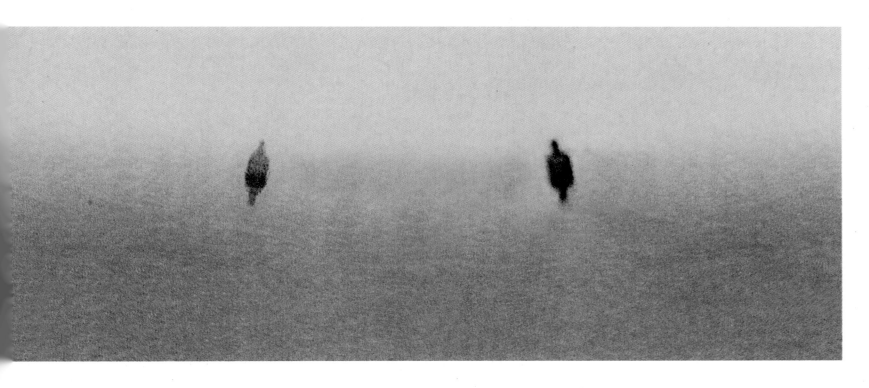

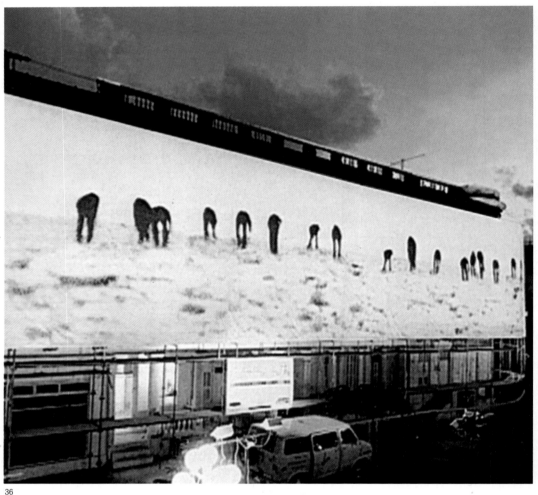

36

37

Figure 36
Michal Rovner
Tel (Hill), 1995

Figure 37
Michal Rovner
Coexistence 1, 1995

As Rovner's exposure increased, more opportunities arose. In 1994 she was invited to make her first site-specific installation. The site was a landmark building in Tel Aviv that was being converted into apartments. The real-estate developers used the exterior of the building as a public art space during the time it took to renovate the interior. Rovner's piece, titled *Tel (Hill)*, was a 27-by-147-foot mural made of nine linoleum panels that pictured figures hunched over in a barren land (fig. 36). "A *tel* is a hill or mound which is believed to have a civilization buried underneath, because there is no topographic reason for it to be there. I think of all Israel as a big *tel*," Rovner explains.[35]

The production of *Tel (Hill)* was no small feat. Because of the scale of the piece and because it had to endure the elements, Rovner used a commercial printing process designed for billboards. (The process has become a favorite of Rovner's, though she now uses it primarily on a canvas surface.) The piece was installed on the facade of the building by dozens of workers. Overseeing a production crew was not an unusual experience for Rovner, but this was her first time directing a project, and her first experience creating a work of art that would be seen outside the boundaries of an art environment. Thinking about how it would be seen and experienced by people in the neighborhood during the months of its installation expanded Rovner's thinking about her potential audience.

A year later, in 1995, Rovner had another chance to address a general audience when she was invited to produce a second site-specific piece, this time by the International Artists' Museum.[36] For a project called *Co-Existence: Construction in Process*, more than one hundred artists from twelve countries were invited to make art on the general theme of coexistence for installation in the Negev Desert. The public art project took place following an agreement between Israel and the Palestinian Liberation Organization in 1993 to recognize each other's right to exist, and before Israel's scheduled withdrawal from Lebanon in July of 1995.[37] The exhibition took place in April, in and around the town of Mitzpe Ramon, and was accompanied by an international symposium of artists, writers, poets, and critics.

In the spirit of *Tel (Hill)*, Rovner produced a 16-by-64-foot mural, titled *Coexistence 1*, that she installed above the Ramon Crater, a valley surrounded by steep walls, in the territory through which Moses led the Israelites.[38] The image contained two figures, standing on opposite edges of a mesa, both leaning perilously over the edge with one foot forward, as though poised to take a step (fig. 37). A personal as well as a political message can be seen in the piece. "It's two people sharing the same space," Rovner remarks. "They've created as much distance from each other as possible. If they take one more step, they will fall into an abyss."[39] Rovner printed and positioned the mural to blend in with the landscape. The piece was large because the desert is large, she explains. "It was supposed to look like a tent or a mountain."[40] Her hope was that people driving by would see the work and wonder about its origin and meaning. Few viewers, however, had occasion to see *Coexistence 1*. The wind at Mitzpe Ramon was great, and fearing that the blowing mural would tear down its supporting wall, Rovner removed the mural within days of its installation.

Undeterred by the forces of nature or by the danger of going into a war zone during times of fire exchange, Rovner made two more outdoor pieces in 1996, both along the border between Israel and Lebanon. For *Dilemmas: The Good Fence*, she hung forty-four flags, marked with an *X*, above an electric fence at the border between Israel and Lebanon (fig. 38). For *Edge-Tower*, she stretched two banners, each approximately 197 feet long and printed with anonymous figures, from a guard tower in opposite directions across the territorial boundary (fig. 39). The installations were meant to engage the curiosity of patrolling soldiers and residents on both sides of the border. (It worked. The commander who would become a central player in Rovner's later video, *Border*, first became interested in her art through these pieces.)

Rovner's effort to engage viewers in creating the meaning of a piece is a practice that has gained currency in contemporary art. In recent years, artists and critics have voiced a shift away from an art that is primarily engaged in a self-reflective dialogue toward one that engages the participation and experiences of the viewer. If the meaning of a piece evolves as a viewer experiences it, then any number of interpretations are possible.[41] Still, Rovner's art projects an aura of universality,

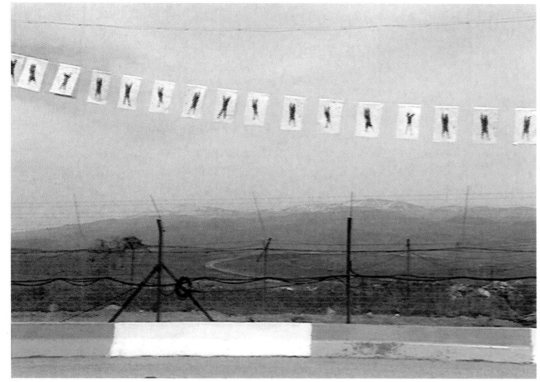

38

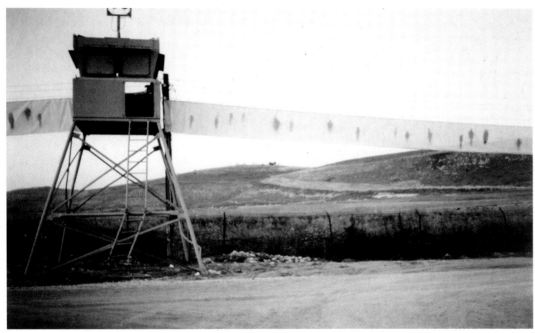

39

Figure 38
Michal Rovner
Dilemmas: The Good Fence, 1996

Figure 39
Michal Rovner
Edge-Tower, 1996

in part because it contains a measure of abstraction that transcends cultural boundaries. The number of exhibitions Rovner has had in countries around the world gives evidence that she is an international artist whose work holds appeal across national lines. This may be because her images of anonymous figures located in a non-specific land offer a safe means for viewers to consider ambiguity, multiplicity, and change as productive agents. When embraced rather than resisted, these ambiguities may lead to discovery and renewal, Rovner seems to suggest. Central to creating an art that allows for multiple meanings is Rovner's deviation from the real.[42] Inference, not reference, is her *modus operandi*.

Rovner is at home with inference, particularly when expressing herself in her second language. In conversations in English, she approaches a topic from the side, like a crab traversing the sand, and she rarely makes an outright demand. Instead, subtle suggestions repeated over time achieve the desired results. In Hebrew, by contrast, she is more direct. Rovner explains that vernacular Hebrew is less precise than English.[43] Little over a century old, spoken Hebrew is an evolving language that lacks ornament and nuance. Because there are fewer ways to refine a thought, words and sentences are more open to interpretation by the listener. Rovner, who is articulate in both languages, finds benefit in each. English offers a broader range of possibilities for personal expression, while Hebrew allows for multiple meanings. If we look at the two languages as metaphors for Rovner's artistic practice, we can see her use of photography to record information as akin to English—capable of providing a wide range of information—and her reduction of photographic information as in keeping with Hebrew's open-endedness. Given Rovner's voracious appetite for different ways of communicating complex ideas, it comes as no surprise that, as she mastered one visual language—photography—she undertook another. In the mid 1990s, Rovner added a second form of communication to her repertoire—one that has a distinct vocabulary of its own.

35

Plate 35
Border #8, 1997/98

Plate 36
Border (Jeep), 1997/2000

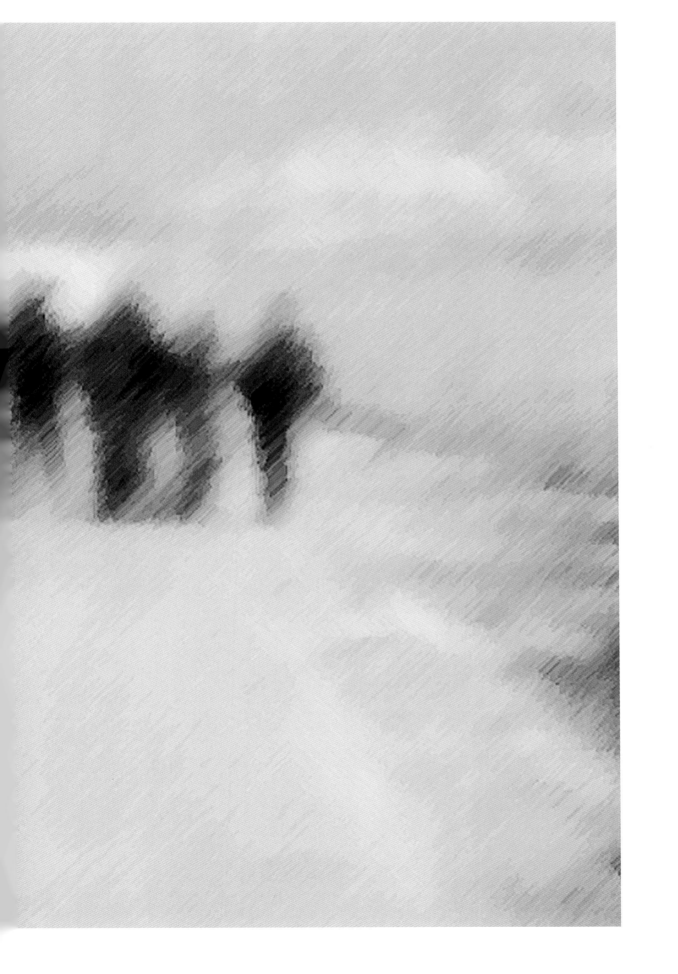

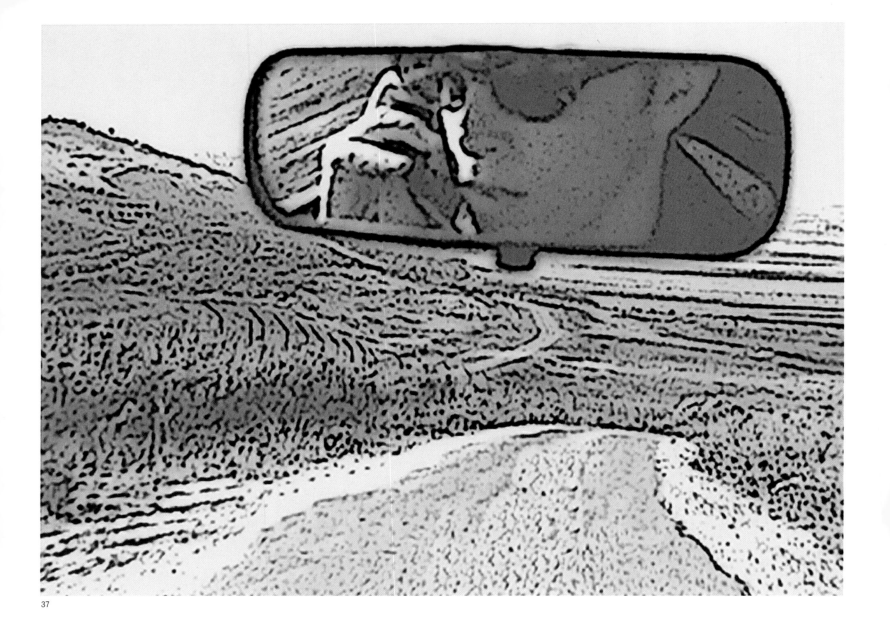

37

Plate 37
Border (Topography 1), 1997/2001

CROSSING THE LINE

In 1996 Rovner embarked on making her first full-scale video in what is her most ambitious project to date. Until then, she had used a video camera to record images at the Dead Sea or in the desert, which she then made into photographs, but she had not made a video as an autonomous work of art. Her first video, titled *Border*, was a 48-minute piece that merges the reflections of several characters living in a highly charged atmosphere. Made on and around the boundary between Israel and Lebanon in 1996 and 1997, it features footage of soldiers along the barbed wire fences and the crossing points of the border. It shows the rocky hills of Lebanon on the other side, and it chronicles the comings and goings of a high-ranking commander in the Israeli army as he patrols the border or passes across the boundary line and into Lebanon while on duty (fig. 40).

Two thematic threads provide the narrative structure for *Border*. The first is the political story of the place: a war between Lebanon and Israel that had been ongoing since 1982. The second is the story of the relationship between Rovner and the commander. The results are what Rovner calls a fictional documentary, a collage of different parts. Repetition is utilized, as is expressionistic color and sound, to blur the boundaries between reality and fiction, the personal and the political. By fictionalizing reality, Rovner removes her subjects from the specificity of Israel, Lebanon, and the Arab-Israeli conflict, which, in turn, lends the piece greater complexity. The four revisions Rovner has made of the video since its initial screening and her production of still images from *Border* as independent works of art (pls. 35–37) further reinforce the artist's belief that—like the shifting borders she addresses in the piece—no single, true interpretation exists.[44]

From the time Rovner began working on *Border* until now, her career has followed parallel tracks in video and photography. Rovner's interest in video art came at a time of extraordinary growth in the medium's practice.[45] Artists had been making and exhibiting video art for decades, but in the 1990s a combination of factors catapulted the medium into the orbit of the world of fine art. Among them was the affordability and compactness of video equipment that made the format accessible to a wider range of practitioners. Also, with the commercial sale of VHS and Betamax machines, people of all ages and interests brought movies into their homes and absorbed cinematic images into their everyday experience. A new generation of artists emerged who had been raised on television and video imagery, and who were trained in the rising number of media arts programs in art schools across the United States. Moreover, starting in the early 1990s, more and more galleries and museums presented video art (the 1992 *Documenta IX*, for example, contained an unprecedented number of video works). Artists' increasing desire for greater scale and visual impact in all mediums, and the development of new video-projection technology that offered larger size and vivid effects, fueled the boom in video production. By the late 1990s, video art seemed to be everywhere, and everyone, it seemed, was doing it.

40a

40b

Figures 40a–d
Michal Rovner
Stills from *Border*, 1996/97

In Rovner's case, the video format gives her options that still photography does not. Through editing, the sequencing of images, motion, and a soundtrack, a video offers a greater narrative potential. It also provides an event that engages the eyes and ears of the viewer, and affects the body's sense of equilibrium within a space. In her video works, Rovner favors multiple screens that surround the viewer with an intense visual and aural experience, whereas her photographs are more meditative. Her still images hint at a larger narrative, rather than suggesting a complex story in a timed sequence of moving images.

In 1997, the year *Border* was first shown at the Museum of Modern Art in New York, Rovner was invited to participate in an ongoing series of exhibitions of contemporary artists' work at the Tate Gallery, London.[46] For the occasion, she created a five-minute video installation, titled *Mutual Interest*. Rovner's second video was distinctly different from her first. While *Border* took several days of filming over a period of weeks and nearly a year to edit, *Mutual Interest*, shot in Israel and California, was edited in roughly a week. The piece features flocks of birds traversing three walls of a square room, with the viewer positioned against the fourth wall (figs. 41–42).[47] Across the screens, birds move like missiles, or rise like feathers

40c

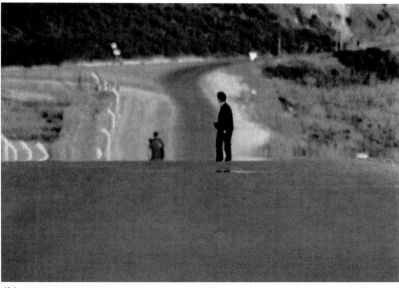

40d

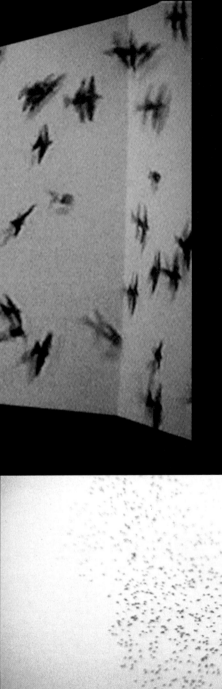

42a

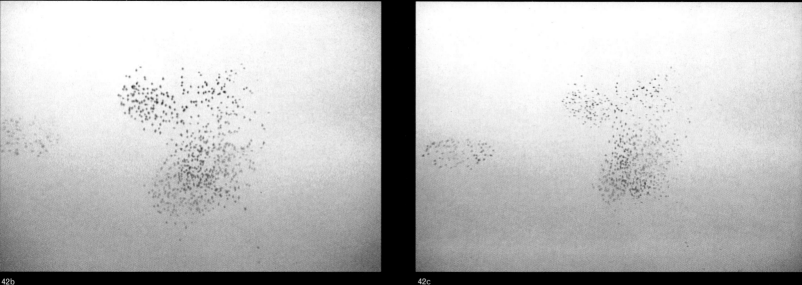

42b

42c

on an updraft, to a soundtrack that suggests the sound of wind, helicopter blades, gunshots, or the flapping of wings. At times peaceful, at others menacing, the video is fluid and intense. There is no linear narrative, but the relentless movement is both hypnotic and full of suspense.

Birds have a long history in the visual arts extending back to the prehistoric cave paintings at Lascaux. In captivity, birds are tragic and melancholy symbols of thwarted freedom. In the wild, they are attackers and they are prey. Virgil wrote in *The Aeneid* of the descent into hell, which is marked by a fetid lake that gives off air so noxious it kills all nearby bird life. Hell, therefore, is a place without birds.[48] Whereas in Alfred Hitchcock's 1963 thriller, *The Birds*, hell is too many birds swarming with evil intent. The idea of the bird as a metaphor for the human soul has inspired numerous contemporary artists. In the paintings and watercolors of American artist Ross Bleckner, for example, and in the billboard installations of Cuban-American artist Felix Gonzalez-Torres, birds symbolize the spirit, transcendence, and loss (figs. 43–44).

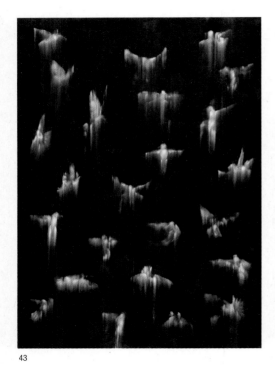

43

44

Figure 43
Ross Bleckner
Birds Falling, 1994-95

Figure 44
Felix Gonzalez-Torres
Untitled, 1995

Israel is a migratory stop for hundreds of thousands of birds that flock twice each year between northern Europe and warmer climates. It is also a place where people migrate from all parts of the globe.[49] The influx of people from cultures around the world, who have brought different languages and traditions to Israel, has tested the utopian idea that a shared religious history is enough common ground on which to build a nation. With this in mind, Rovner's title *Mutual Interest* does not simply refer to Arab-Israeli relations, or even to the mutual obligation implied by a melting-pot society committed to creating an international homeland. Rather it addresses an age-old concern: how human beings respond to and struggle with difference.[50] On the one hand, Rovner was raised to believe that tolerance is both productive and crucial to survival. When two parties share a mutual interest, even when they do not see eye to eye, they have a shared stake in something that creates a common bond. At the same time, in order to preserve those mutual interests, a *quid pro quo* is implied. No one gets something for nothing.

"I use birds as material, not as symbolism in any clear way," Rovner counters to anyone who tries to affix a particular meaning to her images of birds.[51] It is worth noting, however, that the bird types she favors are the eagle, a symbol of power, knowledge and the divine, and the raven, a slayer and carrier of ominous prophecy. No doves, robins, or finches in Rovner's art. As material, there are an infinite number of forms she can envision for birds. In addition to the video installation *Mutual Interest*, Rovner made numerous still images of birds, including some printed on canvas (pls. 38–45). She also produced a series of monoprints on semi-transparent waxed paper she found in a marketplace in Athens, Greece (pls. 46–53).

Making variants of the same image, Rovner says, is like revisiting a meaningful event through memory. No two moments of reflection are exactly the same; memories change and take on a different emotional color and texture over time. In the beginning of her career, Rovner reduced detail and enhanced grain in the darkroom. Now that digital technology makes it possible to alter an image scanned into a computer and to remove an element in the original or selectively blur detail, Rovner's options are greater. But her tools always remain at the service of her ideas. "The work itself is not about process. I'm interested in using different materials to get at different ends," she asserts.[52] Each type of process provides a result that Rovner values independently.[53] Consequently, she places no restrictions or boundaries on what means she employs to make a piece, and she reserves the right to modify or change the materials or size of any work at any time. This is consistent with the nature of her subject matter, Rovner argues. A bird, after all, is rarely seen at a standstill in nature. Instead it is always moving, and our relationship to it is ever-changing. So too is Rovner's relationship to her art.

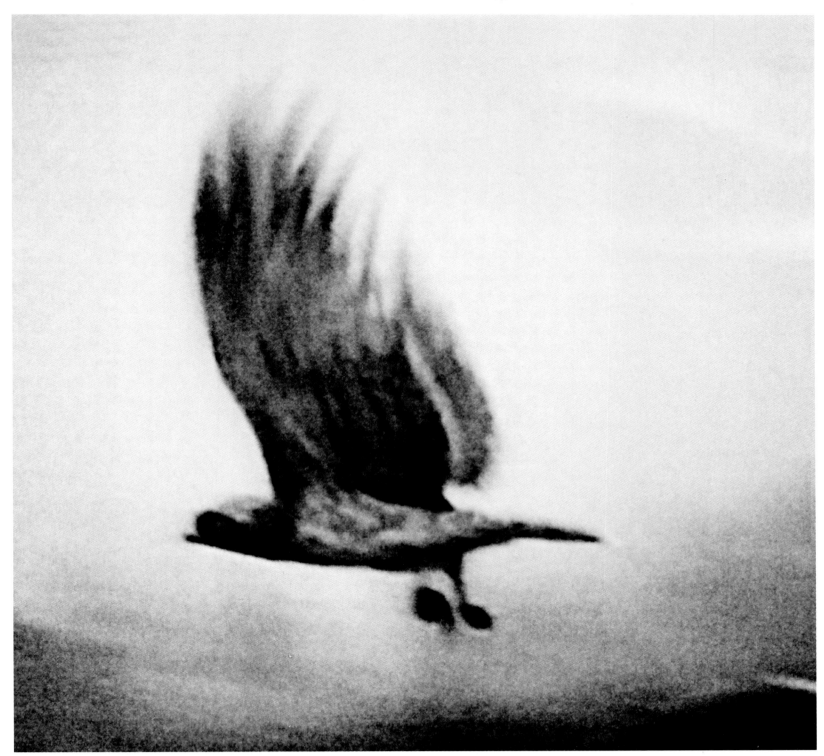

38

Plate 38
Mission, 1999

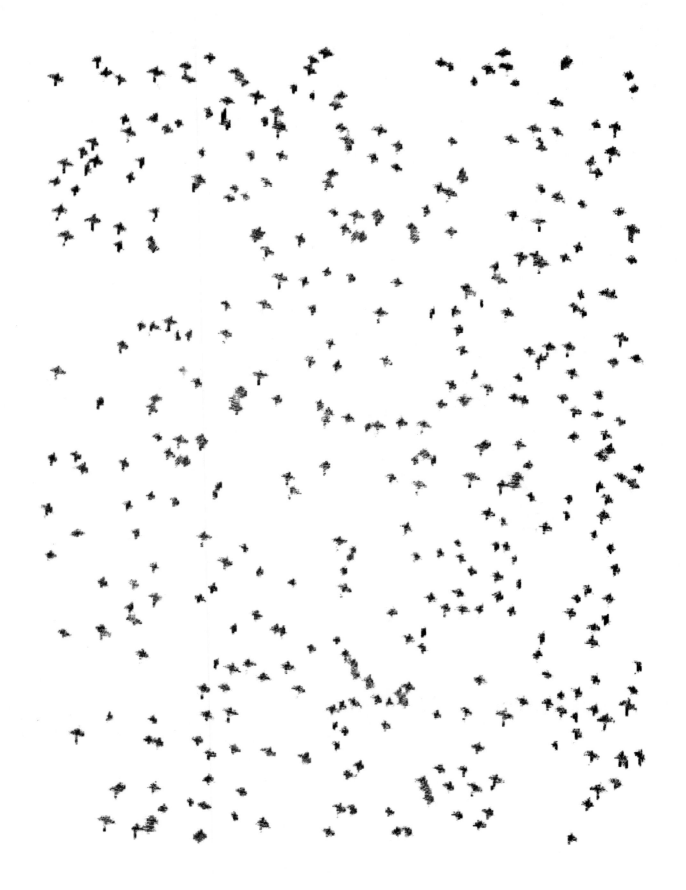

Plate 39
Crosses, 1999

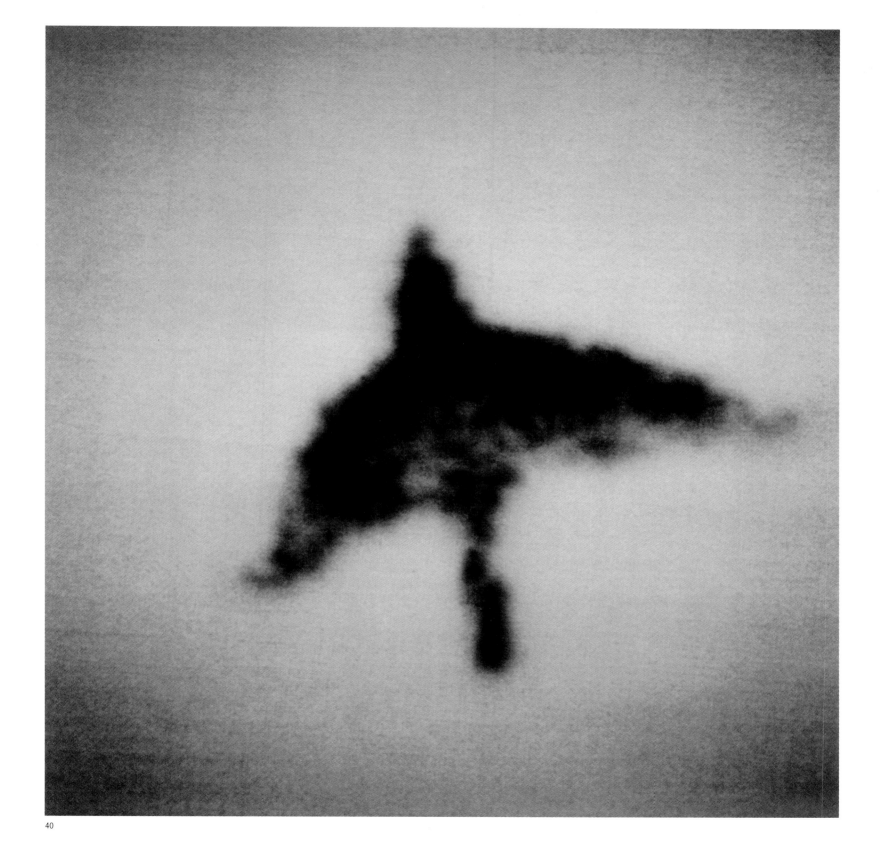

40

Plate 40
While in the Air II, 1999

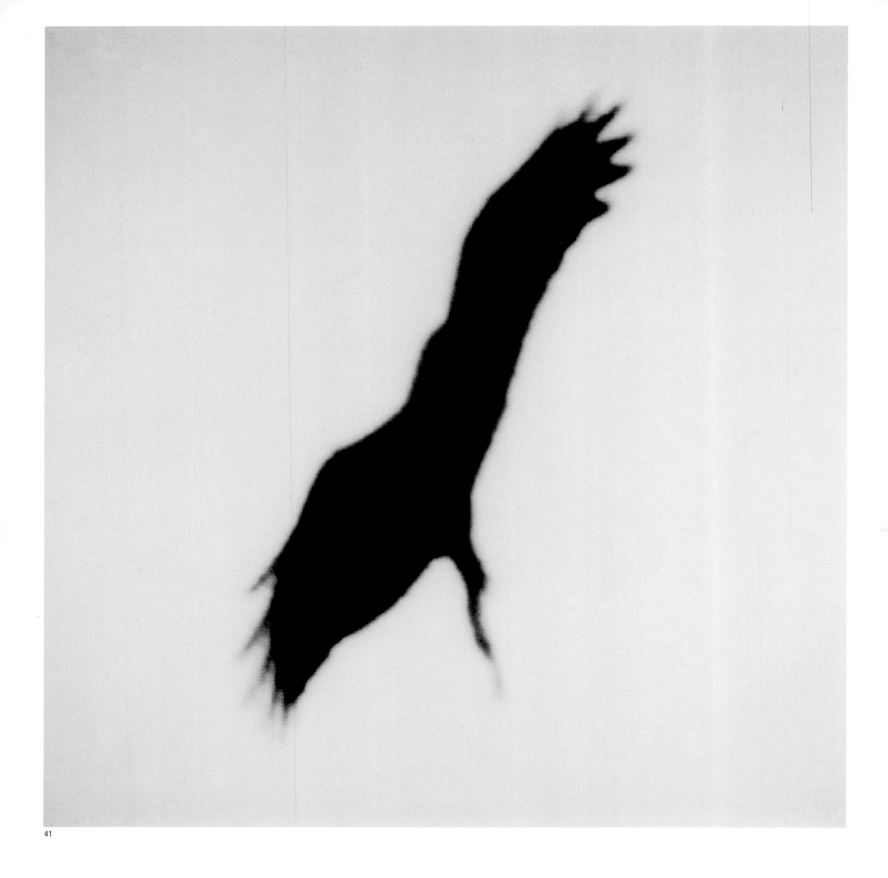

41

Plate 41
While in the Air III, 1999

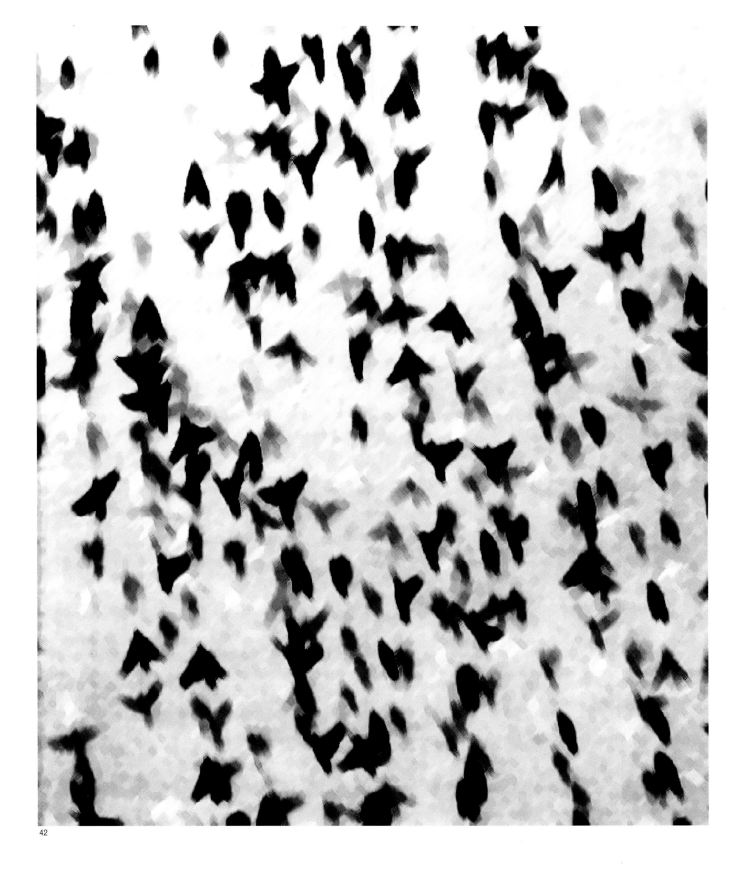

42

Plate 42
Echo, 1998

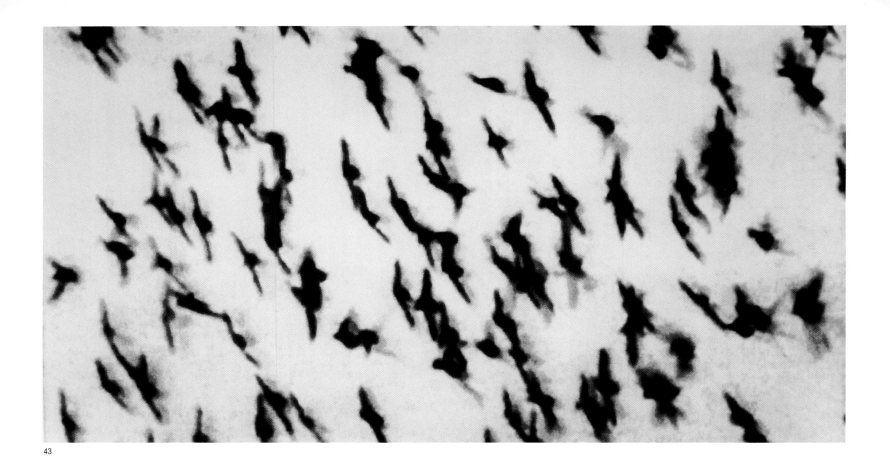

43

Plate 43
Mutual Interest #1, 1997

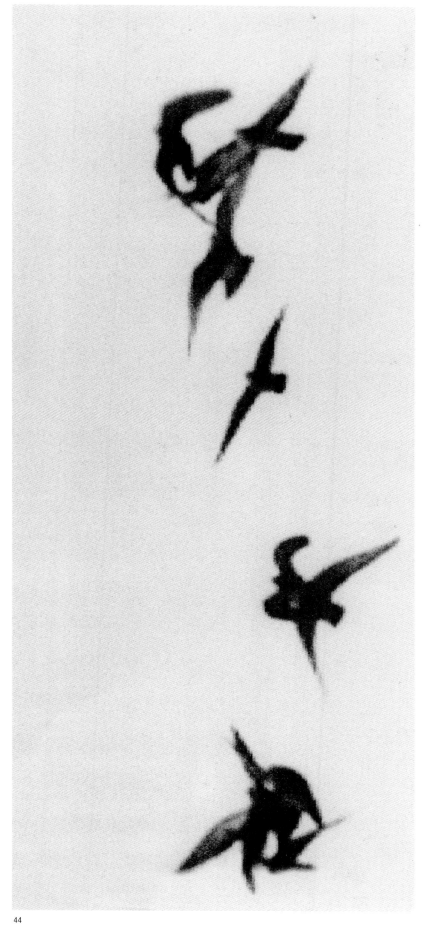

Plate 44
Descent, 1998

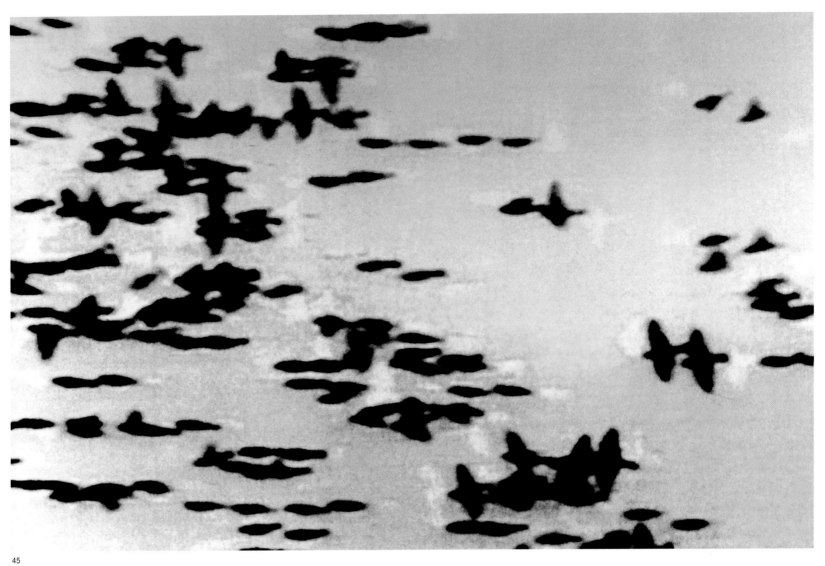

45

Plate 45
Mutual Interest #2, 1998

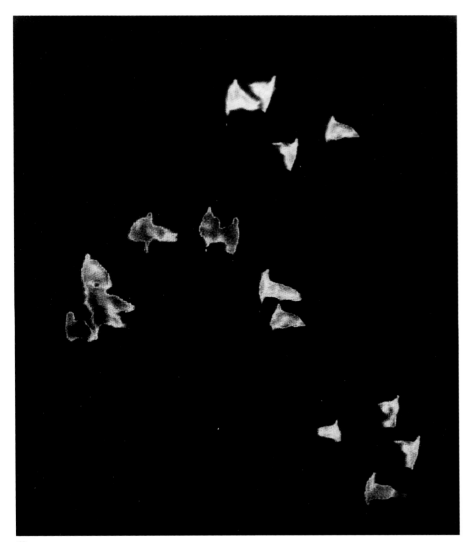

46

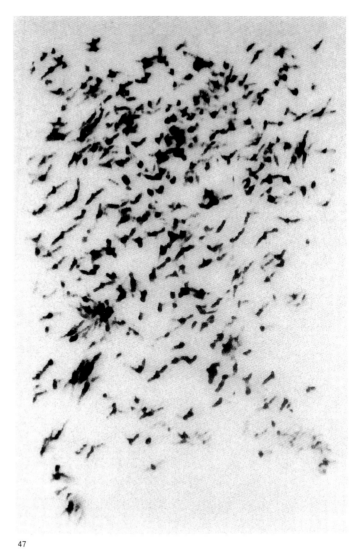

47

Plate 46
Untitled #1 (Athens), 1998

Plate 47
Untitled #8 (Athens), 1998

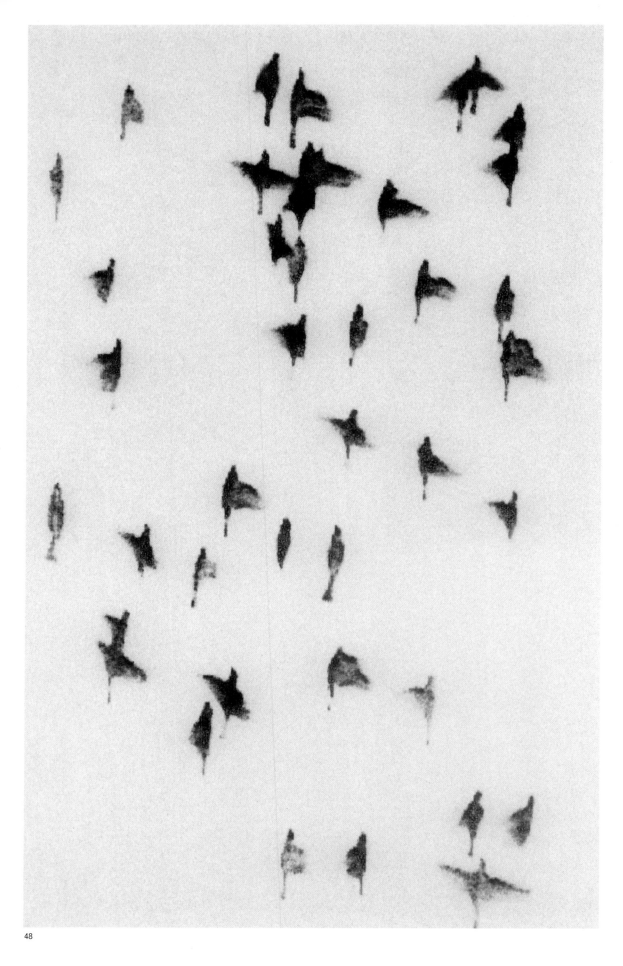

Plate 48
Untitled #6 (Athens), 1998

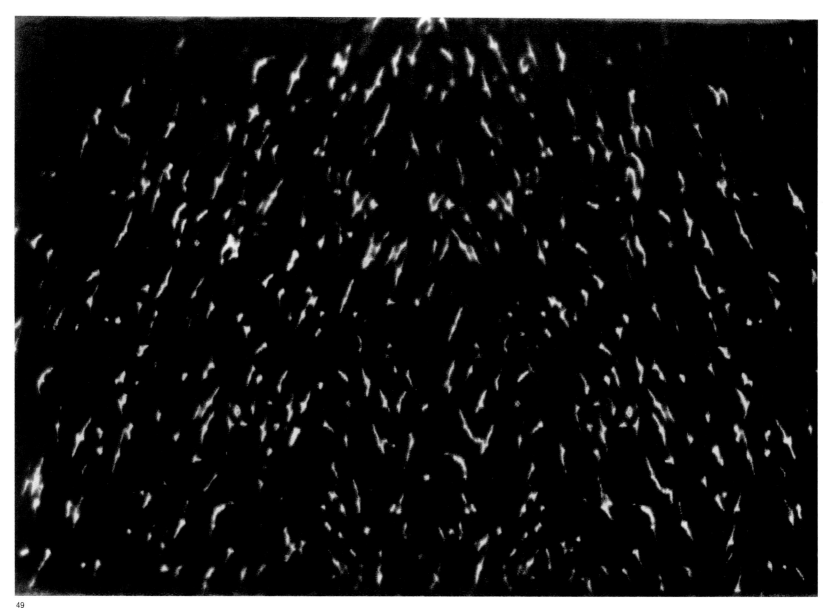

49

Plate 49
Untitled #4 (Athens), 1998

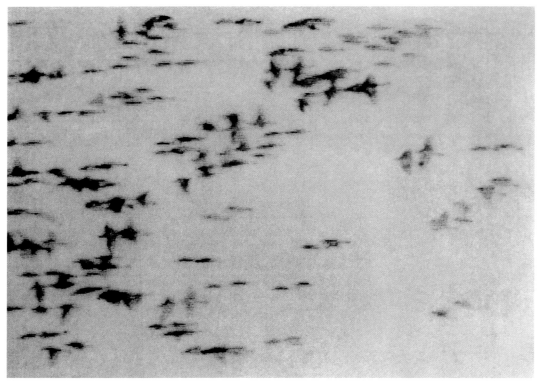

50

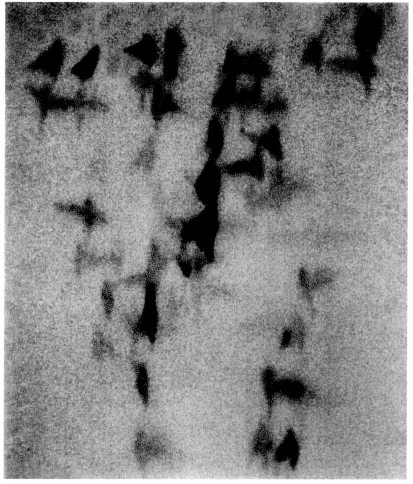

Plate 50
Untitled #11 (Athens), 1998

Plate 51
Untitled #9 (Athens), 1998

51

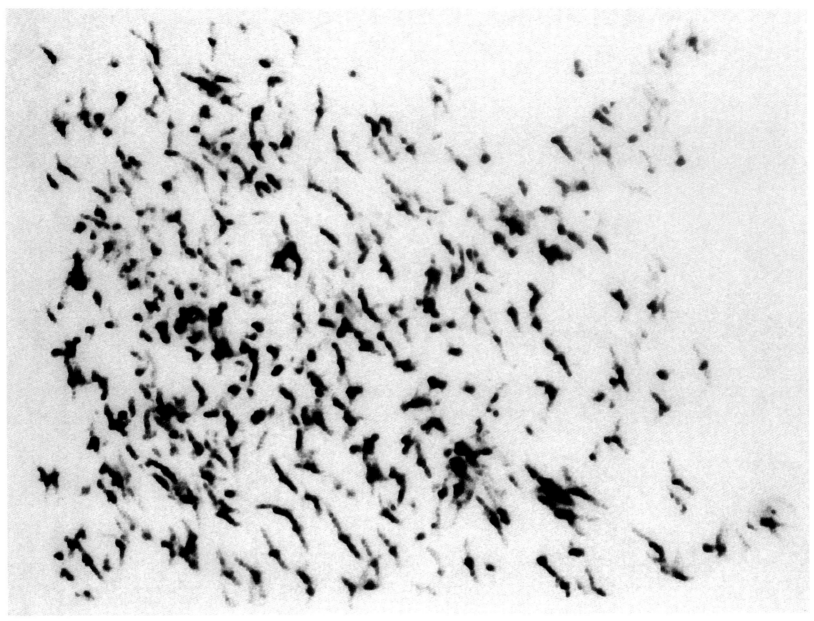

52

Plate 52
Untitled #12 (Athens), 1998

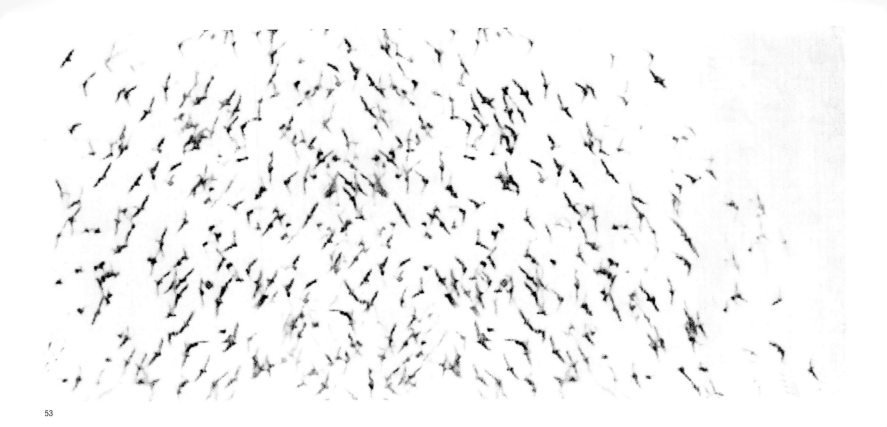

53

Plate 53
Untitled #2 (Athens), 1998

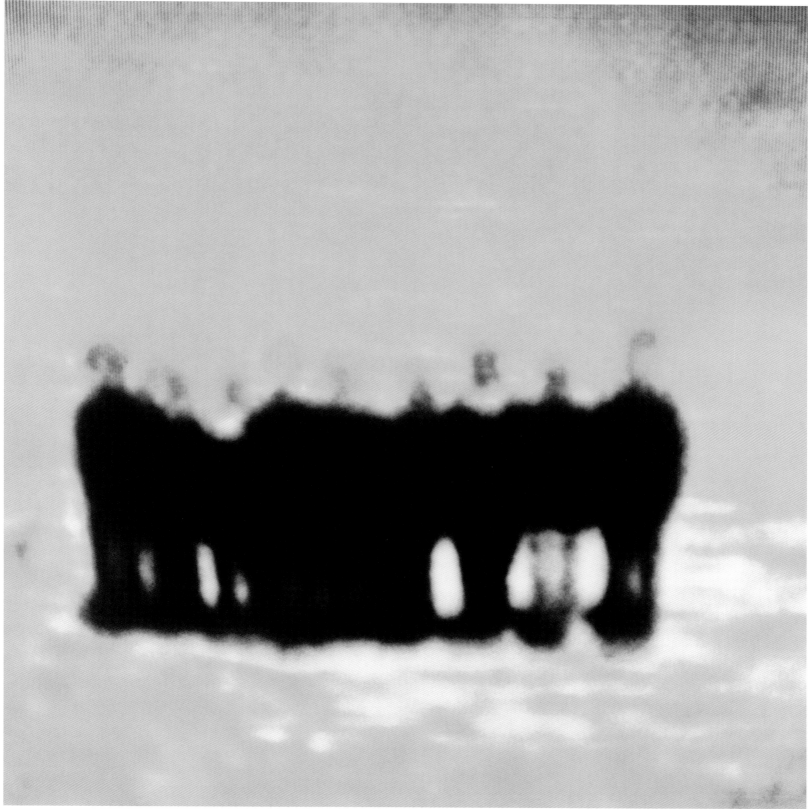

54

Plate 54
Merging P#1, 1997

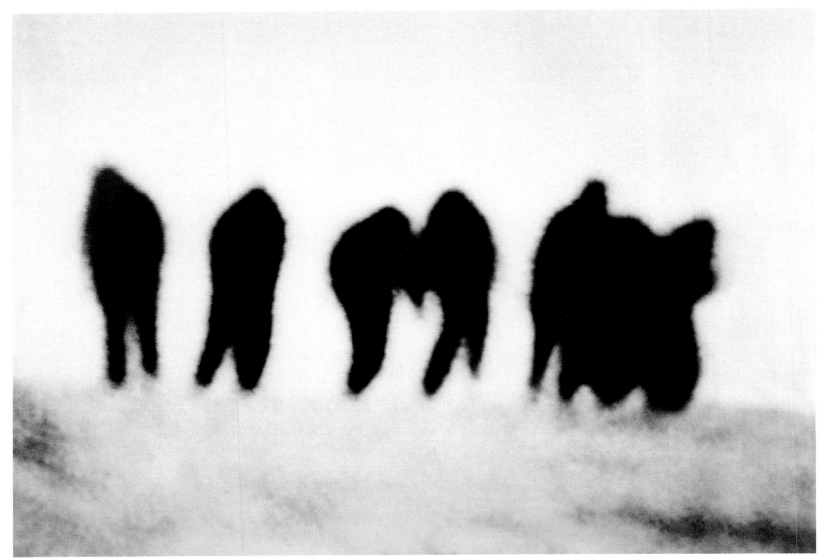

55

Plate 55
Adama (Earth), 1999

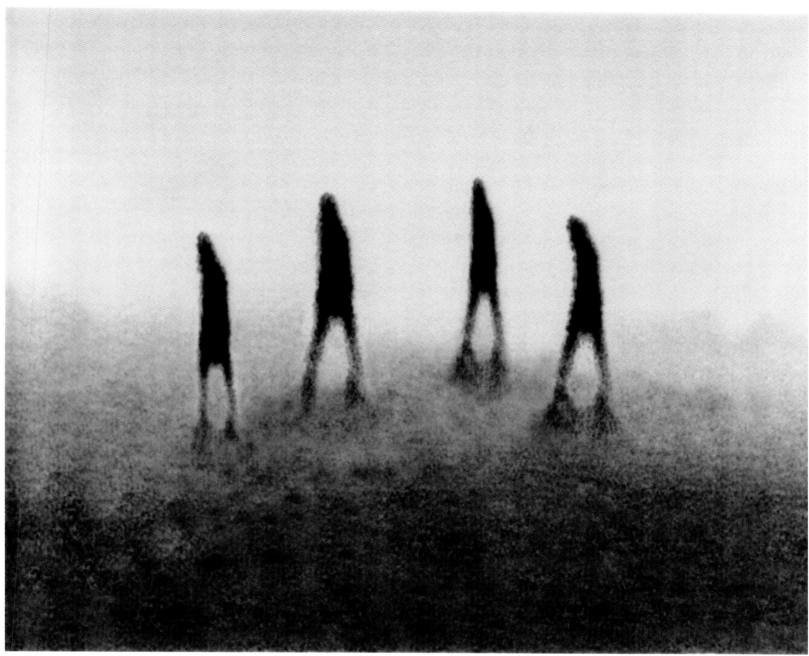

56

Plate 56
Merging #6, 1997

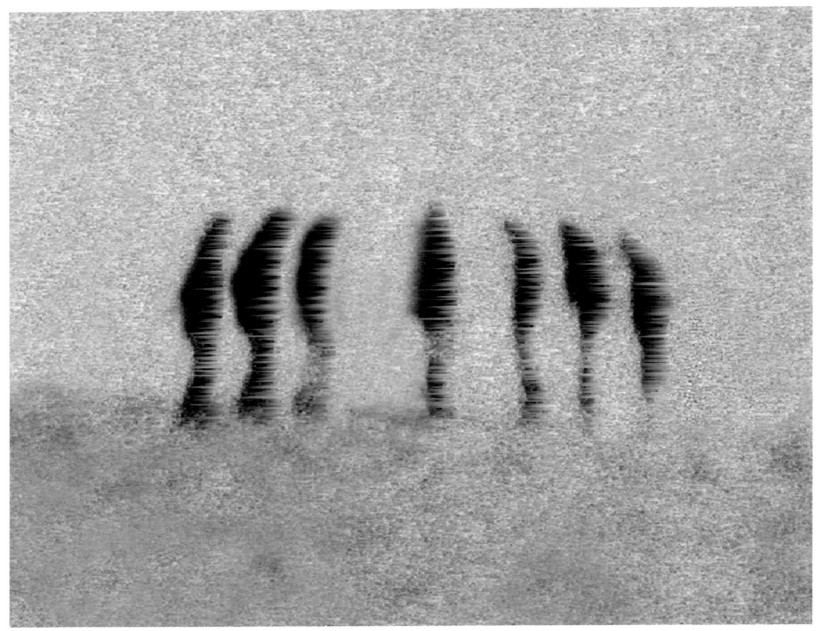

57

Plate 57
Merging in the Wind, 1997

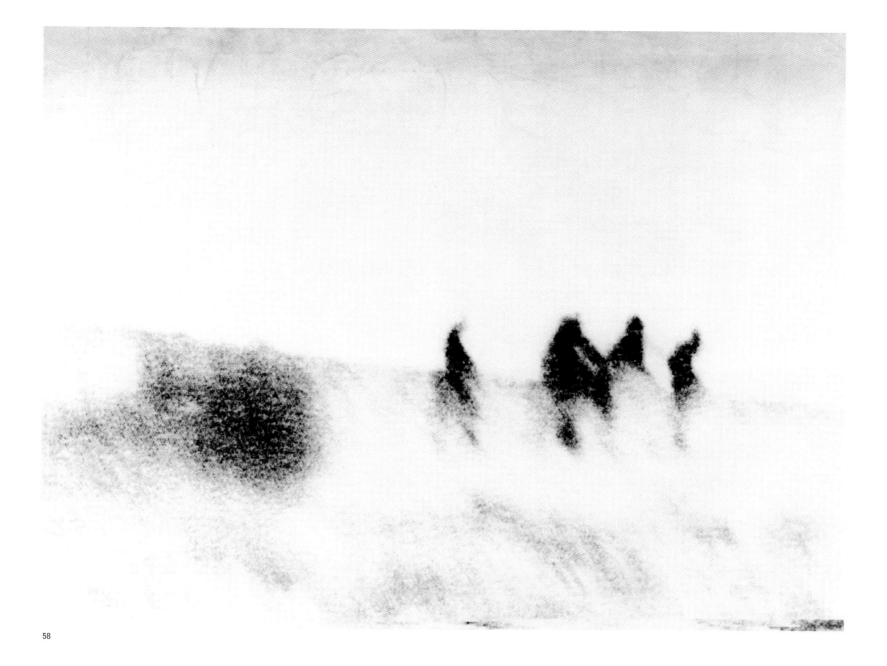

58

Plate 58
Blur, 1998

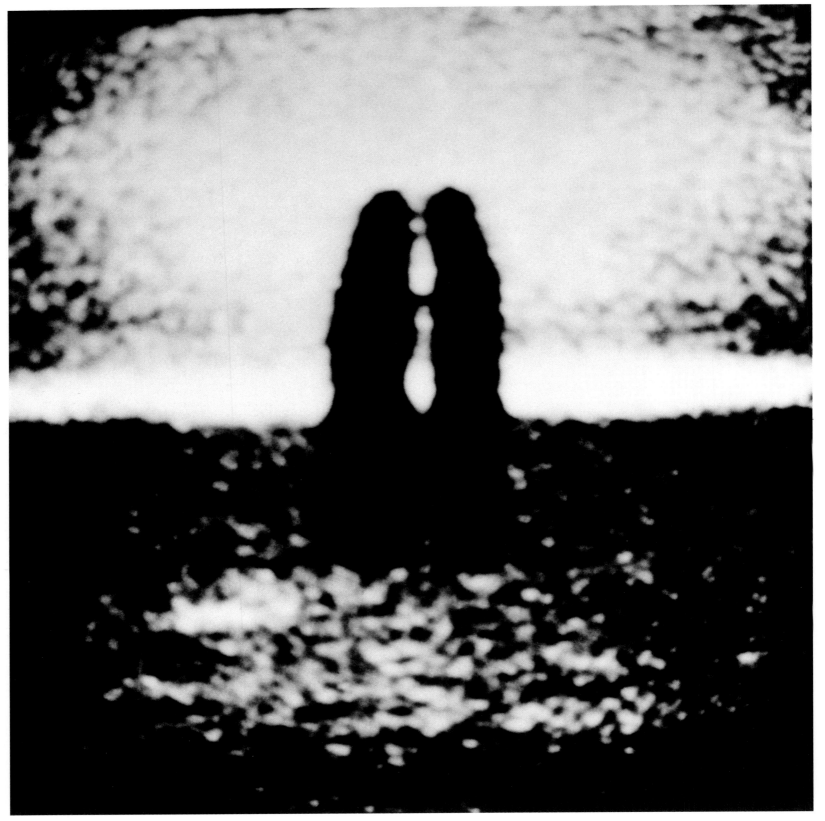

59

Plate 59
Pull, 1999

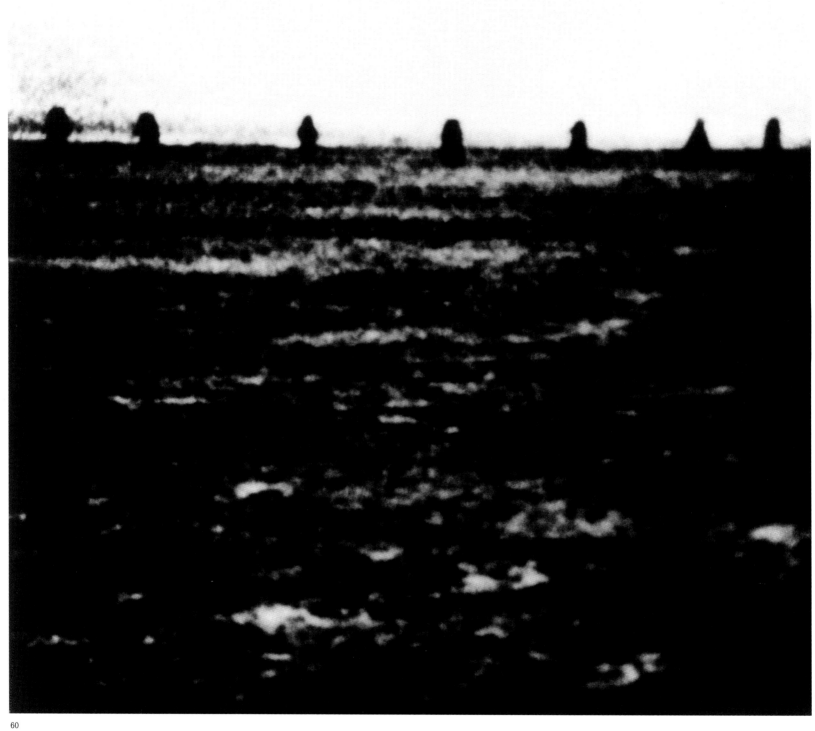

60

Plate 60
Soil, 1999

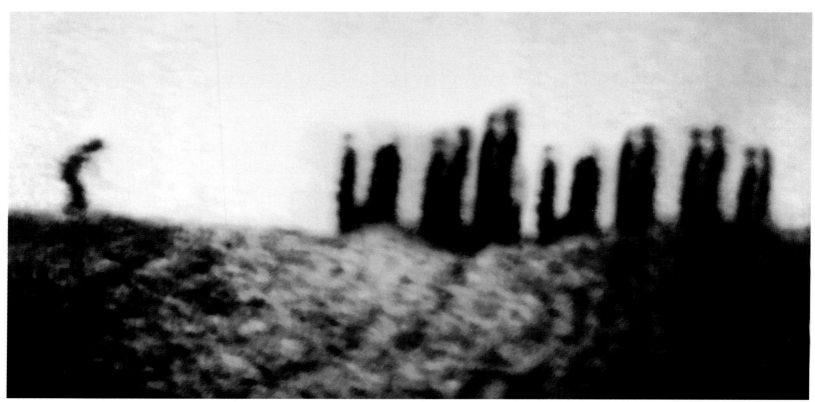

61

Plate 61
In the Presence of, 1999

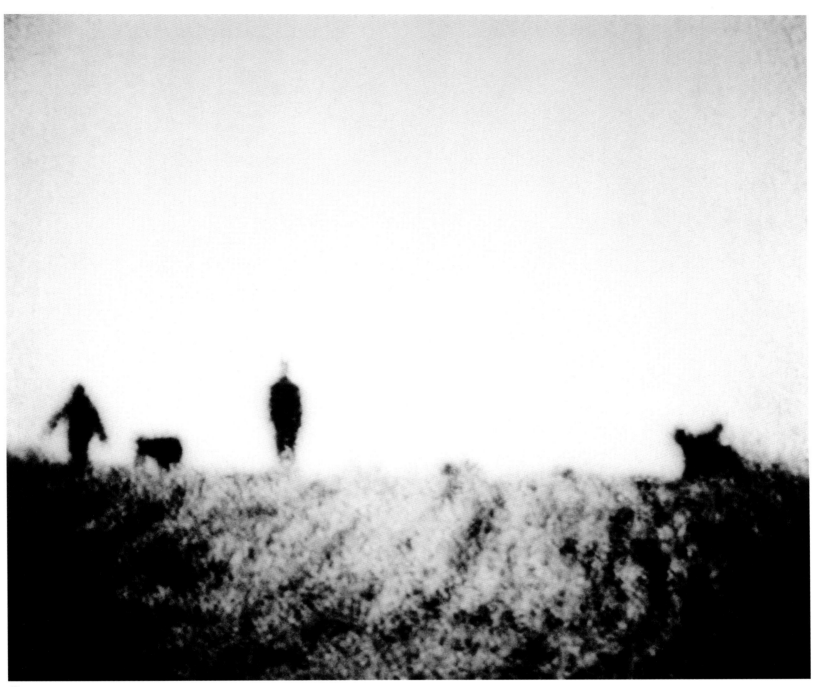

52

Plate 62
Falling in the Field, 2000

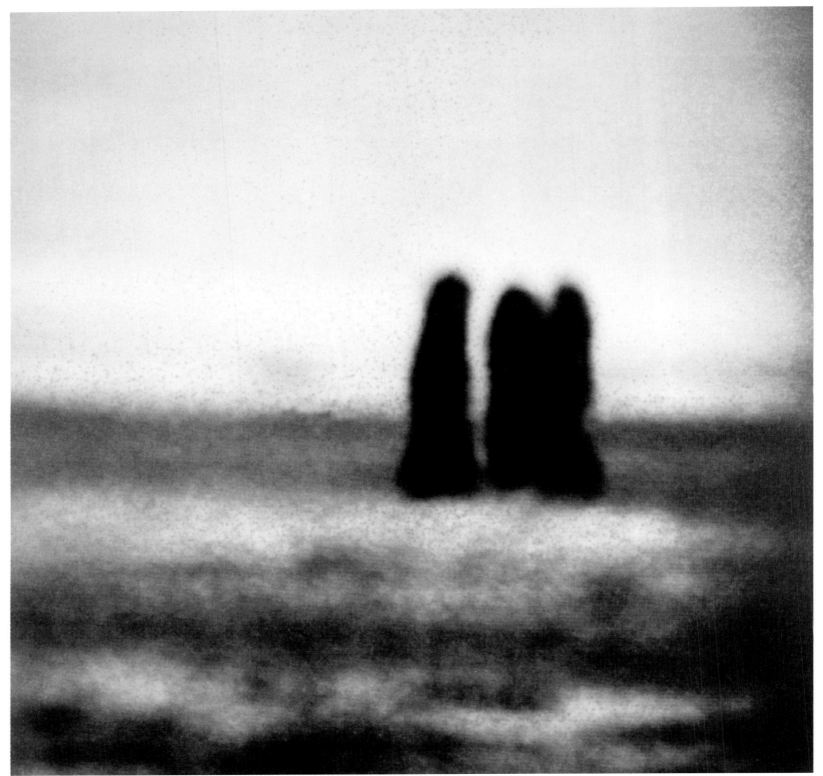

63

Plate 63
Shalosh (Three), 2001

ART AS EPIC NARRATIVE

Mutual Interest signals a shift in **Rovner's** line of inquiry. Much of her earlier photographic work depicted solitary figures or objects in isolation. **N**ow, her still and moving images of birds picture group behavior, socialization, and animated beings on a mission. **M**ade the year Rovner turned forty, *Mutual Interest* marks a time in her life when her attention turned inward and outward simultaneously. **T**hrough her interest in Eastern religions she had expanded her spiritual and philosophical base. **F**rom the international recognition her art had received, she had gained energy and confidence. **W**ith the installation of *Mutual Interest* at the **Tate Gallery** and multiple screenings of *Border*, **Rovner** crossed the line from the world of photography into the world of contemporary art. **S**he also enlarged her sense of what she might do with her art. **T**he works Rovner made following the completion of *Mutual Interest* display a scale and ambition that imbues them with an epic quality.

In an epic narrative, the storytelling is linked to the survival and well-being of the group. **O**ften there is a moral to the story or a reason for the telling of the tale; to strengthen the group's sense of community perhaps, or to teach a moral lesson. **S**tarting in 1997, in photographs, video installations, and various images **Rovner** printed on canvas, multiple figures occupy the frame and group dynamics enter the picture for the first time. **T**he outcome of their interactions, however, remains uncertain (pls. 54–63). **A** canvas piece made in 1997, for example, titled *Merging in the Wind* (pl. 57), pictures seven highly blurred figures with bent shoulders standing on a horizon: three face right, three face left, and one is in the center. **T**he silhouetted figures are striated by what looks like the horizontal lines of a low-quality video camera. **T**he title suggests that they have come together for a purpose, and yet they stand with bent shoulders and a passive stance. "There is an assumption that unity in a group is always for the benefit of others," Rovner remarks, "but with it can come a loss of individuality, of creativity."[54]

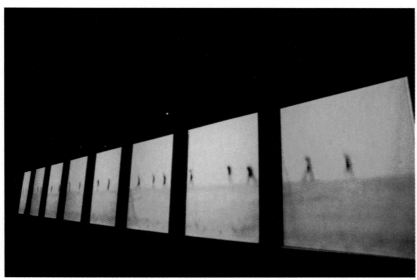

45

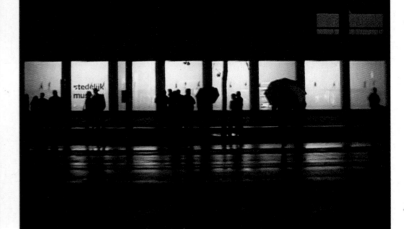

46

Figure 45
Indoor installation view of Michal Rovner's
Overhanging, 1999, at the Stedelijk Museum,
Amsterdam

Figure 46
Outdoor nighttime view of Michal Rovner's
Overhanging, 1999, at the Stedelijk Museum,
Amsterdam

48

Figure 48
Michal Rovner
Stills from *Overhanging*, 1999

In *Adama (Earth)*, made two years later, seven figures are again positioned on a hori-
zon line, only this time two are huddled together, another two prop up a third, and
two stand apart and cower (pl. 55). The title evokes the concept of resurrection
which has a long history extending from ancient Judaism to Christianity. In the
Burial Service in the Christian *Book of Common Prayer*, for example, the body is
committed to the ground "earth to earth, ashes to ashes, dust to dust, in sure and
certain hope of Resurrection."[55] The concept of revival or renewal appears again
and again in Rovner's art. In *Adama (Earth)*, her figures are primordial in their effort
to stand tall (echoes of the epic piece *Tel [Hill]*). They could be at the beginning of
a struggle or at its end. In an epic tale, as conflict arises, human nature is tested,
and a resolution evolves in a narrative with a beginning, a middle, and an end. That,
though, is not what occurs in Rovner's art. In her works, no hero emerges—all fig-
ures look the same. The stories are halted mid-stream: no resolution or moral les-
son is imminent. Instead, faceless figures stand immobile (pl. 54), or disappear
altogether in a blur reminiscent of the salted-paper prints of photography's early
years (pl. 58).

Around the time *Adama (Earth)* was made, Rovner entered a period of intense pro-
ductivity and public exposure. In the next two years, she made three new video
pieces and was included in numerous international exhibitions. In 1999 Rovner was
invited to create a video for the windows in the new wing of the Stedelijk Museum
as part of a world-wide video festival in Amsterdam. The piece she created is
titled *Overhanging*, in reference to a danger or threat that can hang over one's head,

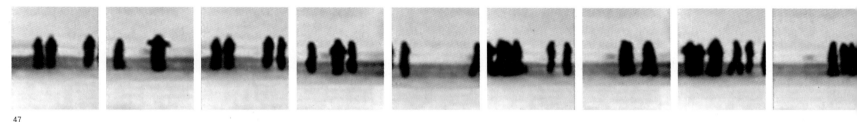

47

49

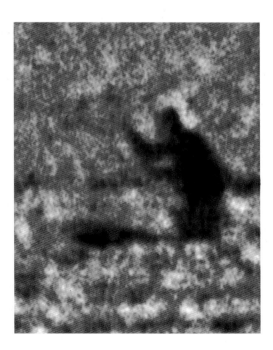

Figure 47
Michal Rovner
Stills from *Overhanging*, 1999

Figure 49
Michal Rovner
Stills from *Overhanging*, 1999

or to an exhibition with an excessive number of works that is called "overhung."
Overhanging is a massive landscape of images that stretched along two sides
of a 130-foot gallery, in eighteen floor-to-ceiling sections that could be seen from
indoors during the day and from outdoors at night (figs. 45–46).

Overhanging seems to focus on the latter half of the life cycle. At a slow, hypnotic
pace, weary figures, some stick thin, some shrouded in black, move with a heavy
step and no apparent purpose through snow and heat (fig. 47). In one segment,
death is present in the form of a figure beating the earth until the screen turns red
(figs. 48–49). Renewal and reincarnation are suggested by a wind that blows across
the screens and wipes the landscape clean (or is that a swarm of locusts, or per-
haps a thick, heavy blast of air filled with stones and sand that obliterates all?).
In a conversation with Leon Golub that appears later in this book, Rovner marvels
at the range of references viewers see in the piece—from military maneuvers
to the Holocaust, to people walking on the moon.[56] "The ambiguity in my work is
not a lack of opinion. I think it is more comfortable to be given the details than
to have to experience something yourself."[57] Rovner herself interpreted the piece
in multiple ways, as she has with other bodies of work in the past. A year after
the Stedelijk Museum installation of *Overhanging*, she produced a variation, retitled
Overhang, which was presented at the Chase Manhattan Bank, New York. She
also made a single-channel piece derived from *Overhanging*, titled *Field 1*, for the
Whitney Museum's *2000 Biennial Exhibition*, and she made still works (some on pho-
tographic paper, some on canvas) with simulated windows that look like video
screens (fig. 50).

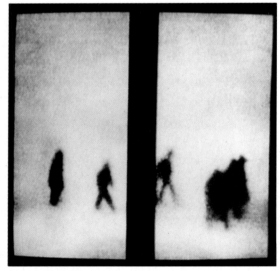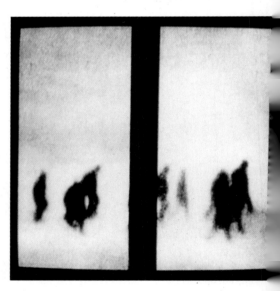

50

Figure 50
Michal Rovner
Overhang #5, 2000

A more modest gesture made that same year is a two-minute flat-screen video, which runs in a continuous loop, titled *Eagle Butterflies* (fig. 51). Drenched in the yellow of a midday sun, what looks at first like a butterfly moves among wildflowers in the foreground, but as the winged insect swoops and dives, it becomes clear this is not a fragile butterfly flitting from flower to flower, but a bird in the distance hunting prey. The kaleidoscopic feeling created by the two identical images joined in the center, the right one flipped, underscores the duality of nature, with its pastoral beauty and its flipside, violence and survival for only the fittest.

More overtly confrontational is *Coexistence 2* (fig. 52), a video installation made in 2000 for the biannual contemporary art exhibition at the Corcoran Gallery of Art in Washington, D.C.[58] In the piece, three projection screens occupy one wall. A line of figures, shown in silhouette against a blank white sky, stretches across the two screens on the left. By the outline of their clothing, these figures are tall, short, thin, wide, male, and female. Like paper cutouts, they suggest a typology of human forms. Throughout the video, they stand as silent sentinels, turning once, then resuming their original position. Meanwhile, on the third screen, a cluster of figures huddles together on a horizon line in the middle of nowhere. Like adolescent boys, they shove and kick, their gestures resembling play one moment, hostility the next. Over time, the figures multiply, and the action becomes harder to read. A soundtrack of shuffling feet is punctuated by the high cant of a human voice. An explosion sounds, the figures disperse, and all three screens go blank. When *Coexistence 2* ends, the storyline remains unclear. Did we witness a riot or a game? Who are these people? Are they under siege? Do they coexist?

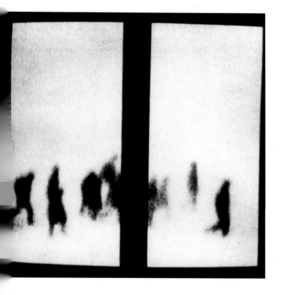 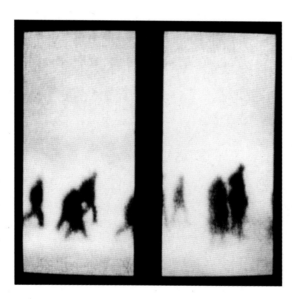 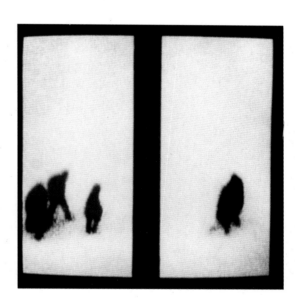

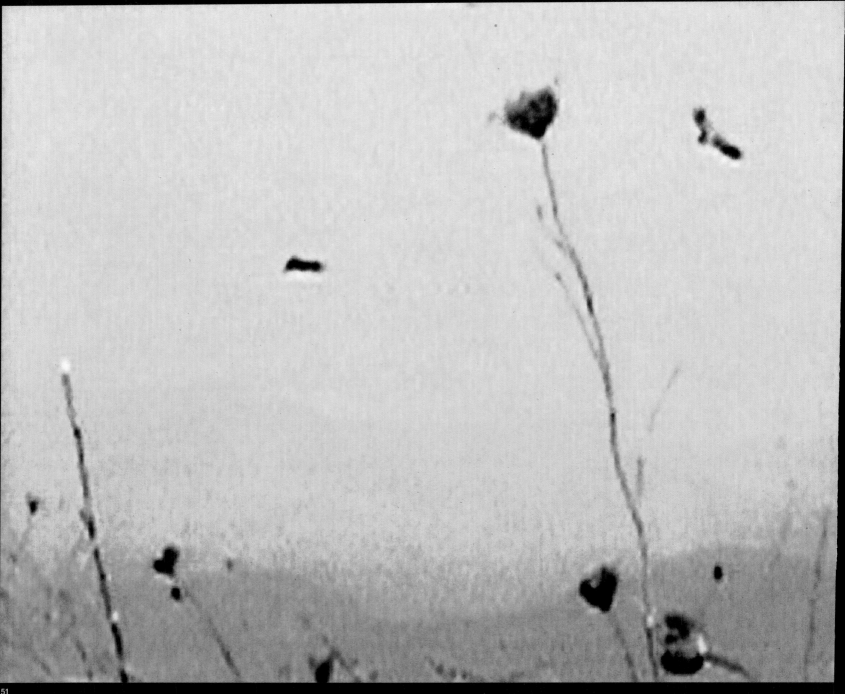

52

53

Made at a time of heightened hostility between Israelis and Arabs, Rovner considers this one of her most narrative pieces.[59] It is also the first time she went far afield for her imagery. Rovner's practice has always been to merge realities with footage shot from disparate places: from America and Israel, for instance, or from Israel and Lebanon. The video footage Rovner used in *Coexistence 2* was shot in Russia and Israel. Footage from Russia and Romania was used in *Notes*, a video Rovner made in 2001 with a soundtrack by Philip Glass (fig. 53), and in *Time Left* (fig. 54), a new video installation made in 2002. This most recent video features horizontal lines of black figures against a white background. Arranged floor to ceiling around three walls of a square room, these images resemble Egyptian hieroglyphs or a section of the Dead Sea Scrolls.[60] Rovner's background in dance can be seen in her choreography of the figures. They move at a solemn pace, with a unity of purpose that is new to her work. At the same time, their syncopated steps create a dizziness that contradicts any sweet sense of camaraderie the images might imply. These people could be prisoners in a chain gang or children on a field trip. In preliminary studies for the piece, figures move in formation, passing by and through each other like ghosts, or like the fractured imagery of a Futurist abstraction.

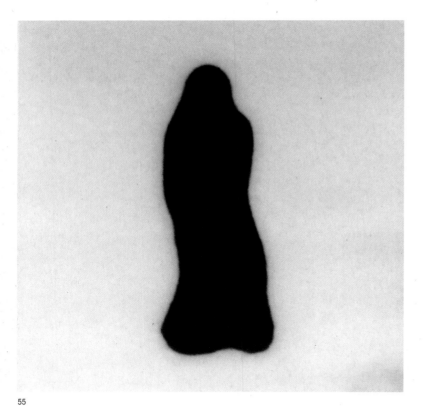

55

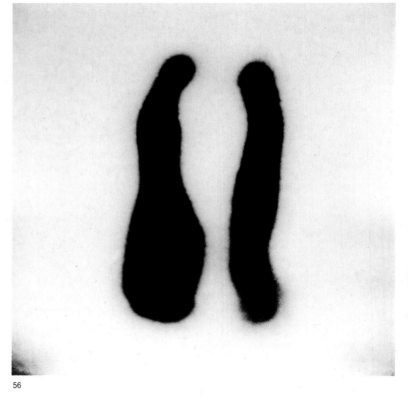

56

Figure 55
Michal Rovner
Untitled #7, 2000

Figure 56
Michal Rovner
Untitled #2, 2000

When Rovner talks about *Time Left*, she refers to the opening sequences of Charlie Chaplin's 1936 silent movie *Modern Times*, in which factory workers are shown engaged in the relentless monotony of repetitive tasks. But rather than simply criticizing industrialization or warning us against a technology-driven world of homogenized humanity, Rovner's new piece also contains elements of hope. She speaks of the figures holding hands as a testament to human survival. No matter what befalls them, they cling together and keep moving, asserting that cycles repeat themselves and life goes on. Rovner employed a similar treatment of black figures against a white ground in a set of photographs titled *Nuns*, inspired by a retreat Rovner took, in search of peace and quiet, to a convent outside Jerusalem. Here models shrouded in black look like chromosomes or amoebas under a microscope in images that expand the artist's thematic concerns to include genetic coding (figs. 55–56). In both *Time Left* and *Nuns*, Rovner's use of a white background gives the works graphic power and further strips the figures of any relationship to a place or time. These are, moreover, Rovner's first works without a landscape element or color.

The barren landscape of Siberia was the source of inspiration for *Time Left*. "I was attracted to the wild, white desert, the emptiness, the silence, the struggle to survive, the beauty and the harshness, the stories about Stalin."[61] Ultimately, Rovner decided to shoot outside Moscow rather than in Siberia, but the idea of the place created that "clear vague picture" in her mind from which she worked. For viewers, the location in which the video was shot is neither obvious nor critical to experiencing the piece, but the location is crucial to Rovner's creative process. As an Israeli artist who lives in America and makes art out of imagery shot in Israel and Russia, Rovner crosses national borders that were closed until recently and creates what she calls a "new reality" from these politically charged nations.

For an artist to straddle cultures and seek a common ground, as **Rovner** does in her life and in her art, is not new. For centuries, artists have relocated in search of resources, inspiration, a vital artistic community, or artistic and political freedom. In recent years, many contemporary artists have moved to America from all over the world. As in Rovner's case, their art is both informed by this transition and colored by where they are from. Iranian-born artist **Shirin Neshat**, for instance, makes photographs and video installations drawn from her Islamic background on the subject of ritual and oppression. Shot in Morocco, Turkey, and New York, they contain the spirit and the look of her native Iran, most notably the image of anonymous Islamic women, shrouded head to toe in black chadors (fig. 59). Unlike Rovner's collage of repeated motifs, Neshat's videos have a linear structure, with a beginning, middle, and end. But like Rovner, Neshat maintains a measure of ambiguity in her works. The power of her art lies in an open-ended narrative that transcends place, and in an exoticism that asks viewers to give themselves over to a world outside their experience.

Another artist with whom Rovner shares an affinity is Latvian-born **Vija Celmins**. Like Rovner, Celmins experienced a proximity to violence in her childhood that has affected her artistic sensibility (born in 1938, she spent her first ten years in war-torn Latvia and Germany, before she settled in the U.S.). Celmins's early images of bombers, for instance, are very real expressions of danger (fig. 57). At the same time, they contain a strangeness that is not of this world and a simplicity that removes them from any particular reality. For over three decades, Celmins has used photographs as source material to make highly detailed prints, drawings, and paintings of common objects and natural elements—a space heater, for instance, or the surface of an ocean that resembles an aerial landscape of an arid land (fig. 58). Rovner, by contrast, uses photographs and video footage to make objects that look like paintings and drawings. In the work of both artists, images emerge from the real world but are not about external reality. In both cases, there is a disjunction between the original subject and the final work of art, which is several times removed from any connection to the here and now. There is also a haunting beauty in their work, and a sense that something is missing.

57

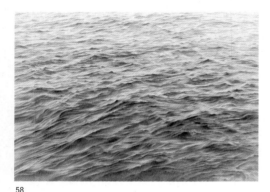

58

Figure 57
Vija Celmins
T.V., 1964

Figure 58
Vija Celmins
Untitled (Ocean), 1970

Figure 59
Shirin Neshat
Untitled (Rapture), 1999

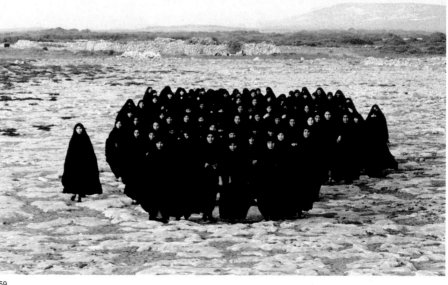

59

Were Celmins's and Rovner's images made a century ago, they could be seen as giving voice to romantic melancholy, as resonating with "the still sad music of humanity."[62] But Rovner's art, in particular, asserts a defiance that is distinctly modern. With its relentless repetition of form and action, her work suggests that endurance over time is a positive and hopeful trait in an otherwise grim human condition. Indeed, Rovner sees her works as containing a measure of optimism. When she and Leon Golub speak of what happens when one gets to the end (of life, Rovner asks?), Golub wonders if there is nothing left to do but lie down and disappear. "Or you start again," Rovner proposes, affirming the power of renewal and the cyclical nature of life.[63] Rovner's movement between America and Israel is a cycle of its own. Like a binary system, in which two stars revolve around each other under mutual gravitational pull, Rovner's two worlds never meet, but her passage between them generates an energy that fuels her art. The results are images that are at home neither in Israel nor America, but occupy a space between. This middle zone, this unnamed territory, is not a stopping point or a way station, but a location she has chosen to inhabit as a place of opportunity.

Coming from a world in which uncertainty is a constant state of mind, Rovner has made a virtue of it in her art. In fact, she cites complacency as the target of her most recent work. "It is very dangerous to have fixed ideas about things, because then you don't allow for change. The basis of change is the ability to create. If we stop making something new out of what there is, we are not alive anymore."[64] When Rovner talks about change, she is not referring to social or political transformation. Instead, her emphasis is on psychic change. With her own art, she gives form to a blurring of boundaries between territories and cultures, the personal and the political, the world of abstract spiritual concepts and the here and now. She asks us to consider ambiguity and not-knowing as positions of strength—to view flux and transition as constructive and conducive to growth. For Rovner, the uncertain has always been familiar and productive. When the world is off balance, revelation takes place.

Notes

1 The battles are known as the conquest of Canaan. According to the Bible, Joshua implored the Lord to assist him in his cause by lengthening day and night until his battles were won (Josh. 10:12–14 King James Version):

> Then spake Joshua to the Lord . . . and he said
> in the sight of Israel, Sun, stand thou still upon
> Gibeon; and thou, Moon, in the valley of Ajalon.
> And the sun stood still, and the moon stayed,
> until the people had avenged themselves upon
> their enemies.

2 Rovner, in conversation with the author, 1 April 2001.

3 Some of the biographical information in this essay is adapted from an essay by the author in the 1993 catalogue *Michal Rovner* that accompanied the exhibition of the same name on view at the Art Institute of Chicago from 30 October 1993 to 16 January 1994. The remaining biographical information was obtained through interviews with the artist during several sessions between 2000 and 2002.

4 The information in the next two paragraphs was drawn from Nissan N. Perez, *Time Frame: A Century of Photography in the Land of Israel* (Jerusalem: The Israel Museum, 2000).

5 Since 1881, when the first nationalist pioneers arrived in the land that is now Israel, the aim of Zionism has been to establish a Jewish state in Palestine. Amos Elon, *The Israelis: Founders and Sons* (Tel Aviv: Adam Publishers, 1981), pp. 6 and 26.

6 Edited in its early years by Adam Baruch, *Monitin* was in circulation for ten years. I am grateful to Nissan N. Perez for introducing me to *Monitin* and lending copies of it from his personal collection for research and reproduction in this book.

7 The school was founded in 1906 by Lithuanian artist Boris Schatz.

8 Rovner, in conversation with the author, 28 August 2001.

9 Rovner, in conversation with the author, 2–3 June 2001.

10 Henry Horenstein is thanked for lending his knowledge and experience with color photography to this text.

11 Rovner, in conversation with the author, 4–5 June 2001.

12 *Ani-Mal* was published by Parkett/Der Alltag in 1991. The title of the book, *Ani-Mal* (which includes Rovner's early images of animals, dogs, and some color images of houses from the 1990 series *Outside*) reflects the spirit of exchange between Rovner and Frank. Frank suggested that Rovner break her original title, *Animal*, into two words. "In Hebrew, *ani* means *I*," Rovner remarks. "In French (Robert's native language), *mal* means *bad*. So the new book title meant 'I am a bad animal.' I loved it" (see note 8 above).

13 *The Lines of My Hand* was originally commissioned as a limited artist's edition by Kazuhiko Motomura and first published in Japan in 1972. The second edition was published by Lustrum Press, also in 1972. The third edition, referred to here, was simultaneously published by Pantheon Books and Parkett/Der Alltag in 1989 and re-released by Scalo and Distributed Art Publishers in 1992. Each edition is distinctly different. For the third edition, Frank asked Michal Rovner and Phillip Brookman to assist him in the editing and sequencing of the works. I am thankful to Brookman for sharing his insights about Frank's influence on Rovner's art.

14 The original script for *Last Supper* was written by British novelist Sam North, based on personal thoughts and notes given to him by Frank. For a full discussion of the film, see Phillip Brookman, "Window on Another Time: Issues of Autobiography," in *Robert Frank: Moving Out*, exh. cat. (Washington, D.C.: The National Gallery of Art, 1994), pp. 142-65.

15 Rovner later renamed these images, removing the descriptive titles and calling them all *Outside*.

16 See note 8 above.

17 This position was argued by Jean Baudrillard in a series of three articles written before, during, and after the conflict, and published in the book *The Gulf War Did Not Take Place*, trans. Paul Patton (Bloomington and Indianapolis: Indiana University Press, 1995).

18 I am indebted to Nissan N. Perez for sharing this and other views on Israeli artistic production and the Gulf War. Thanks also go to Suzanne Landau and Adam Weinberg for contributing to this topic.

19 At the time, the farm had no cable access for CNN.

20 See note 11 above.

21 Rovner, in conversation with the author, 24 July 2001.

22 From John Milton's *Paradise Lost* (reference is to book and lines), 7:506–10.

23 See note 11 above.

24 The concept of "game theory" was first advanced by the Hungarian-American mathematician John von Neumann in a series of papers dating to the 1920s and 1930s. For a more recent analysis, see Andrew M. Colman, *Game Theory and Experimental Games: The Study of Strategic Interaction* (Oxford: Pergamon Press, 1982).

25 See note 9 above.

26 Livia Kohn, *The Taoist Experience* (Albany: State University of New York Press, 1993), p. 15.

27 For more on Rovner's response to the media, see "Michal Rovner and Leon Golub in Conversation" in this book.

28 To make the images, Brooks took photographs of magazine images, colored them with crayon and paint, then rephotographed them through a mesh screen. David S. Rubin, *Ellen Brooks: Nature as Artifice*, exh. cat. (Cleveland: Center for Contemporary Art, 1993), p. 26.

29 Also in the Wooster Gardens exhibition were British photographer Christopher Bucklow and American conceptual artist Jan Henle.

30 From "Uta Barth in Conversation with Sheryl Conkelton, 1996," in Sheryl Conkelton, *Uta Barth: In Between Places* (Seattle: Henry Art Gallery, 2000), p. 14.

31 For the phrase "Seeing less, we imagine more," I am indebted to a conversation with the artist Vik Muniz.

32 See note 8 above.

33 From a list of ancient Mesopotamian kings compiled in the second millenium B.C.E. *The Epic of Gilgamesh*, trans. and ed. Benjamin R. Foster (New York: W.W. Norton and Company, 2001).

34 Shaul Tchernichovsky, "Man is Nothing But," trans. Robert Friend, in *Voices within the Ark: The Modern Jewish Poets*, ed. Howard Schwartz and Anthony Rudolf (New York: Avon Books, 1980), pp. 190–92.

35 See note 9 above.

36 Established in Lodz, Poland, in 1990 and maintained as an artist-run operation around the world. The first "Construction in Process" event, in 1988, predates the formation of the International Artists' Museum.

37 An agreement of mutual recognition by Israel and the Palestinian Liberation Organization was signed as a declaration of principles (also referred to as the Oslo Accords) on 13 September 1993. *The Middle East and North Africa 2001* (London: Europa Publications, 2001), p. 648.

38 This area was known as the "wilderness of Sin" (Num. 33:12 KJV).

39 See note 9 above.

40 Ibid.

41 Jean Fisher writes about viewers as participants in creating the meaning of a work of art in an essay for the exhibition catalogue *New Histories*: "the meaning of any artwork is not strictly determinable and is potentially as nuanced as the number of viewers who interact with it." Jean Fisher, "The Syncretic Turn: Cross-Cultural Practices in the Age of Multiculturalism," in *New Histories*, exh. cat. (Boston: The Institute of Contemporary Art, 1996), pp. 32–38. I am grateful to Madeleine Grynsztejn for introducing me to Fisher's writing through her own essay "CI:99/00," in *Carnegie International 1999/2000*, exh. cat. (Pittsburgh: Carnegie Museum of Art, 1999), vol. 1, pp. 98–127.

42 On the subject of deviation from the real, see Gilles Deleuze and Felix Guattari, *A Thousand Plateaus: Capitalism and Schizophrenia*, trans. Brian Massumi (Minneapolis: University of Minnesota Press, 1987), p. 489.

43 The revival of Hebrew as a spoken, vernacular language, rather than a language of prayer and sacred study, was initiated by a Lithuanian émigré to Israel, named Ben Yehuda, in the 1880s. See Amos Elon, *The Israelis: Founders and Sons* (Tel Aviv: Adam Publishers, 1981), pp. 96–97, 237.

44 In addition to revising existing imagery, Rovner has been able to add more footage of the commander in recent revisions, now that Israel has withdrawn from Lebanon and the commander has retired.

45 I am grateful to Chrissie Iles and John Hanhardt for sharing their experiences and thoughts on the proliferation of video art in the 1990s.

46 *Border* premiered in New York, at the Museum of Modern Art's Roy and Niuta Titus Theater II, on 18 April 1997. *Mutual Interest* was first shown in an exhibition at the Tate Gallery, London, in 1997.

47 Some later installations of *Mutual Interest* have used two screens, not three.

48 David M. Lank, foreword to *Great Bird Paintings of the World*, by Christine E. Jackson, vol. 1, *The Old Masters* (Suffolk, England: Antique Collector's Club, 1993), p. 7.

49 The Law of Return, enacted in 1950, welcomes and offers automatic citizenship to any member of the world's Jewish population. In little over fifty years since Israel's independence in 1948, the Jewish population has swelled from over six hundred thousand to close to five million.

50 The tribes of ancient Israel understood that their covenant with their deity Yahweh, and with other tribes, was motivated by mutual obligation. See Frank Moore Cross, *From Epic to Canon: History and Literature in Ancient Israel* (Baltimore: Johns Hopkins University Press, 1998), p. 17.

51 Rovner, in conversation with the author, 3–4 June 2001.

52 See note 2 above.

53 Rovner has printed some negatives on canvas, some on photographic paper, and she has made prints from the same negative in different colors. Some of her works are laminated glossy, others matte, and still others are mounted on Plexiglas.

54 See note 51 above.

55 *The Book of Common Prayer* (1662), The Burial Service.

56 Many art historians feel that the shadow of the Holocaust hangs over all works made by Israeli artists, regardless of their age or the subject matter of their art. Rovner, however, cites a wide range of sources for her inspiration, and therefore insists on a broader reading of her art.

57 See "Michal Rovner and Leon Golub in Conversation" in this book.

58 Organized by Phillip Brookman and titled *Media/Metaphor*, the biennial exhibition comprised works by fifteen artists, including photographic work by Chuck Close, Nan Goldin, Vik Muniz, and Lorna Simpson, and videos by Shimon Attie, Victor Burgin, and Gary Hill.

59 For Rovner's discussion of the piece, see "Michal Rovner and Leon Golub in Conversation" in this book.

60 For a discussion of *Notes*, see Michael Rush's essay, "'There Will Be Silence': The Video Art of Michal Rovner," in this book.

61 See note 9 above.

62 From "Line Composed a Few Miles above Tintern Abbey, on Revisiting the Banks of Wye during a Tour, July 13, 1798," line 91. See *William Wordsworth: The Poems*, ed. Hohn O. Hayden, vol. 1 (New Haven: Yale University Press, 1981), p. 360.

63 See "Michal Rovner and Leon Golub in Conversation" in this book.

64 See note 11 above.

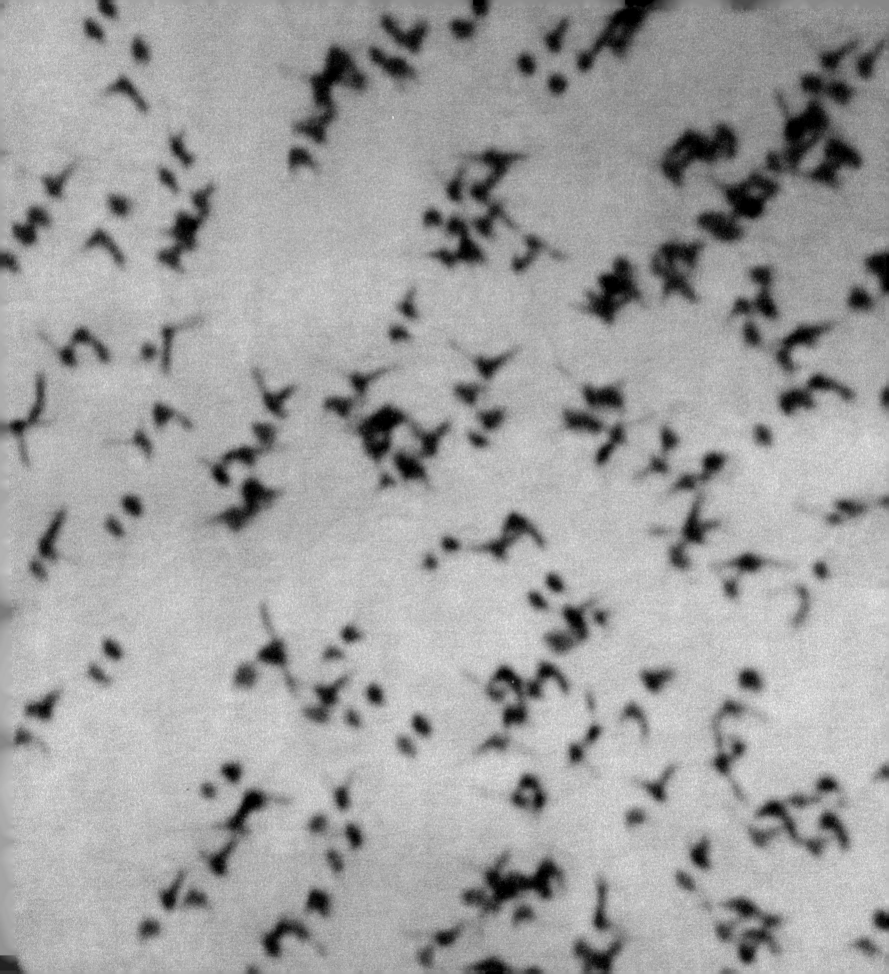

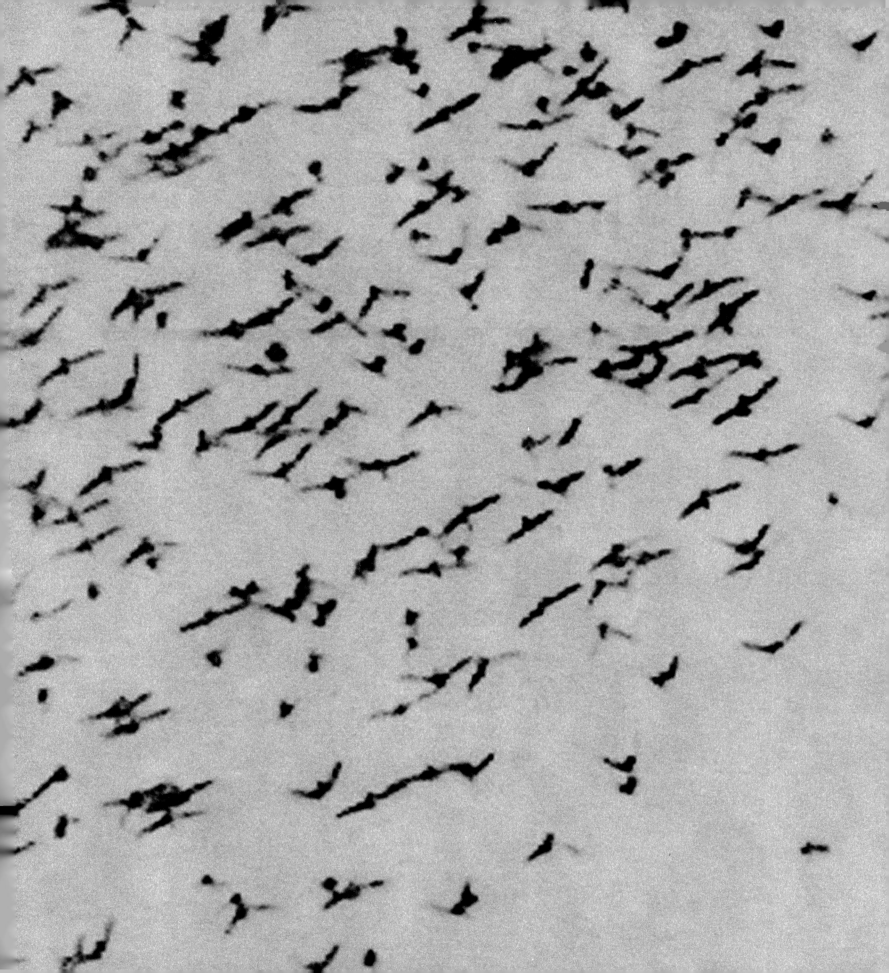

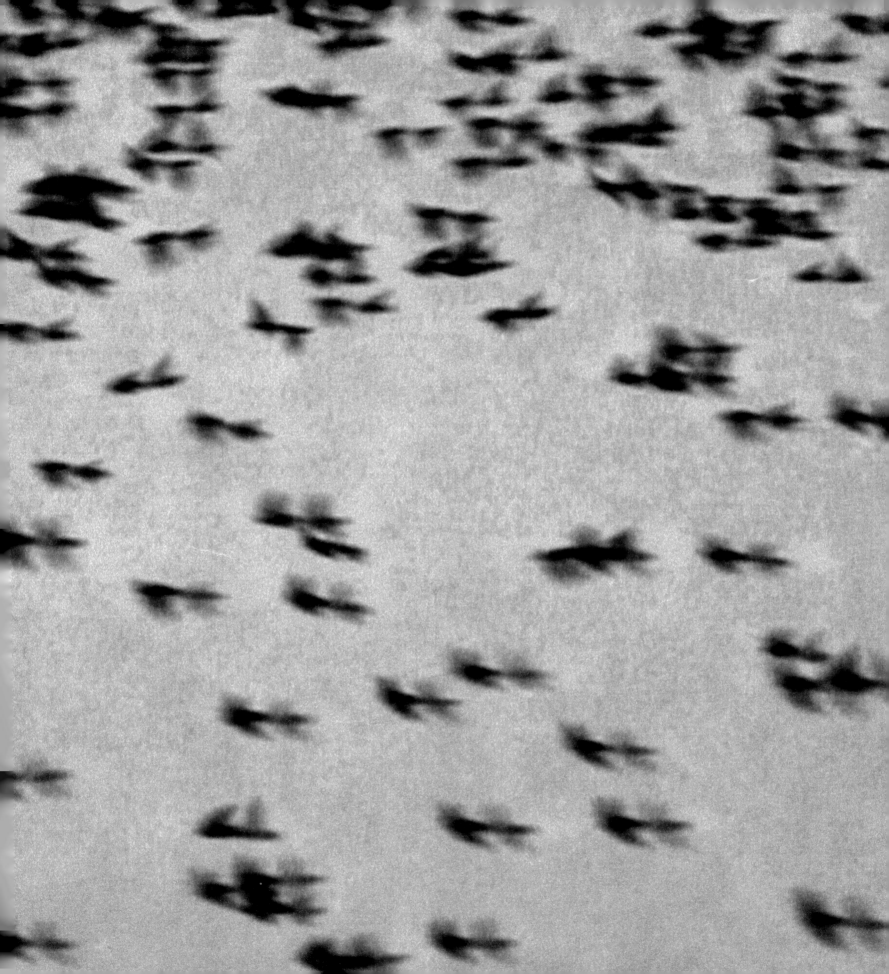

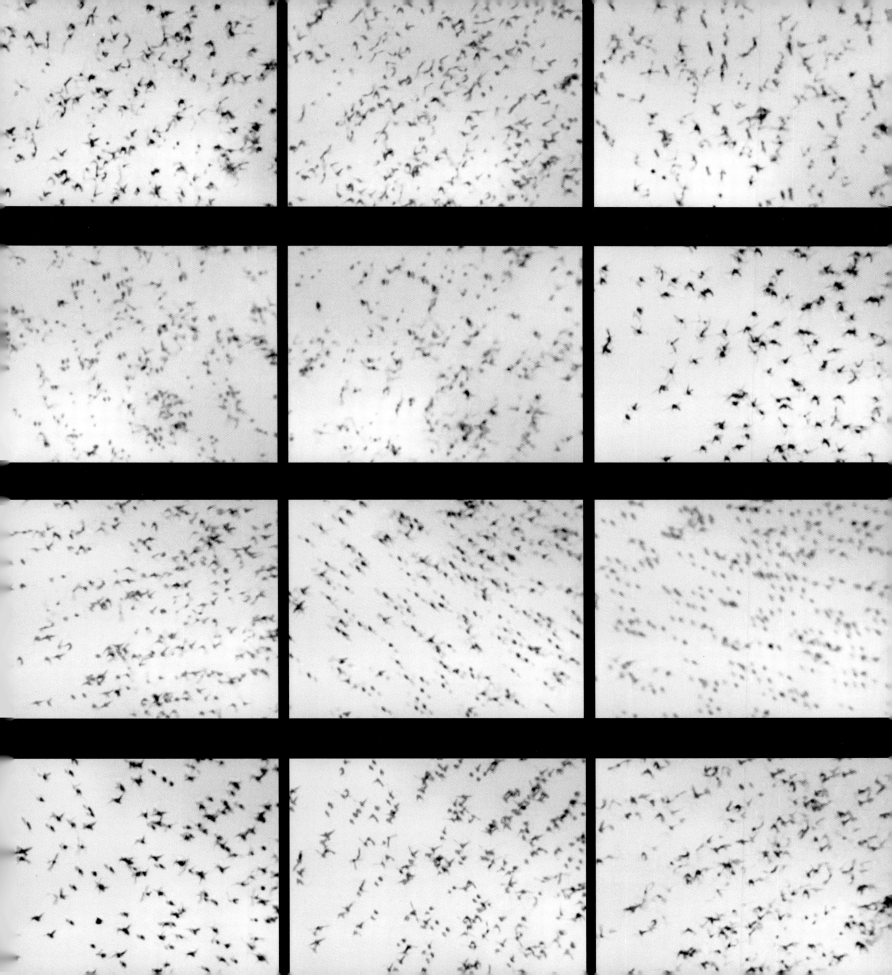

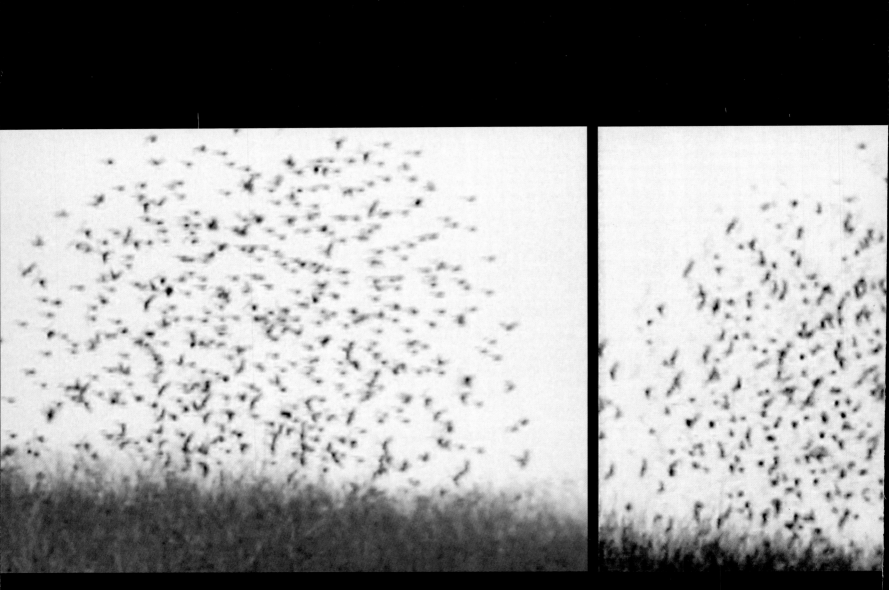

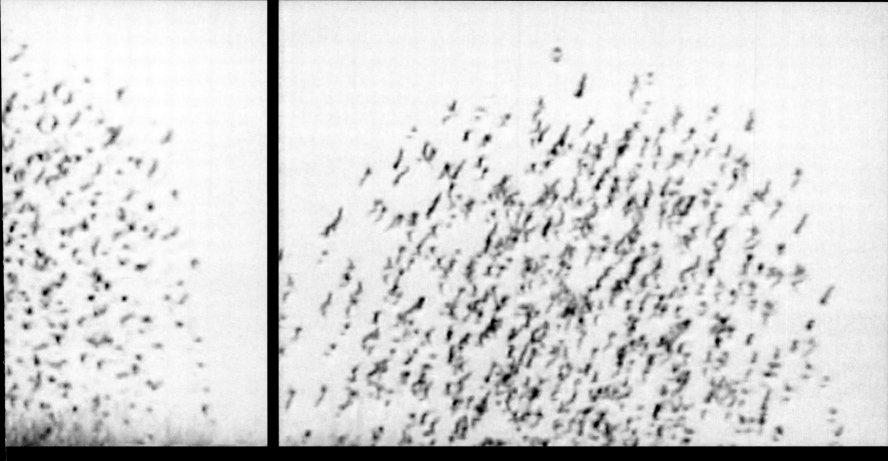

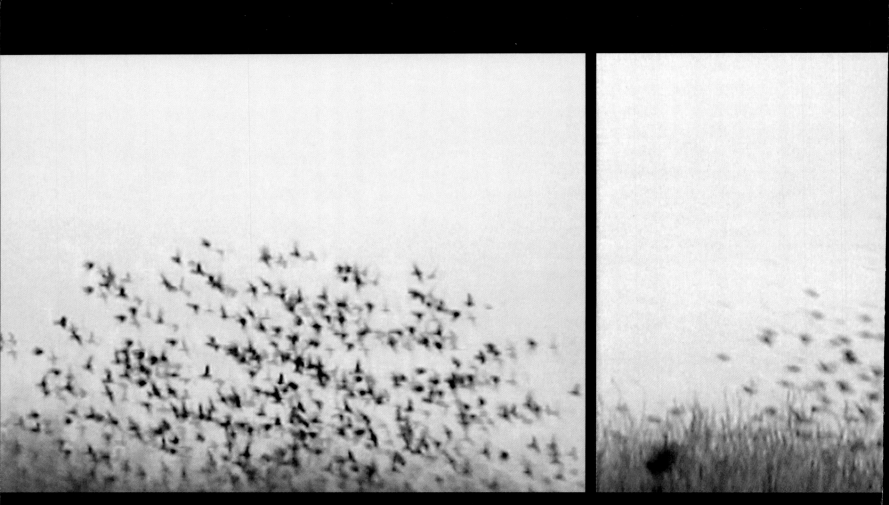

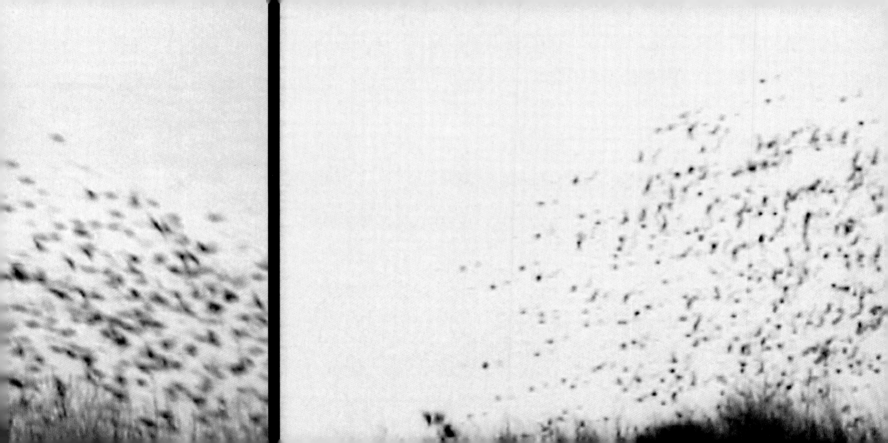

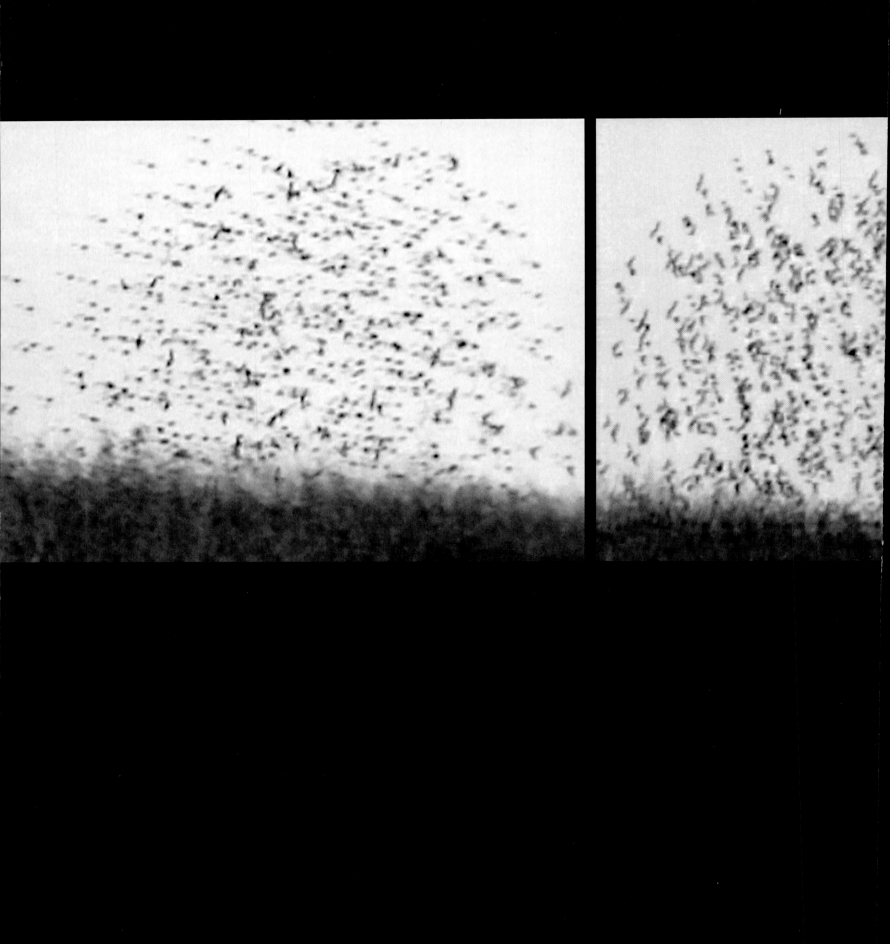

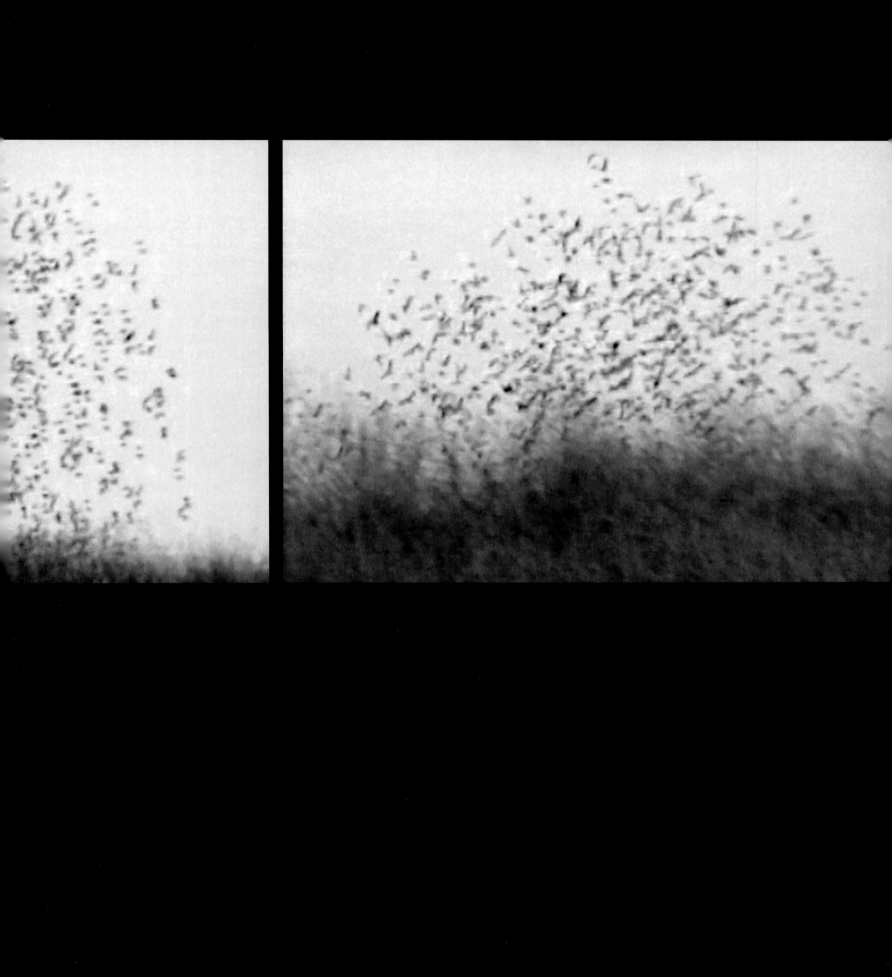

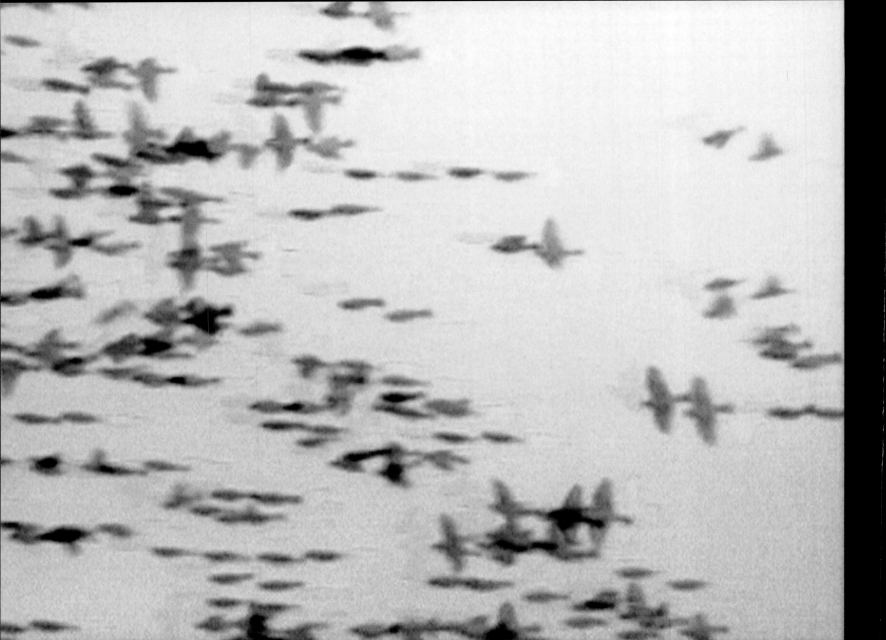

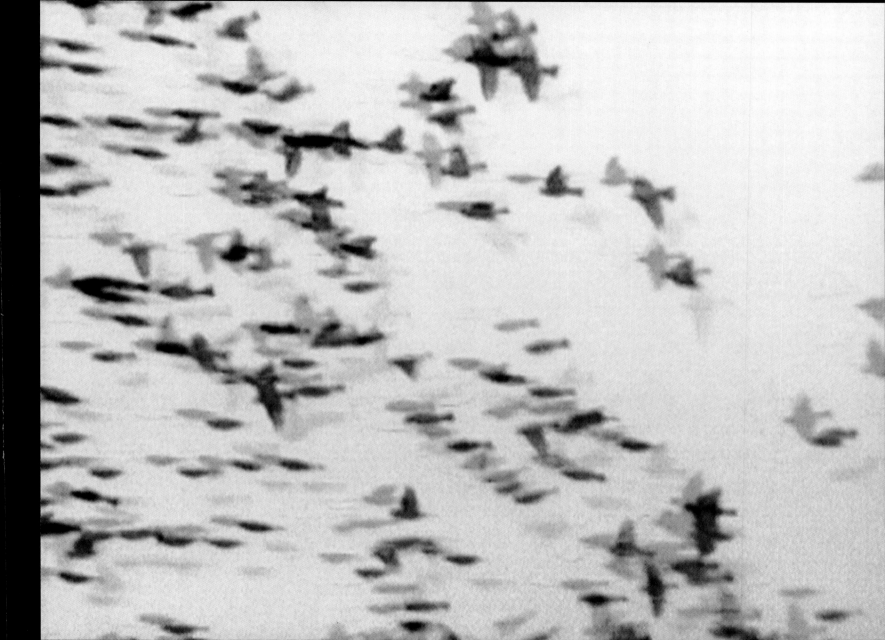

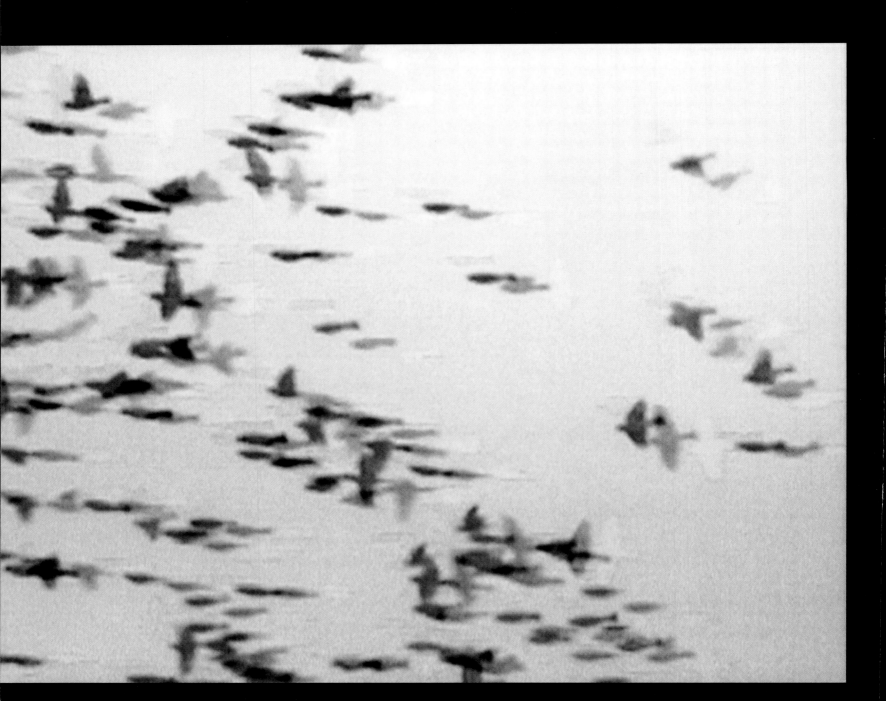

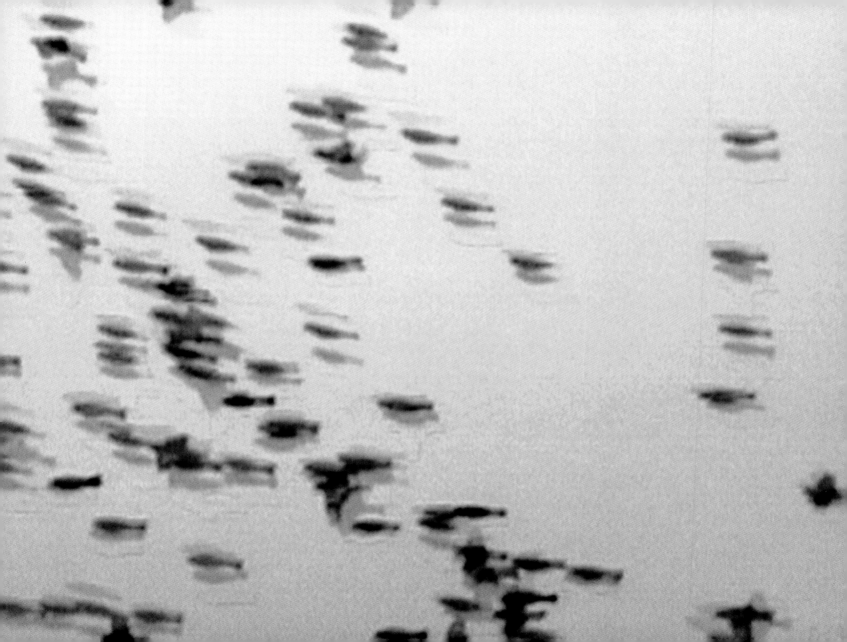

1

Figure 1
Leon Golub
White Squad I, 1982

MICHAL ROVNER AND LEON GOLUB
IN CONVERSATION

CIPHERS AND EMPTINESS

20 March and 1 April 2001

Leon Golub **The first question I'd like to ask you is: What are your overarching concerns in doing what you do? What are you after? As an artist, as an Israeli, or as anything else.**

Michal Rovner **All my work is about an experience of something that has to do with human existence, which is very fragile. But not only human existence—existence all together. I'm fascinated with how breakable it is, and how thin the line is between being good or bad, being and not being.**

Golub **That's abstract. I'm going to try to get you to be more specific, if possible. I was going to say that basically you're dealing with appearance and non-appearance. In other words, the figures in your work wander through . . . through what? They're dramatized, but to what end? They're like fragments, molecular fragments, often moving in terse and subtle ways. They're more than anonymous, you know. They're ciphers.**

Rovner **What is a cipher?**

Golub **A cipher is something like a shape.**

Rovner **An outline of something?**

Golub **A kind of notation, a shape for something not totally defined. So the humans in your work are like ciphers to me. I can't get hold of them because you have reduced them in a most extreme way. They virtually disappear. Even as they walk across the space of the screen, they're disappearing on us—they are so slight. Yet, at the same time, they are *there*. Generally in your work you seem to view people not just as abstract phenomena, but as part of some huge (or small), irregular, ambiguous action or dispersal, arhythmically moving through time. I don't know quite what to think! Your figures are not just nomads, you see. They're like flecks of consciousness, spots of recognition. We can barely connect the dots, because they're always in motion. You see the world in an extremely atomized way.**

Rovner I actually have not thought about it quite like that. I'm always thinking about how people collect information all the time. In order to acquire understanding or experience of something, there is a constant process of collecting evidence. I am suggesting that if we drop some of the details, then maybe we can get a better sense of something.

Golub No, it's more brutal than that. Your work has a kind of existential nothingness, populated with these fragments of human existence.

Rovner Or existential "somethingness."

Golub "Somethingness"?

Rovner Yeah, instead of nothingness.

Golub Emptiness.

Rovner Emptiness or "somethingness."

Golub "Somethingness"?

Rovner Why not?

Golub Why not. I'm interested in pushing images in your face—the public's face . . . And people say, "I don't want it in my face. I know about all this." But I don't give a damn; I push this in their face anyway. Now you're not pushing.

Rovner I actually try to pull someone into my zone.

Golub Zone is a good concept.

Rovner I try to be more seductive, in order to get viewers to walk in and experience something. They take a look at the work, see how they feel about it. At first it looks rather aesthetic and non-threatening. Maybe the second thing that comes to mind is: "What's going on? What does this have in common with another reality? Is this something I don't want to look at? How do I feel about this?"

BEYOND REALITY

Rovner **Leon, if I understood you right, you are wondering where my work is situated in terms of reality. I always record reality to start with. So what is the relationship between reality and my work? How much is reality just a material to use? The more confident I get about life, the more I see the real world as material, as a point of departure toward something else. And the more worried I am, the more I cling to reality, and the more I need to know the details. At the same time, when there is a very hard situation near me, it affects me. For example, when I was in Israel last winter, there was a lynching of Israeli soldiers by a mob of Arabs. When this happened, I had started a video piece called** *Coexistence 2.*[1] **In the video, the imagery is dark and the figures are beating each other. They may also be playing, and at one moment they look like sculptures. When the lynching occurred, I decided to make the work more on the harsh side. At that specific moment, I didn't want to be ambiguous.**

But with some works, like my 1999 installation *Overhanging* **at the Stedelijk Museum in Amsterdam, people had very different reactions. Some people said it reminded them of figures walking on the moon, others that the figures seemed to be walking toward the next millennium, still others that the work suggested past life, and many people said it reminded them of the Holocaust. There are many possible interpretations. The ambiguity in my work, however, is not a lack of opinion. I think it is more comfortable to be given the details than to have to experience something yourself.**

Golub **That statement makes a lot of sense. I understand to some extent where you're coming from and where you're going. At the same time, I'm coming from somewhere else and I'm going somewhere else. So you and I cross at certain junctures and we test our assumptions about the other person's work.**

Rovner **Artist statement or no artist statement, we both try to make a strong impact, right?**

Golub **Of course. Your statement is not your art, but it's a way in which, if you need to, you can explain how your art lives on. Viewers in Amsterdam who encountered your work came up with different opinions. That happens with the most explicit as well as the most abstract art. People are always interpreting and misinterpreting, and saying the most amazing things about what artists do, even if artists think their statement is very clear. That's how art lives!**

Rovner I think the power of art—the power of your painting, let's say—is way beyond the idea that this guy is beating a dog, or that guy is pointing a gun (fig. 1), or your reference to Vietnam or America. There's another power there that is beyond words. It's nonverbal. It has to do with experience, and it has to do also with the force, the energy, with which you lay an image on the canvas, with this movement or that color. It has to do with an experience that is very much like music. I would hate to give someone direction on how they should look at my work or to give my intention behind it. I can tell you my ideas about life, my feelings about war, wealth, poverty, etc. But because I don't include a manual with my work on how to look at it, I'm not going to pursue this direction in our conversation.

Golub Yes, but I always look within the work and beyond the work, because the work occurs in a civilization, and civilizations are contested territories. When I look at your work, I ask certain questions. For example, who are these people who move through your videos? What is their special connection to you as an Israeli artist? If there is a special connection, which there probably is, we get into difficult territory. You're an Israeli artist living largely in the United States, doing images which cross various boundaries. I'm not sure of all the boundaries you're crossing, so I ask questions to see if I can get from you . . .

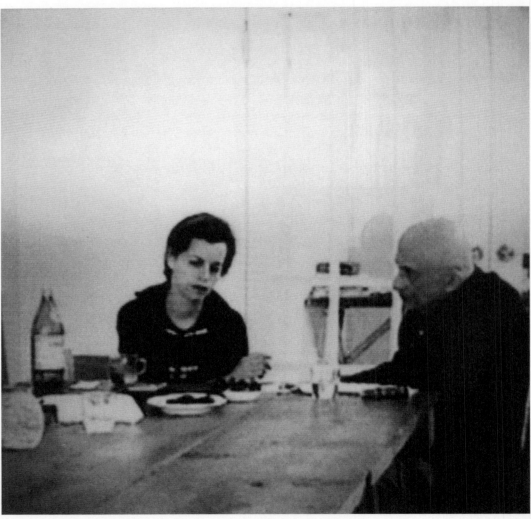

Figure 2
Michal Rovner and Leon Golub,
1 April 2001

2

Rovner **Some help.**

Golub **Some help. In this world, I need a lot of help.**

Rovner **So, you asked me about my overarching point of view.**

Golub **Yes.**

Rovner **In Hebrew, there is a toy called "rugatka." This is a very inexpensive toy. It is a piece of wood that has two branches at the top, connected by a rubber band. You hold it and you put a stone in the rubber band.**

Golub **A slingshot.**

Rovner **Yes, a slingshot. This is a frequent weapon used now in the conflict in Israel, by the way. Let's say the slingshot is a point of reality. I always start from reality. I record it, and then, little by little, I pull the image away from reality, and then the image gets blurrier. It loses definition. It becomes about something else. It goes here, it goes there. When I release it, it goes through reality and past it, to another place. Leon, do you know what I mean?**

Golub **Yes.**

Rovner **I am not trying to get away completely from a situation that has to do with reality, but I take it, break it, restructure it—I make another reality. Very often, I like to make a reality that is combined from two very different realities, like footage from America and Israel, footage from Russia and Romania, footage from America and Russia, Israel and Russia. In the film** *Border***, which is the most specific of all my works, the first text identifies the place: "Israel-Lebanon border."[2] And the second text says, "This is not a true story."**

Golub Even when you say it's not a true story, you're still dealing with levels of reality, representation, stereotype, abstraction, regardless of whether it's a true story or not.

Rovner Do you need a true story in order to be connected to something? To me it's very interesting to take something out of context, out of identity, out of locality, and shift it elsewhere. Often people ask me, "Where is this place? How old are these figures? Who are they?" People's desire is to have more information. My desire is to erase information.

Golub You used the slingshot analogy. A slingshot is quite an aggressive item. I get a different feeling from your work. Do you know the word abraded?

Rovner No.

Golub Abraded means worn down—to be worn down either intentionally or by water, nature, time. An object gradually loses its substance, its appearance. Sometimes you can't tell what it was. Sometimes, paradoxically, an abraded form appears more like what it is than in its original form. The very fact of stripping it down over time gives it a condensation. That condensation can be very powerful. I think you arrive at condensation in your work. You have reduced your imagery virtually as far as you can go, and still retained human or animal contact. We recognize these images as human because they move in a vertical stance. If they were stationary, they might look like sticks, you see, but they are human. I think you're saying something quite metaphysical. These sticks, these humans, these abraded, reduced forms are "finis."[3]

Rovner What do you mean by "finis"? Dead?

Golub Yes. Well, maybe not dead, but finished. Endgame.

Rovner But they keep going, these "finis."

Golub They're going somewhere . . .

Rovner Elsewhere.

Golub Maybe, but when you get to the end, you are "fini." Suddenly there's nothing left to do but either lie down flat and totally disappear into nature or keep moving, despite the fact that you're abraded and reduced.

Rovner Or you start again.

Golub Yes, you can start again.

Golub Your work can be relentless. We see birds moving in extreme patterns, the screen is full of them.[4] Then the view shifts and shifts again, and there's even more seething motion. The motion stops and starts. No closure, nature is scary in these ways. It's beautiful, but frightening because it's so incomprehensible. I think you're dealing with a kind of incomprehensibility.

Rovner The painter Francis Bacon said, "It is the slight remove from fact that brings me onto reality more violently" [*sic*].[5] Now, you can show reality very violently, if violence is your purpose. Or you can be very removed from reality and still create a similar effect. I always try hard, especially in my video works, not to be too directive. Instead, I try to pull viewers into a place of some kind of "unknowingness," so that they are willing to experience confusion, are willing not to have all the information. Then, at that moment of confusion, of not knowing, maybe they find out something new. Maybe they view the images differently, see them in a new light, and realize what it was that they didn't want to look at before. Take news, for instance, news footage . . .

Golub Yes.

Rovner News footage, the raw stuff you see on television, is bad. It's there every night, people watch it, but it hardly has any effect because it always has a similar intensity. People adjust accordingly. They develop a filter, a shield. Sometimes, though, when you amplify the voltage or you reduce the voltage, you get the viewer's attention. Maybe you, Leon, amplify the voltage and I reduce it or shift it.

Golub Right. Yes, you mute the appearance of these people, and I try to make images that are more aggressively present. So we're going in near opposite directions, okay?

Rovner Yes, but once you mentioned that both my work and your work "bites."

Golub Yes.

Rovner So is it a different means or a different purpose?

Golub Certainly a different means for a different purpose. I recognize the bite of your work, but it's a different kind of bite than I insist on.

Rovner Is it more pleasant?

Golub It's more . . .

Rovner I'm joking.

Golub **No, it's a fair question. The bites are different, that's for sure. It's easier to pretend not to see your bite. Incidentally, I disagree with you about the effects of television and the news. I developed a notion, which I've used for years. I say that these images—something happening in Vietnam, automobile ads, situation comedy, discussion on politics, more lies, more distortions, more propaganda— all break down. We don't get one image to assimilate, we get all sorts of images simultaneously and that gives us the jitters. I call it jittering. All of this stuff that we encounter all the time, we're moving between locations, situations, individuals, so on and so forth. All this is bouncing around in our head. We can reduce the volume, we can pull down the curtain, but it's still there and it's jittering. Things are much more simultaneous than ever before, and when things are more simulta- neous, we jitter more, because we're trying to balance a hundred million different things in our heads. That's modern consciousness.**

PHOTOGRAPHY AND ABSTRACTION

Rovner **You take photographs as your reference point, very specific pictures from specific moments. A lot of them are known moments from the media or from news- papers. Some you find in magazines, like the lions or the dogs. But sometimes you take news footage, and you create paintings that have a very realistic aspect to them. Your product is a painting, it's made up of pigment on canvas. I don't paint. But I take my work to a place where it corresponds with painting. And you take your paintings to a zone where there's something very photographic about them.**

Golub **Yes.**

Rovner **So I think this is an interesting connection or disconnection. There are actually lots of connections between us.**

Golub **Well, we're both lost in the world!**

Rovner **I don't actually feel lost. I'm vulnerable, but I'm not lost.**

Golub **No, and you have the power of abstraction available.**

Rovner **So do you.**

Golub **In a different sense. The power of abstraction is the power to change phenomena in such a way that they can be recognizable, but don't have to be rec- ognizable. I have never given myself that leeway. In fact, I have fought against it theoretically. The point is that the power of abstraction gives you a lot of avenues into the world, and at the same time you have never given up on representation. You use abstraction to make your representations more powerful. You use abstrac- tion to universalize, in a sense, some of the feelings you have about representation. That's part of the vitality of what you're doing as an artist.**

We intersect at certain points, not just one point. We intersect in various ways, on various levels. But it's never a total match. I'm coming from an asymmetrical position, you know—an off-balance position, and a largely prejudiced position based upon my own history. It's not possible for me to see your work quite like somebody else would—certainly not like you would. But I pick up certain cues from you, and from looking at your work, and I try to enter it. I may enter it quite clumsily, but it is still an entrée.

We both have big ideas of what the hell our work is all about. Your videos are not simply contemplative little gestures. You've got movement through your canvases—I'm saying canvas deliberately, you know? I think of canvas in a larger sense, you see.

Rovner A canvas of movement.

Golub Exactly. Your works have to do with the movement of people—the movement of life forms. That seems to me where many of your interests lie. You want a wide screen, that's your ambition. I'm not talking about size, I'm talking about up here [gesturing to the head]. I want a wide screen too. Physically, I've fought for it in terms of scale of painting, but I've also fought for it in the psychic sense.

Rovner I disagree with you that my work is about movement of people and birds. I see the work as about dynamics.

Golub That's the same thing.

Rovner No, dynamics is not movement. Movement happens from one place to another. Dynamics happens between things. The term refers to their relationship, to the forces that play the game—between themselves, with themselves, with the environment—their strengths versus non-strengths, their effect upon each other. And how much they relate to or rely on each other.

Golub Are you saying that your figures have even less control over their movements?

Rovner No, I say they not only move, they also interact. Even in the case of the houses in the series *Outside*, or of the single figures in *One-Person Game Against Nature*, there is an interaction.[6] The subject and the background are very often the same material, the same color, the same substance, the same weight, the same density. But with the houses there is an interaction between one image and the other—a dynamic. When they are seen together, they become a single picture.

Golub I have great interest in technology and the future, in a theoretical way. The most advanced technological things are still an extension of our hands and mind, you know. In a developmental sense, a handprint on a cave wall is not so far from the most advanced super-computer! The last couple of years, I've been reading popular books on cosmology. I don't understand two-thirds of what I'm reading, but I get certain things out of it. The info is beyond comprehension—universes beyond universes beyond universes. Black holes, which can lead into new universes. Cosmologists speak of galaxies with billions of stars. Billions of stars? Billions of galaxies? What is this all about?

Rovner Have you answered these questions for yourself?

Golub No, I don't know what the hell is going on. One reads of the receding scale of ten to a minus thirty-sixth (10^{-36}) second—big-bang time—a trillionth, or is it a trillionth of a trillionth, of a second! This stuff knocks me out.

Rovner What does it make you feel?

Golub Certainly, I like this concept of the universe more than traditional notions of God and the cosmos—its hugeness and abstraction. It's so vast, I find it consoling. Some scientists think the big question is: "Why is there anything at all? Why not nothing?"[7] In other words, once there is something, we require an explanation for why it is. You're tangible, the table is tangible. Why?

Rovner Somewhere, somebody, in some form or another, had some intention that something should be and then it occurred. That's what I think.

Golub Maybe. Maybe not. In one of my paintings a man is under a lion and he's holding a little sign that says, "Why me?"

Rovner I know that painting. I like it very much.

Golub The other question one always asks is, why not me? These are the two basic questions in life. Why me, and why not me?

Rovner **Leon, you asked me what I try to achieve in my work. I think I often like to take two realities and to combine them together into one reality. For example, I take footage from Russia, from New York in a snow storm, and from Israel in the heat, and put them together, and they work together seamlessly. There are often two or three realities in my work. Even in** *Border*, **the viewer knows there's not one reality. There is the general's and mine.**

Golub **In the final form, are they distinguishable?**

Rovner **They are not.**

Golub **So you have eliminated the differences.**

Rovner **They're cooked into another dish. Do you feel you do the same?**

Golub **No, we have different attitudes about form, human form, very different attitudes. At the same time we are consciously controlling form. Before, we were talking about the origins of the world, of the cosmos. Now we're talking about the origins of our work. We've dropped the level of our discussion down a few million degrees. But your conscious decisions, in terms of form, are different than mine. We have both used animal or bird forms, but the levels of abstraction are extremely different. Unless you do a film like** *Border*, **which you did on the Israel-Lebanon border, and which has a very specific line of inquiry, we never see a specific human form in your work. We see ciphers. We see a mark that moves, a shape that moves. We know that's a human form, even if it's beyond the point of any kind of identification. My figures, instead, are identifiable. I project characteristics onto them, this nose, or that mustache.**

Rovner **Expression even.**

Golub **Yeah. One fist is different from another fist. One figure lunges differently than another figure. We both claim to make works that refer to certain national issues. You were talking about Russia and Israel. I'm talking about American power.**

Rovner But you're talking about "referring to" and I'm not sure that I necessarily want to refer to either Russia or Israel. I am trying to create a space that is like an autonomous reality. I'm very interested in working in photography, while you are working in painting. The first time I picked up a camera, I noticed that, while recording something, I was already taking it out of context, abstracting it, rearranging it, or changing something about it. The color, the perspective, the form, the time, the movement, the depth of it, the composition, and so on. My basic desire was to deal with the things I wanted to interact with.

Golub Well, the question still is, why the particular levels of abstraction that you are working with. I want to see you explore this.

Rovner I am doing that. But you are impatient.

Golub Well, yes. The last few comments of yours were too general. They didn't give me any information. They could apply to anybody in any circumstance. I need specifics from you. You know, I am a reality freak. I use photographs and other material and whatever I can to try to get as close to the tangible as I can. And then I try to impose upon that my own freak nature. I'm using the word "freak" deliberately, because I'm referring to an extreme way of how one distinguishes how one makes something. I recognize that your work, from where I sit, is at an extreme distance from most levels of seeing. I mean, you're creating works that express in extreme form how people move through time and space. That's part of your work's interest. It's going to be hard to get too much more abstract, because your figures are very, very reduced.

Rovner I am looking for a point of departure from concreteness. But I don't want to totally lose the presence of something, or even the meaning of what it was, or used to be, or could have been. It's very, very interesting that you, who are such a "reality freak," use painting, and I, who am such a freak for different possibilities of reality, use photography. But something comes across even when I abstract something. Even when I take off one layer after another, something does remain. And maybe it has potential—energy, information, visual information—to make a very strong statement about a specific reality, which an exact recording of that reality wouldn't have. You're more didactic than I am. I am refusing to be.

Golub **Right, but you reduce humans to a molecular kind of level and movement. They're in some kind of motion, and it's a kind of molecular motion. Each individual is somehow involved in a kind of mass movement, a process of continual migrations, and interruptions, and regroupings, and then migrating once again.**

Rovner **Migrating is a good word.**

Golub **What is the relationship of the birds to human form, if any?**

Rovner **They are another example of moving material.**

RHETORIC AND THE REAL

Rovner **And you, Leon. What is your slant?**

Golub **What's my slant? I'm going to use a word I almost put into one of my recent paintings—declamatory. A demand.**

Rovner **I know it has to do with claiming something.**

Golub **Claiming something in a very strong way. It has a political aspect. It has an aggressive, rousing aspect. It is declamatory, when we say, "Citizens, it's time to go and fight the enemy!" That's declamatory. It's enlarging the rhetoric in a very strong way. It can be almost sentimental or overkill, the violence and fake violence of rhetoric and public statements.**

Rovner **Maybe you shove your ideas into the face of your audience. I say to my audience, "Would you like to take a look at this? I'd like you to see something. I know you know about war and you've seen the news, but I have something else to show you. Do you have a minute? Would you like to take a look?"**

Golub **Does that attitude refer to most of your work?**

Rovner **I'm talking about the** *Decoy* **series, my pictures of the War in the Gulf.⁸ I'm telling the viewer: "It's pretty, right? It's red, it's green, it's shiny. It could look nice in the living room, maybe above the couch." Then I say: "Look at it again. What do you think it is? What does it make you feel?" I invite viewers to participate in an inquiry. I bring them to a certain space of unclarity. A certain space that is easy to enter, at first glance, because of its vagueness. It's a soft door to enter.**

Golub **You must be a lot more subtle than I am.**

Rovner **Seductive, actually. It's a different mode of operation, it's a different tactic.**

Golub **I like the idea of rhetoric, of influencing actions through a kind of attitude, a kind of language, a kind of presentation. I'm trying to say to the world that this is the way it is. This is a kind of reportage. I am trying to say something about the nature of American power, the power of our modern world in general. I'm trying to say something about how men enact themselves. When I say men, I mean women as well, but men retain a lock on power. But lately I've moved partially away from this confrontational kind of thing. Now I'm trying to insert myself in angular displacements, within contradictory setups.**

Rovner **Less in the face.**

Golub **Less in the face, more sardonic, more irritable, with smart-ass comments inside the painting. But in terms of our work, we dance a strange dance between optimism and pessimism, to use such trite terms. I would say, for example, that I am pessimistic in showing how power is used and in showing the cruelties and corruptions involved in it. The people I show are not so nice. At the same time, the positive side is that these figures display energy and awareness in their appearance and actions. It takes energy to twist somebody's arm, okay?**

Rovner **To beat somebody.**

Golub **Exactly. Now your work is pessimistic—or do I dare call that optimism— in that you reduce individuals so they are no longer individuals. They are ciphers— to use that word again. Certainly the positive, optimistic side of your work is its endlessness. They're always there, they're always in motion, they never stop. There's a continuous movement of these human forms through time.**

Rovner **But what's pessimistic about the fact that these figures are reduced? To me it is very optimistic. What's bad about that?**

Golub **They're hard to get a hold of. They're hard to grasp. I want to reach one of them—mentally—but I can't because it hardly has any shape and then it's moving, it's out of sight. Then there's another one, I try to grasp that one, I can't reach it. But if I look at them all together, I see a panorama of them through time and history.**

Rovner **Yes, but Leon, your work is much grander than the way you describe it. The power of your communication is way beyond the specific guy, and face, and reality in that specific moment in time. You're trying to show force being abused, but force can be also positive.**

There is something in the way you lay the paint on the canvas, for instance, in the way you use materials . . . You can take many elements together and they remain what they are, and sometimes you can take them together and something occurs—it suddenly becomes a very strong experience. This effect doesn't necessarily relate to the specifics of the situation, but it is another level of existence, which is very hard to translate into words—and shouldn't be translated—because it is something that exists beyond words. You can be critical of sentimentality and religion and spirituality. But there is a lot of feeling in your work. Not only in the way you layer subject matter, but particularly in the way you layer paint. I see a dog's face and I see the pink paint. I see the way the black is smeared and suddenly there is an interaction.

Golub **Surely I want beauty, but it's not about beauty.**

Rovner **Okay, it's not about beauty, but it's about something else, which you really don't say so much about.**

Golub **I would call that the reality effect. But what is the real? We don't even know what that means. The word is so abstract in itself. There are huge gaps between talking about art and doing it. There are huge gaps in everything.**

Rovner **When I was in Moscow, I was asked if I would be interested in filming in the fields where Napoleon surrendered to Russia, and I said yes, absolutely. I went there, and they were just fields. Other fields, though, looked more Napoleonic to me.**

We always have an image that we create when we have not been somewhere. Then we go and we see the place. That's a very interesting moment. I had a very strong moment like this with Russia. Before I went, I had a huge, imaginary space in my mind. I had a sense of how it would look and how it would sound and how I would be scaled against it. What was amazing was that I went there and it was as I imagined it. That was the weirdest experience. Maybe I went anticipating such a reality that I inflicted that reality on the place. Maybe there was no space for a new experience.

Golub Perhaps you had such a strong sense of reality that reality couldn't even enter.

Rovner It's as though you create a film of the space in your mind, then you walk into the space, and it's the same. So, you wonder, am I psychic or am I blind?

Notes

1 For *Coexistence 2*, 2000, see figure 52 of Wolf essay.

2 For *Border*, 1997/98, see figures 40a–d and plates 35–37 of Wolf essay and figure 1 of Rush essay.

3 Here Golub uses the term "fini," as he has heard it used in street slang, pronounced in the French manner, with an accent on the last syllable.

4 See, for example, *Mutual Interest*, 1997, figures 41, 42a–c of Wolf essay.

5 "I think it's the slight remove from fact, which returns me onto the fact more violently. Through the photographic image I find myself beginning to wander into the image and unlock what I think of as its reality more than I can by looking at it. And photographs are not only points of reference; they're often triggers of ideas." Quoted in David Sylvester, *The Brutality of Fact: Interviews with Francis Bacon* (New York and London: Thames and Hudson, 1987), p. 30.

6 For the series *Outside*, 1990/91, see plates 2–4 and 13–20 of Wolf essay. For *One-Person Game Against Nature*, 1992/93, see plates 21–29 of Wolf essay.

7 For a discussion of Rovner's art on these terms, see Steven Henry Madoff's essay "In the Zone of Transition," in Sylvia Wolf, *Michal Rovner* (Chicago: The Art Institute of Chicago, 1993), pp. 45–49.

8 For the series *Decoy*, 1991, see plates 5–12 of Wolf essay.

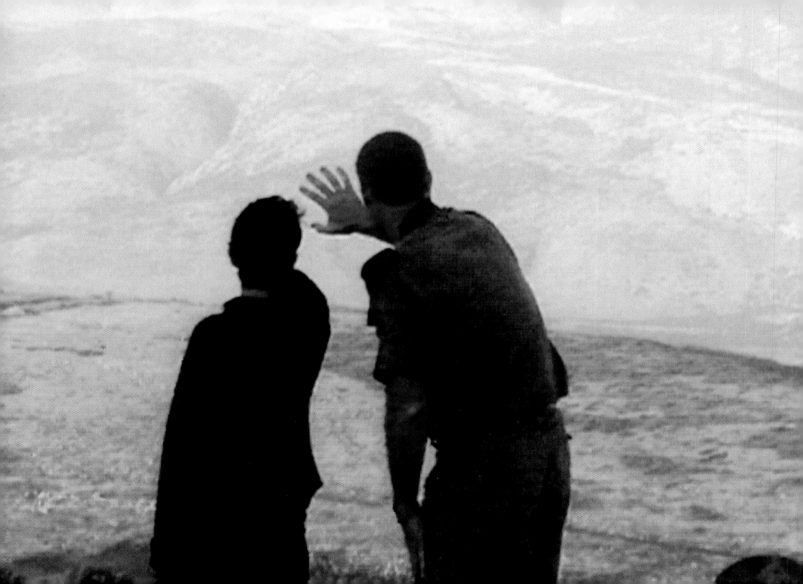

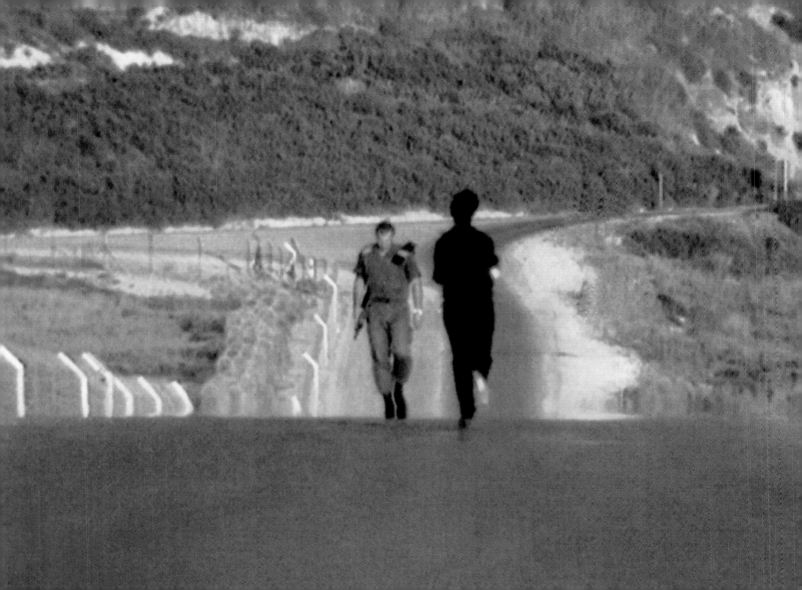

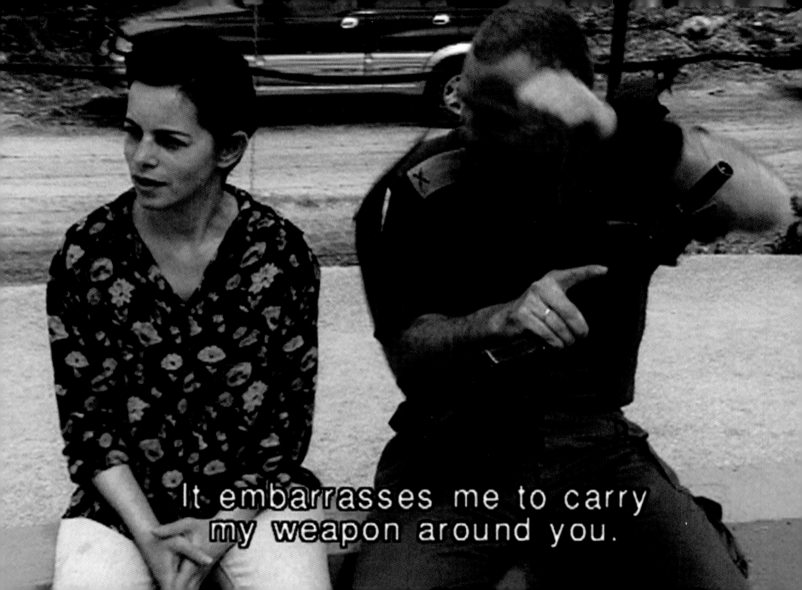

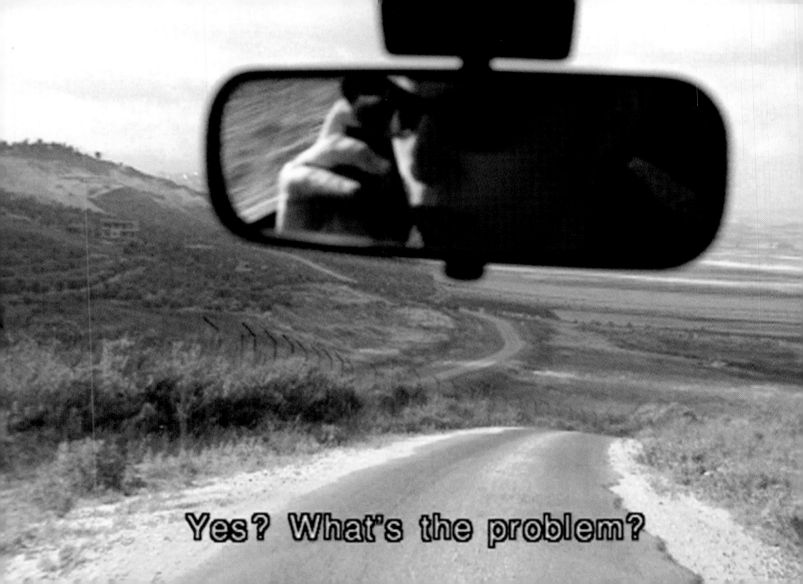

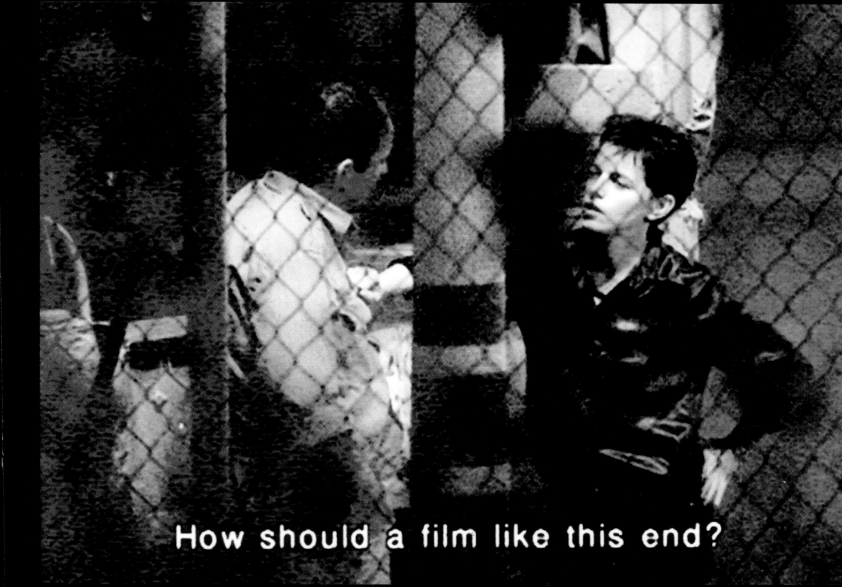
How should a film like this end?

Is it dangerous here?

Everything will be fine

But five minutes after the fire
ceases, everything looks so peaceful.

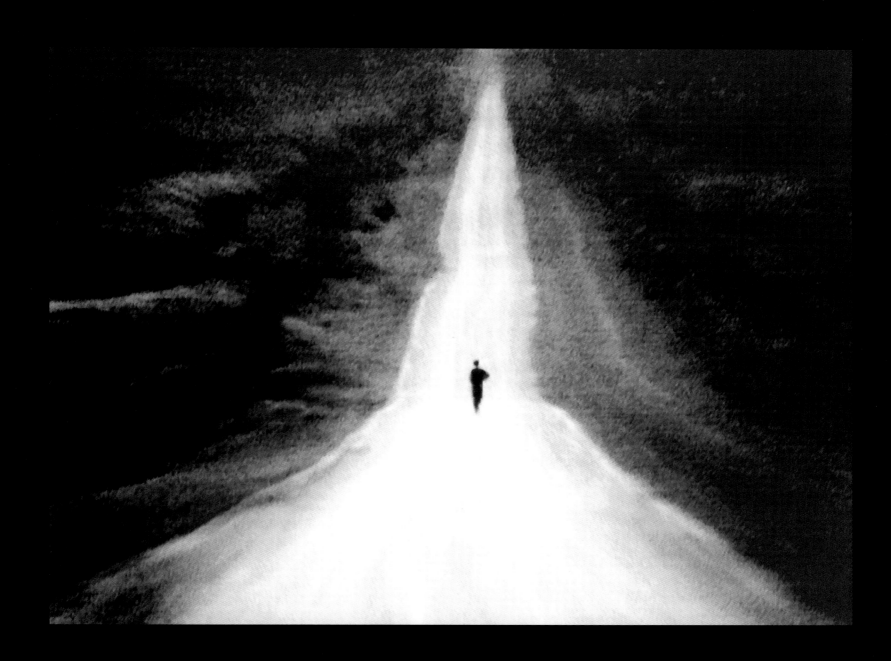

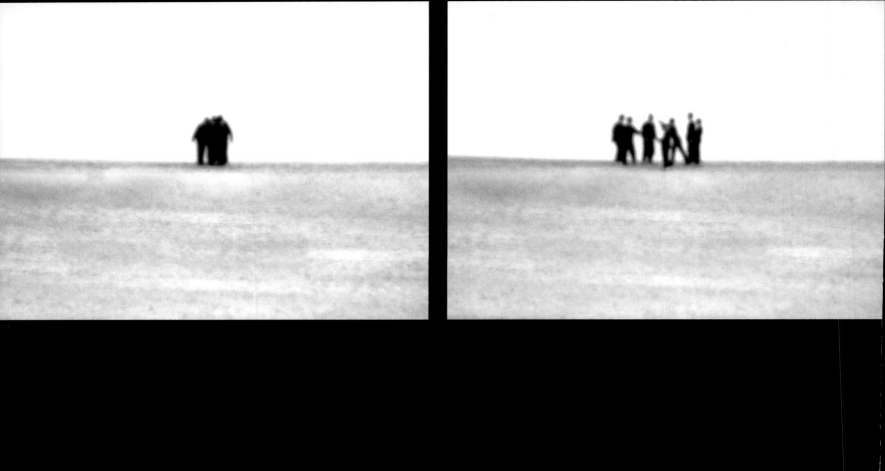

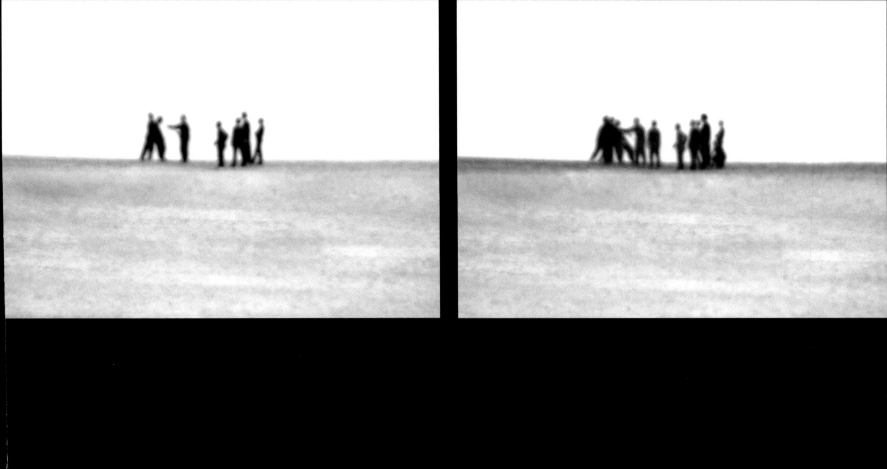

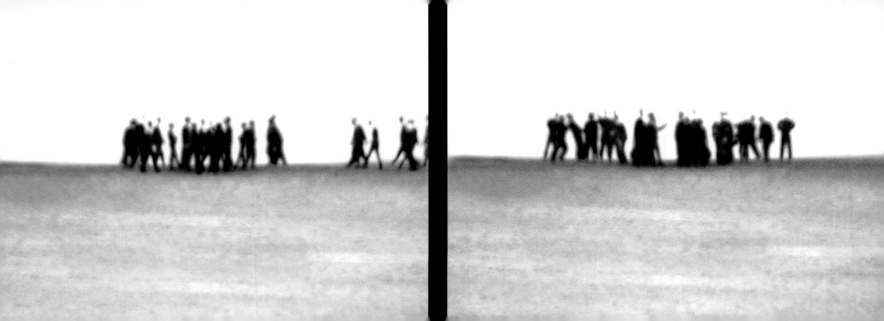

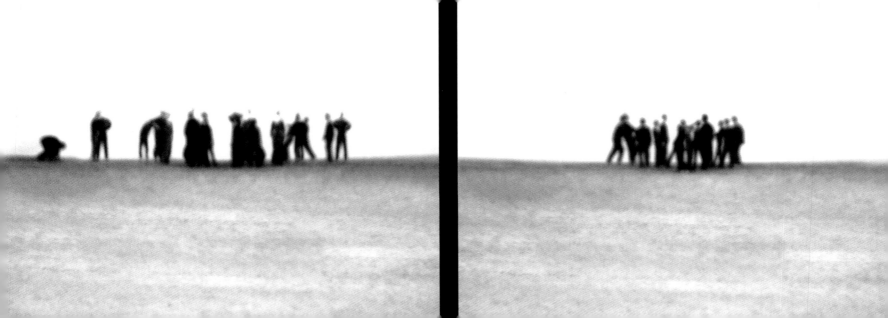

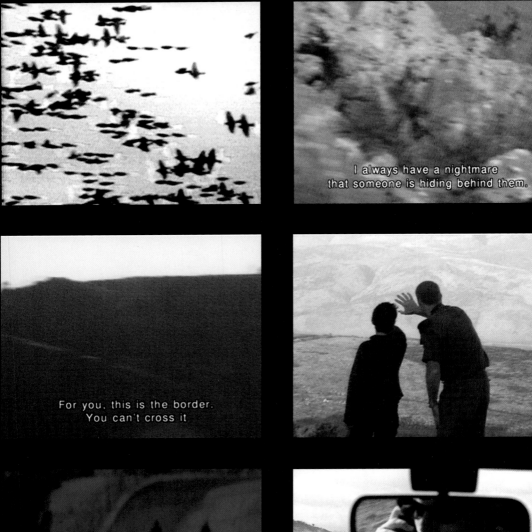

I always have a nightmare
that someone is hiding behind them.

For you, this is the border.
You can't cross it

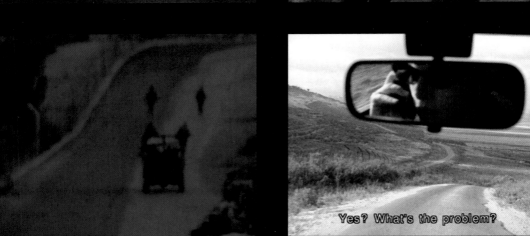

Yes? What's the problem?

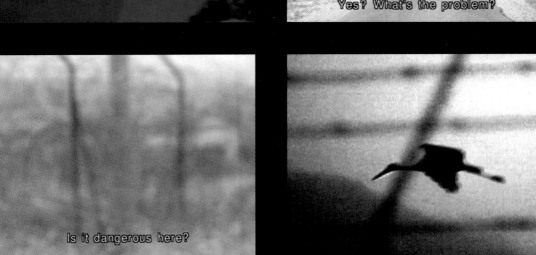

Is it dangerous here?

"THERE WILL BE SILENCE"
THE VIDEO ART OF MICHAL ROVNER

MICHAEL RUSH

Toward the end of Samuel Beckett's characteristically haunting *Texts for Nothing*, his monologist says, "Whose voice, no one's, there is no one, there's a voice without a mouth. . . . it won't be long now, there won't be any life, there won't have been any life, there will be silence."' The same longing for understanding that motivates so many of Beckett's characters, ultimately leading them to a deep silence after a lifetime of misspent words, seems to permeate the video images of Michal Rovner. Not that Rovner seeks the same reconciliation with an absent God that Beckett does. No, for her the silence in works such as her 1996/97 film *Border* (fig. 1) is the residue of the failed human interaction that has resulted in war, especially in her native Israel, where the real threat of annihilation from bombs and gunfire has been the constant backdrop of life for her family. Rovner's searching silence is what remains after all the questions she asks incessantly in *Border* remain unanswered. "Is it safe?" Rovner, the protagonist of her own film, asks of an army commander before heading out in a Jeep toward the border of Israel and Lebanon. "What if you had to kill? How should this film end?" she repeatedly queries.

Rovner, a photographer since the early 1980s, began using video in 1992, but only as a source for still photographs. "I am always collecting information," she says.² She submits the information, drawn from the world around her, to multiple manipulations that result in intentionally ambiguous images. According to the artist, her first video project, *Border*, remains her most complicated, due in part to the logistics of filming in an embattled area. Filmed on the boundary between Israel and Lebanon during a time of war, this straightforward looking video (filmed with three hand-held cameras: hi-8, DV, and Beta) is actually a fictional narrative, in which repetition, spliced dialogue, and surreal juxtapositions of texts and images result in a terrifying meditation on war and art.

In this work, Rovner films herself engaging in conversation with passersby (consisting mainly of questions and answers on the subjects' feelings about the war) and, most dramatically, with a general in the Israeli army, who keeps warning her "to stay in your own reality" instead of trespassing into his. This philosophically minded commander—sometimes seen, but most often heard in voice-over—questions her motives in making the video. "How famous you'd become if I died while you were filming," he opines in a characteristically challenging fashion. "This film will help you in your world, will get you where you want to go," he adds, "but what will it do for me?"

But unlike the stereotyped, maniacal officers in movies such as *Apocalypse Now* or *Platoon*, he is very protective of her even as she plies him with questions and dangerous requests to travel into conflict areas. "There is no ending to what you're filming," he answers, mournfully, to her constantly repeated inquiry: "How will this film end?" As their Jeep passes through the dry landscape along the barbed wire border, normal life goes on. A sheep farmer herds his flock across a dirt road; a man emerges from a building. Smoke from gunfire rises into the air a short distance away; a phalanx of birds swirls up and down in the blue sky beyond. The quotidian collides with the terrifying, as Rovner's camera seeks out the danger in the commonplace. A white car moves slowly down the hill like a snake about to strike. Who's inside the vehicle and what are they doing in this war zone?

At the end of *Border*, there is an explosion. Though Rovner allows for some ambiguity, the inevitable loss of life seems to have occurred, and the question "How will this film end?" no longer appears open-ended. The birds, looking now like fighter planes in the distance, fly in harmony to safer skies. According to Rovner, every-

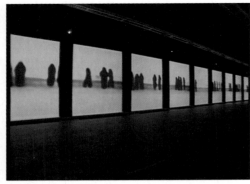

Figure 2
Installation view of Michal Rovner's *Overhanging*, 1999, at the Stedelijk Museum, Amsterdam

Figure 3
Outdoor installation view of Michal Rovner's *Overhang*, 2000, at the Chase Manhattan Bank, Park Avenue and Fifty-fifth Street, New York

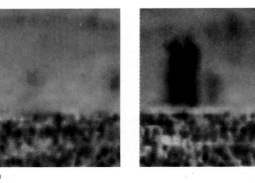
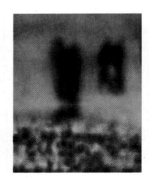
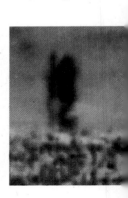

4a

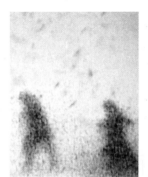

4b

Figures 4a–b
Michal Rovner
Stills from *Overhanging*, 1999

thing in the film is repeated at least twice. Words, phrases, and camera shots are cut and clipped, moved and reinserted elsewhere to create a driving rhythm that leads to the sad conclusion. We are left with the sense that there is indeed "no ending to what [she's] filming," no resolution to the self-perpetuating hostilities documented in Rovner's video.

Despite its ambiguities, *Border* is still watchable as an unfolding narrative. In her installations, however, Rovner would largely abandon this narrative element. This is true, for example, of *Overhanging* (figs. 2, 4–9), which was mounted originally in 1999 in the Sandberg Wing of the Stedelijk Museum in Amsterdam. The following year, it was reconfigured and retitled *Overhang* (fig. 3) for its presentation at the Chase Manhattan Bank on Park Avenue in New York. *Overhanging* is a work of extraordinary ambition, complexity, and beauty. Filmed with three video cameras and projected onto adjoining scrim-covered windows (each on two sides of the gallery in Amsterdam, seventeen overall in New York), it is a haunting work of figurative abstraction, depicting what look like black-hooded figures making their way, effortfully, through an unidentifiable space. Above them, other human figures are shown walking, slowly, ploddingly, in white silhouette in a straight line across an equally barren landscape. They all move in painstakingly slow motion, across what looks like a desert or a snowy tundra, advancing endlessly toward no visible destination (fig. 4). It's as if these lonely souls were muttering the closing words of Beckett's novel *The Unnamable*, "you must go on, I can't go on, I'll go on."[3] Rovner's figures (I call them "figures," for in this case Rovner does not reveal their sex, age, or anything else about them) move on in an infinite repetition. The screen fades from the palest white, to rouge, to black, and back to white.

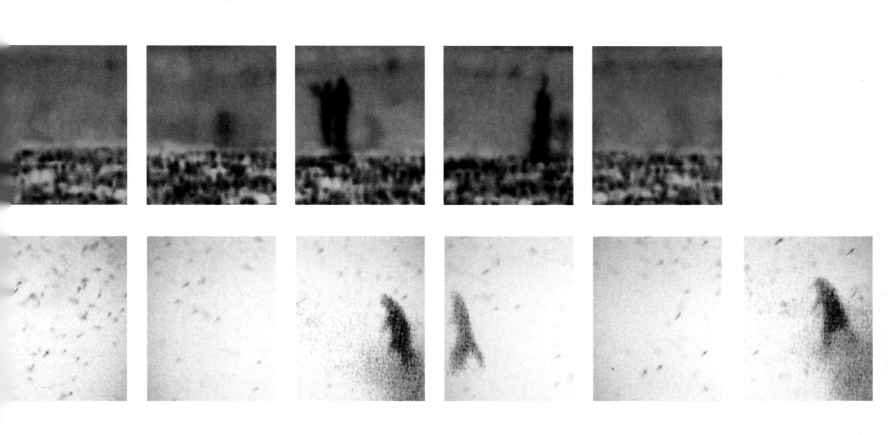

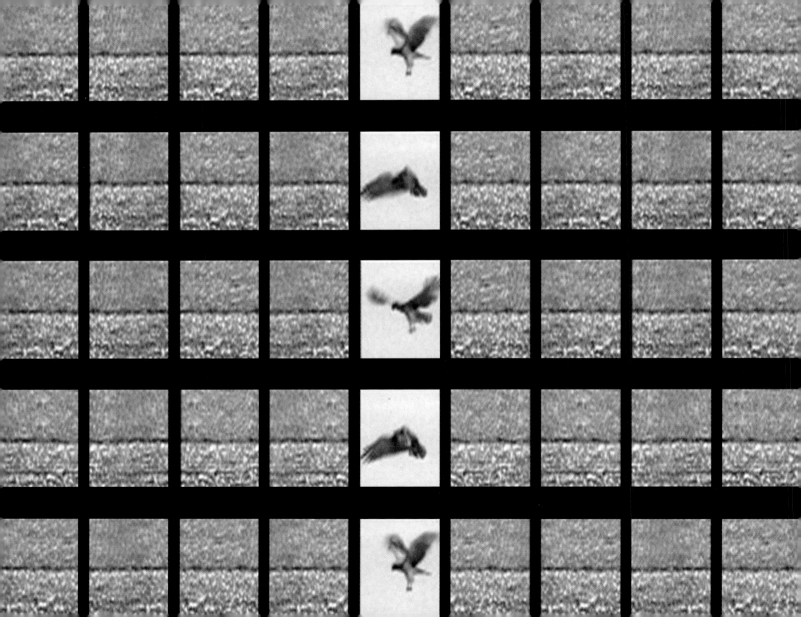

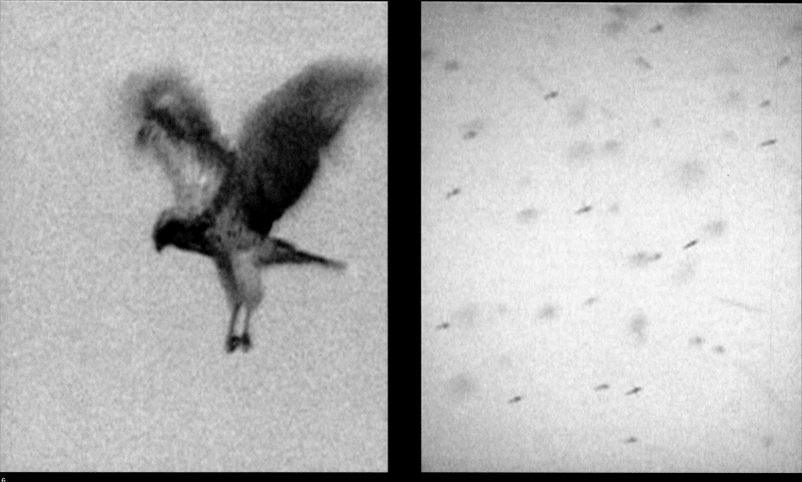

Swarms of birds then appear and disappear, racing from window to window. A huge eagle materializes, furiously flapping his wings from a stationery position in the sky. Rovner has captured this movement and repeated it in an unending loop, rendering the statuesque creature incapable of landing (fig. 5). At times the hooded figures seem to be making their way, as in a pilgrimage, toward the enormous bird, a substitute perhaps for God. But then the majestic bird is erased only to reappear later in its suspended flight, forcibly confined by Rovner's digital editing. He is no deity. He offers no solace.

Surrounding these images is an electronically manipulated score for human voices by Rea Mochiah. Like the drone of Gregorian chant, these voices are the disembodied vocal equivalents of the figures passing before us. Their sounds reach no crescendo, no conclusion. They just go on, accenting the strained movements of the figures and the impossible, endless flapping of the eagle's wings. Exhaustion should be claiming all these beings; they nevertheless go on.

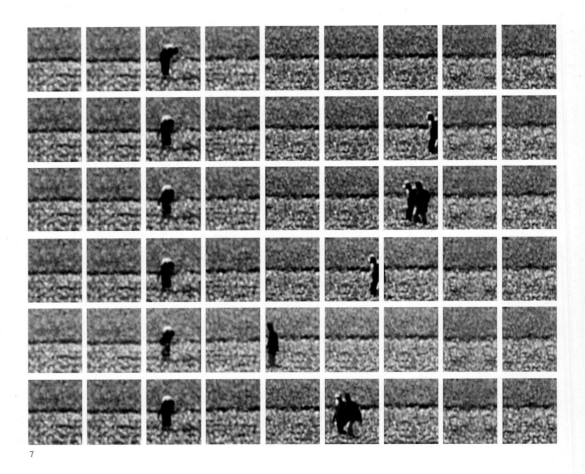

7

Figure 7
Michal Rovner
Stills from *Overhanging*, 1999

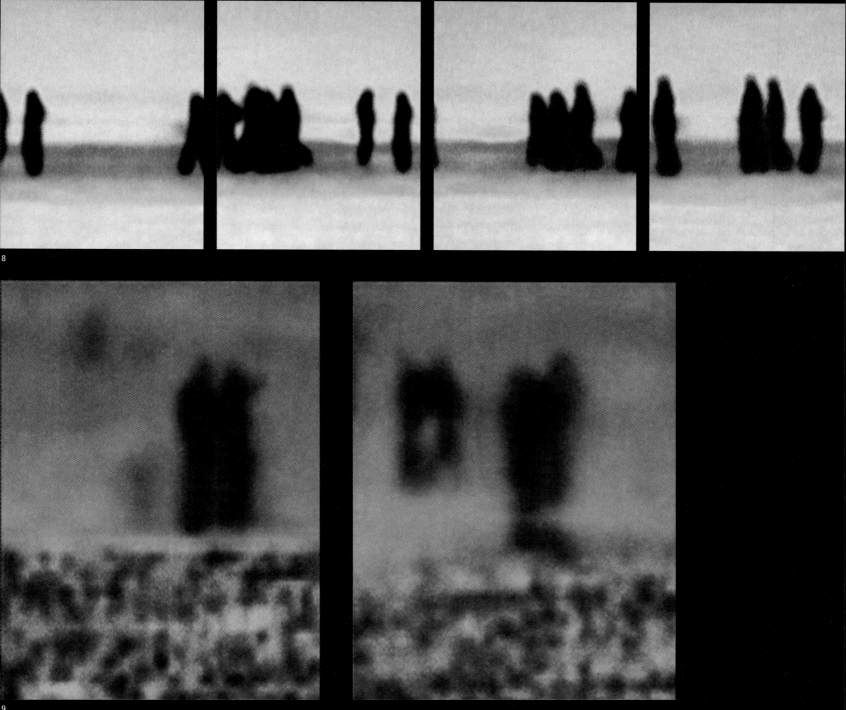

8

9

A single-channel version of this installation, titled *Field 1* (fig. 10), was seen in the *2000 Biennial Exhibition* at the Whitney Museum in New York. Even this relatively compressed version was subtly and stunningly structured, attaining the full effect of the earlier version by using the same repetitive choreography and black-hooded figures traversing a nameless land. But what was all that activity on the front of the screen? A manufactured graininess? An electronic intrusion of the kind the early video engineer Shuya Abe might have invented? To achieve this effect, Rovner overlaid shots of swarms of insects onto the videotape, creating an impression of dense, restless movement (its source is not at all clear from a casual viewing) on the screen, which at first makes the footage seem old, spotty, fading, and after a while, timeless.

Given Rovner's nationality, associations with images of Holocaust prisoners and other victims of war come easily to mind—too easily. Rovner refuses to be specific, preferring to allow her seamless mixture of realism and abstraction to address universal emotions. Like Beckett's characters, Rovner's figures are suspended somewhere between being and nonbeing, reality and fantasy. Unlike them, however, Rovner's are bereft of language. If Beckett's players maintain existence solely through words, Rovner's are doomed to endless, silent movement. What these figures seemingly have in common is infinite repetition, whether of words or of gestures. The urge to go on, to persevere despite a sense of futility gives both Beckett's and Rovner's characters dignity.

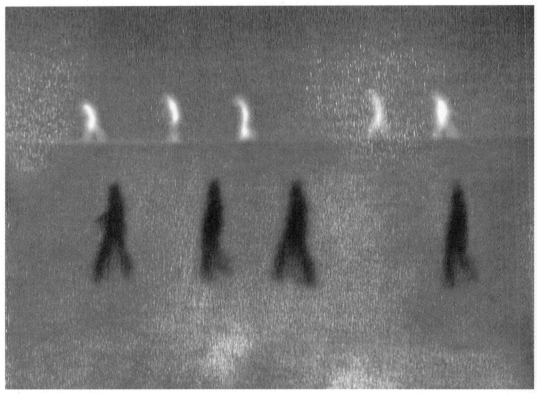

10

Figure 10
Michal Rovner
Still from *Field 1*, 2000

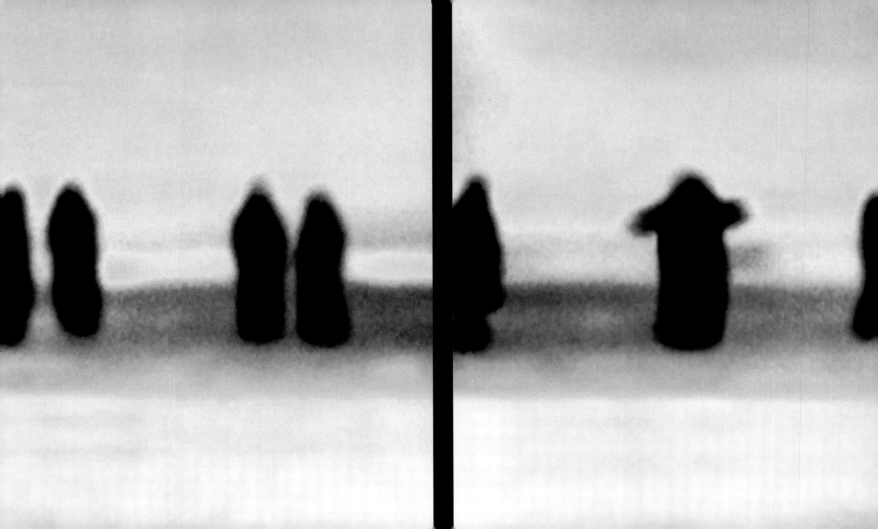

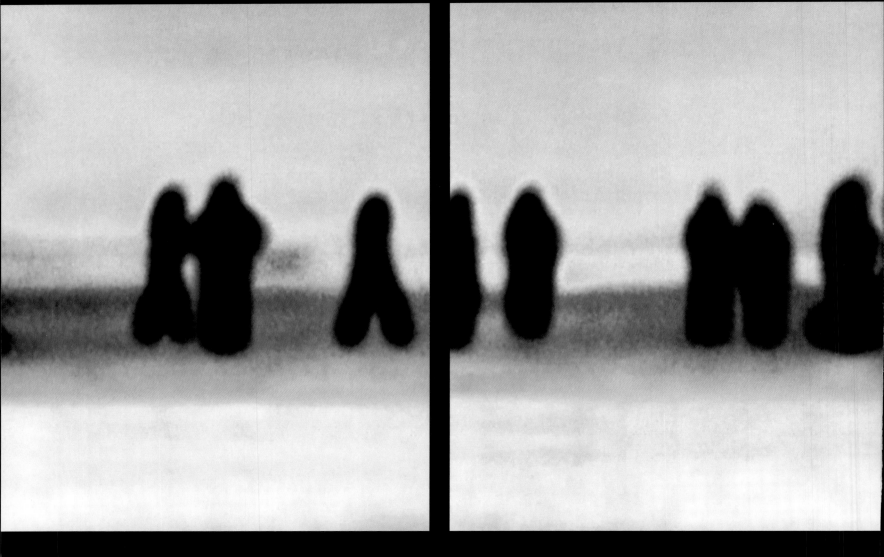

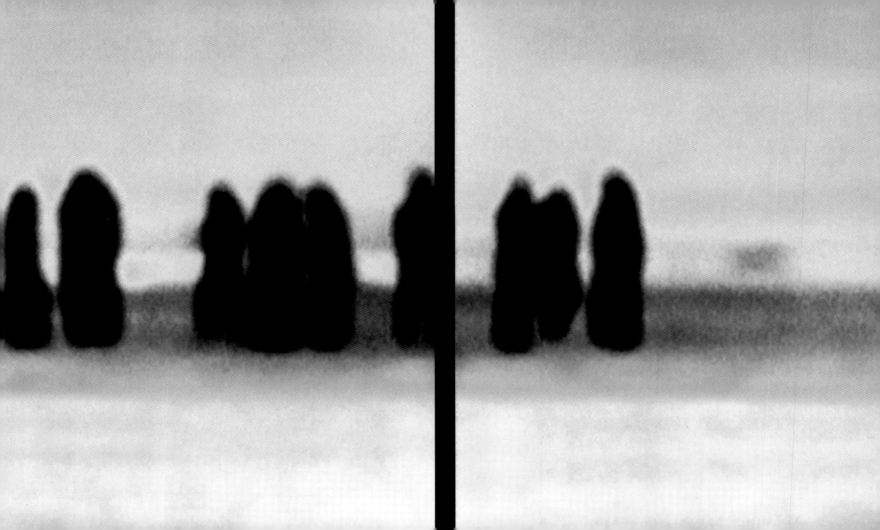

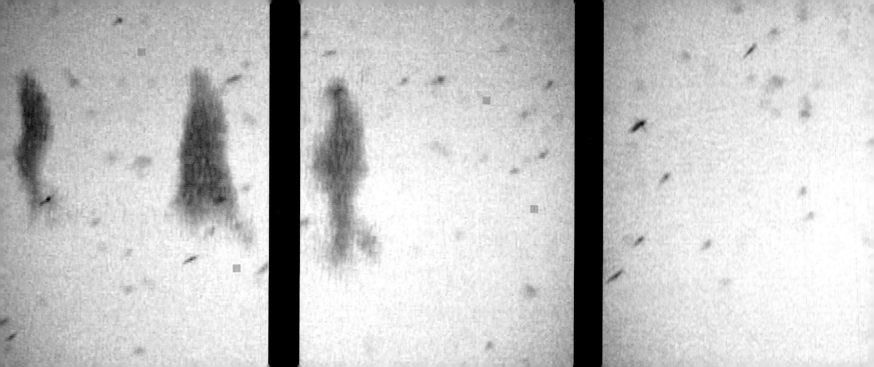

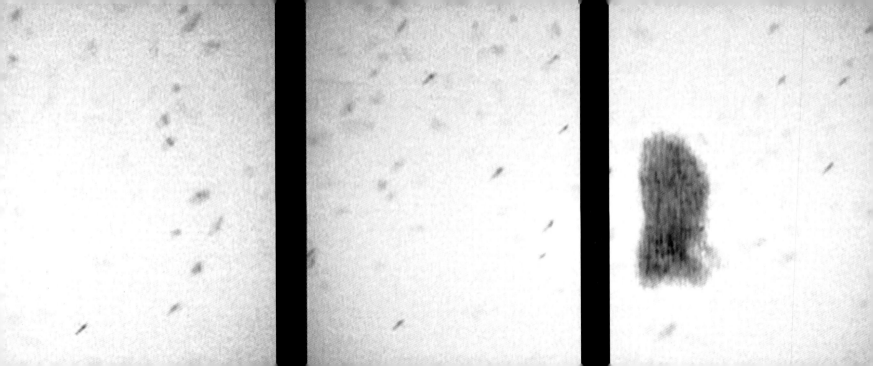

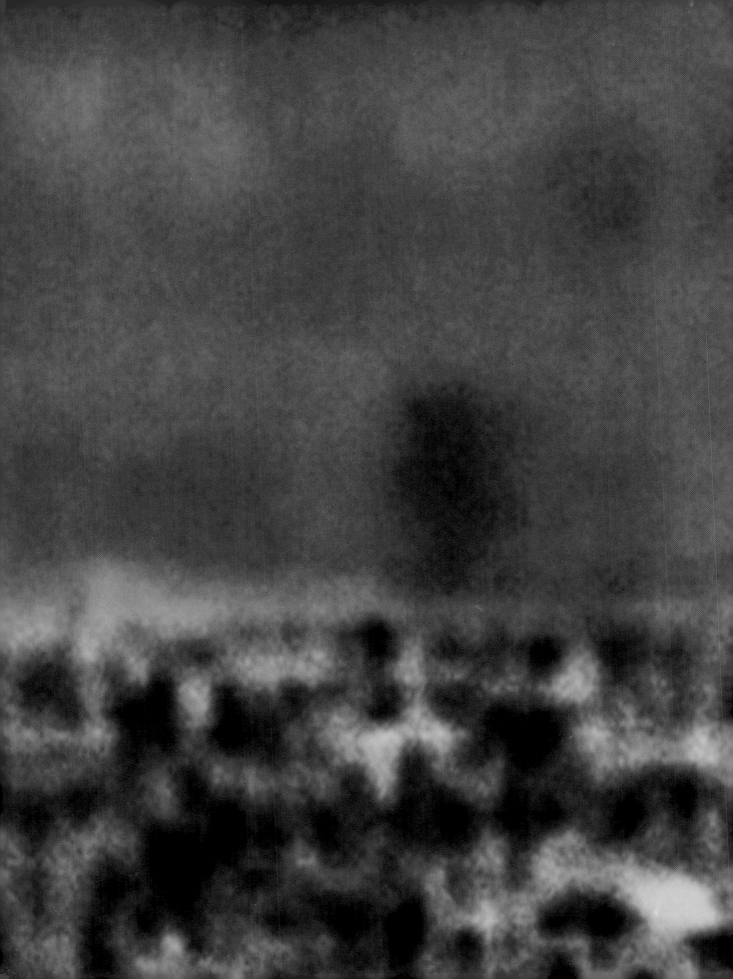

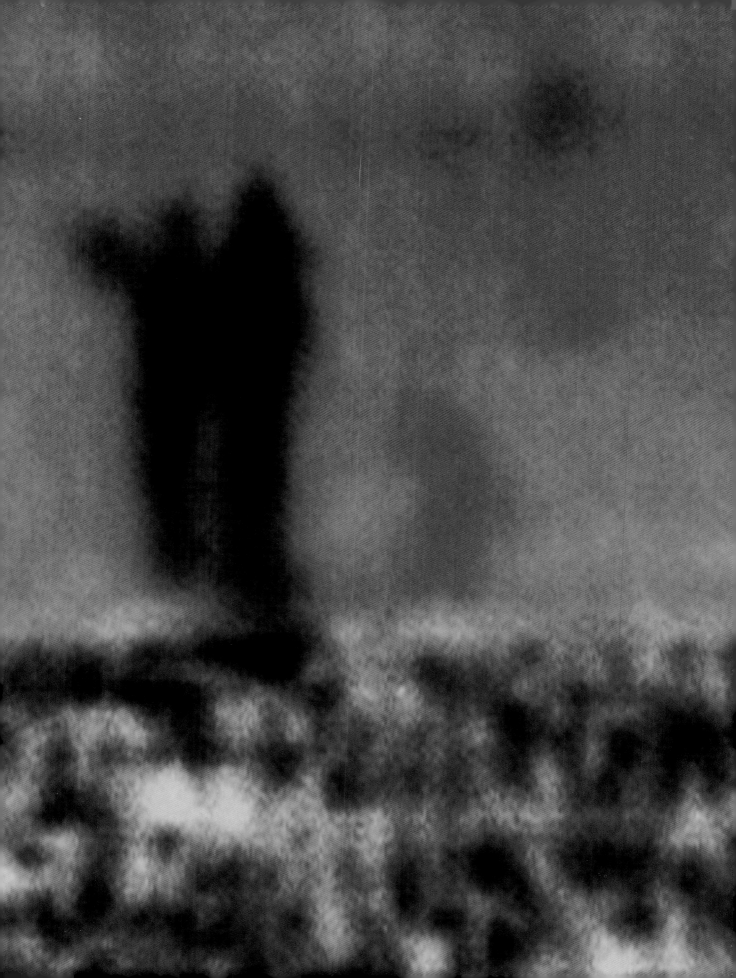

Though Rovner is still in the early stages of exploring the potential of video in her work, it is not too soon to suggest affinities with other media artists of the mid-to late twentieth century, who have created poetic filmic meditations.[4] These predecessors include filmmakers such as Stan Brakhage and Hollis Frampton, and video artists such as Shalom Gorewitz and Mary Lucier. Brakhage's film *Dog Star Man*, filmed from 1959 to 1965, is particularly relevant. In this multipart film, Brakhage offers a vast puzzle of images, sometimes at breakneck speed, that serve as poetic equivalents for his ruminations on the cycle of life and death, the seasons, and the progression from infancy to adulthood. What is important in the context of Rovner's work is Brakhage's physical manipulations of the film in order to offer the viewer a lyrical handle on work of an arduous abstraction.

In "Part One" of *Dog Star Man*, following the dizzying fast cuts of the "Prelude," Brakhage pictures his protagonist struggling to climb a snow-covered mountain (fig. 11). Shots fade in and out very slowly, sometimes melting into green or red. "Part One is a *Noh* drama," Brakhage has written, "the exploration in minute detail of a single action and all its ramifications."[5] With astonishing success, Rovner manipulates her digitized video footage to the same effect. The Giacometti-thin figures in *Overhanging* result from Rovner's almost obsessive process of whittling away all particulars from an image, leaving it barely discernible as human.[6]

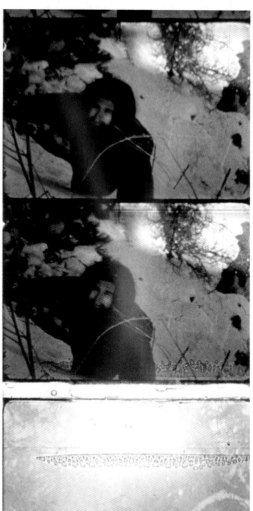

11

Figure 11
Stan Brakhage
Stills from "Part One"
of *Dog Star Man*, 1962

For both Brakhage and Rovner, the "person" in a film is an archetype and thus necessarily anonymous. Persons or figures exist in their work as in a memory or dream, embedded in a continuing struggle from which there is no possibility of emerging. They are lost in endless repetition, suggested by slow motion or the duplication of an image or gesture multiple times. One of Brakhage's signature techniques is to lay images over one another several times. The resulting abstraction renders the original image virtually undetectable, and identifiable only by the most attentive viewer. By adopting such intense abstraction, both Brakhage and Rovner demand that we relinquish our customary search for meaning in film, that we accept, through an altered sense of time and space, a new relationship to what we are seeing. What they offer is an experience of the present moment shaped by color, gesture, sound (or, in Brakhage's case, silence), and mystery. To critic Gene Youngblood, Brakhage was attempting in *Dog Star Man* to express nothing less than "the totality of consciousness, the reality continuum of the living present."[7]

Rovner might not go this far, of course, in describing her own work, but a piece like *Overhanging* does indeed reach in this direction and succeeds in *allowing* for such interpretations. The ambiguous figures in her landscapes, marching endlessly toward an unspecified goal, speak to everyone who has ever asked the existential question "Why?" and found no ready answers.

Rovner's affinity for digital editing techniques also echoes the work of some early video-art explorers for whom the new technology was a means of attaining aesthetic results from electronic devices. Ed Emschwiller (1925–1990), an Abstract Expressionist painter, found in the new technologies animated equivalents for his canvases. Video synthesizers, computer systems, and a Moog audio synthesizer all came into play in his videos, especially in works such as *Thermogenesis* from the early 1970s. Keith Sonnier, another painter, created sensuous multiple-image video collages that served as metaphors for the processes and materials of painting.

Most prominent among these early video artists (in addition to Nam June Paik, who was first out of the gate with almost every technique) were Woody and Steina

Vasulka, who pioneered digital processing and electronic-image processing. In works such as *Home* of 1973, in which colorizing and electronic imaging techniques glamorize everyday objects, and *Golden Voyage*, also of 1973, an homage to the painter René Magritte, the Vasulkas invented new means of electronic manipulation that altered viewers' perceptions in much the same way as Pointillism and Impressionism had done for painting a century before.[8]

As these techniques became more accessible, video artists such as Shalom Gorewitz used them to make more complicated narratives in much the same way as Rovner has, though I would argue that her approach to digital editing is singular among artists. In particular, Gorewitz used imaging devices like the Fairlight CVI and various components of the short-lived Amiga Computer to create poetic meditations on landscapes (*Autumn Floods* of 1979, *Delta Visions* of 1980) and on human relationships and longings (*Jerusalem Road* and *Promised Land*, both of 1990). In some of his tapes, the human figure appears erased or dissolved into some other type of reality in a manner comparable to that found in Rovner's work. Gorewitz also shares Rovner's political determination, though his work is at times much less optimistic.[9]

Mary Lucier is another video artist with whom Rovner shares definite affinities. She, too, began as a still photographer (she was also a performance artist) in the late 1960s, and incorporated technological interventions in her work, as in her 1975 *Air Writing* and *Fire Writing*. Multiple video monitors, lasers, pre-recorded audio texts, and other elements contributed to energetic "techno-performances" that reflected Lucier's profound and enduring interest in air, fire, and earth. Since the 1980s, she has been making lyrical video installations steeped in issues of memory and nature. *Ohio at Giverny* of 1983, *Wintergarden* of 1984, and *Wilderness* of 1986, to name but a few, are all exquisite multi-channel installations, in which landscapes become metaphors for personal memories and dreams. Critic John Russell wrote of *Wilderness*, "The images that come and go (on seven screens) are at once the same and not the same . . . and although the tempo is slow and even, there is more going on at any one time than we can consciously absorb" (fig. 12).[10]

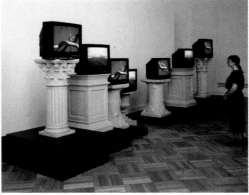

12

Figure 12
Installation view of Mary Lucier's
Wilderness, 1986, at the Henry Art Gallery,
University of Washington, Seattle

207

In her recent work, Lucier, like Rovner, uses technology to add complexity and abstraction to her narratives. In *Forge* and *Nesting*, both made in 2000, she used the digital editing technique called "nesting," which refers to the practice of placing images inside other images to produce a layered effect that suggests the repetitiveness of nature's ways and the lingering of memory.

Rovner is thus representative of the newest generation of video artists for whom digital techniques are paramount. She uses aftereffects with names like "Symphony," "Flame," and "Inferno" to attain her haunting images. Just because they are "digital" doesn't mean these techniques are simple or fast. Rovner may take up to six months to edit a seven-minute tape, painstakingly erasing colors, fabrics, or other elements that might refer to specific places and times. In filming, she may also use "incorrect" exposures to "stretch" images before subjecting these images to further manipulation in post-production.[11]

Rovner's other short video installations, *Mutual Interest* of 1997 (figs. 13–14) and *Coexistence 2* of 2000 (figs. 15–16), illustrate her enduring interest in the potential of highly simplified images to convey meanings about the world around us. She begins with this world and, through painstaking editing processes, arrives at near-abstract results, fully aware of their link to the original images. This working method finds particular resonance in her photographs, which often materialize as outtakes from her edited videos.

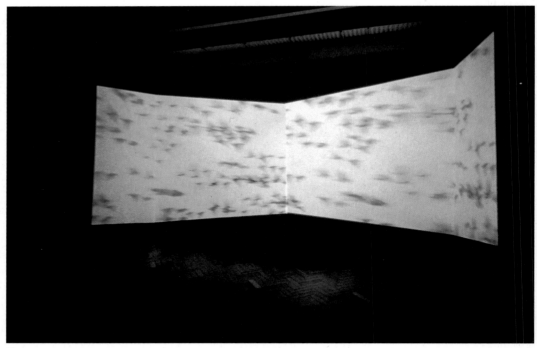

13

Figure 13
Installation view of Michal Rovner's
Mutual Interest, 1997, at the Stedelijk
Museum, Amsterdam

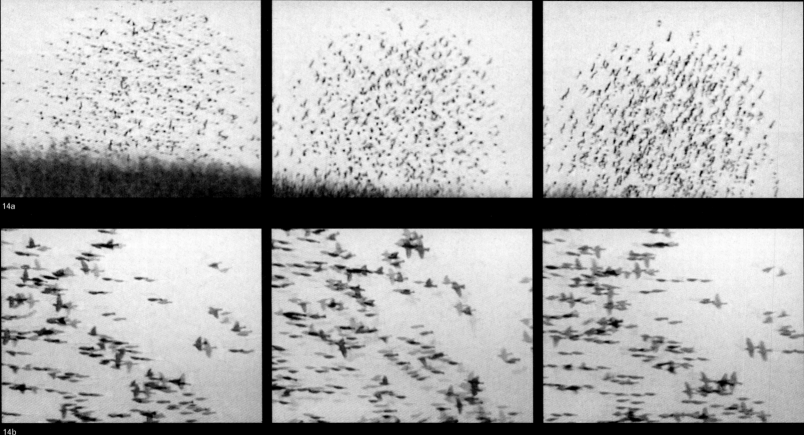

14a

14b

15

Figure 15
Installation view of Michal Rovner's *Coexistence 2*,
2000, at the Corcoran Gallery of Art, Washington, D.C.

Mutual Interest **features a flock of birds flying in patterns around a gray, cloudless sky. Rovner has the birds charging forward and then swiftly backward, looking like dive bombers on a midday raid. Her sound score of helicopter wings piercing the wind builds tension and fosters association with military operations. At one point the birds (hundreds of them) stop in midair as if they had been shot. We expect them to fall. Indeed, her camera captures a few, who had strayed from the pack, flying aimlessly.**

Such editing techniques may at first appear to be pure displays of bravura. But the viewer soon realizes that these seemingly improvisational maneuvers are very consciously calculated for maximum impact. We cannot take our eyes off her images because she convinces us that, if we do, we'll miss the climax.

A similar sense of foreboding permeates *Coexistence 2*, **a short narrative that features a group of men, dressed in black, huddled together on a barren strip of land and filmed at a distance. All of a sudden, they separate and start jostling and pushing each other, in a possible prelude to a fight. We hear wind blowing, as an**

increasing number of darkly clad men gather in the frame. Their bodies become spindle-thin as Rovner manipulates the images like cutouts from a photographic negative. At one point she splices in a quick shot of a large, tense group of men. Though she keeps the image characteristically ambiguous, there is danger in the air.

A catastrophic explosion occurs, and the screen slowly becomes saturated in white as the men disperse in slow motion. One of them, apparently dazed, runs back into the frame as if drawn to his own death. He retreats. In Rovner's mind, it is the little skirmishes that lead to larger and larger fights, and perhaps to con-flagrations.

Rovner's most recent video, *Notes* (2001; fig. 17) is a collaboration with composer Philip Glass. An extraordinarily beautiful and mysterious video, it opens with a shot of a row of odd-looking figures, resembling pods with skinny legs. They are lined up horizontally across the entire frame, standing on dry, rocky terrain. In the distance, a dull-white background gradually takes the form of a snowy hill.

 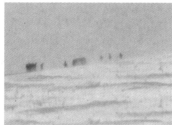 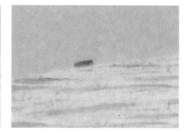

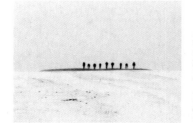 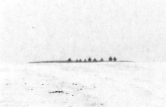

Figure 17
Michal Rovner and Philip Glass
Stills from *Notes*, 2001

Black-clad figures emerge from the other side of the hill into the camera's eye. They, too, form a line. Meanwhile, the strangely shaped figures below stand up, revealing themselves to be men. They face another line of men and, suddenly, they all bow, one row facing the other. The snowy divide (digitally created, as in *Overhanging*) becomes another "border," but here, at least for now, those on either side honor each other in a profound form of submission and respect.

As the video proceeds, more and more figures, silhouetted in black, gather on the hillside in packs and walk slowly toward nowhere in particular. As they proceed down the hill, Rovner makes a quick cut to five horizontal lines (as on a sheet of music). These lines are created from cuts of very thin strips of earth, upon which cluster more black figures. These figures move, sometimes separating, sometimes clinging together, like musical notes, first in the languorous tempo of a Beethoven suite, then like frantic eighth notes in a Bach cantata. Glass's score moves determinedly forward with intermittent clanging sounds, suggesting deep-seated conflict.

Rovner's choreography reverberates in the music and vice versa. The five horizontal lines become crowded with men milling about, huddling, separating, bonding, escaping. References to musical notation are unmistakable. Rovner fades back to the snowy hilltop where a few men now gather toward the left of the frame. Then she leaps again back to the five levels, each with dozens of figures now moving slowly across the lines, one row going forward toward the right, one row walking backward toward the left, while on another row some move left, others right.[12] The effect is mesmerizing and otherworldly.

Finally, all the "notes," the dozens and dozens of figures in black, stand on their assigned row and bow in unison. The camera fades to the snow-capped hill where a few figures remain. They turn and walk down the hill away from the camera; the music stops, the screen abruptly goes black.

Having had her characters bow, shake hands, walk together, and stand side by side, Rovner appears hopeful that union can be achieved. This is what sets her apart from Beckett and the existentialist Alberto Giacometti. For them, the void is a natural habitat for human beings, who are, after all, solitary. Giacometti's *Three Men Walking I* of **1948–49** anticipates Rovner's semi-choreographed videos, but the men in the sculpture are caught in the eternal stillness of their bronzed stance. They are not really "walking," of course. Rovner's figures are, and they are walking, it turns out, toward reconciliation. Their movements have purpose, while those of Giacometti's figures do not.

Giacometti's figures are shown standing, seated, or in movement. His thin characters sometimes point, walk, or turn around, as if responding to a voice. Beckett's, by contrast, are often constricted (buried in sand or confined to garbage cans). Still they strive for expression and, above all else, they "go on," despite their constraints. This is the triumph of the human for Beckett: to go on in the face of the meaninglessness that seems to surround us.

Rovner is much more of an optimist, but not a sentimental one. Her landscapes are as barren as any in Beckett, her silhouetted figures as lonely as any of Giacometti's bronzes, but, eventually, they find themselves in the company of others. In fact, the others turn out to be very much like themselves. Rovner seems to believe that, unless these solitary figures in a landscape recognize their interdependence, they will destroy each other.

The silhouetted figures in Rovner's video installations do not speak. They walk, they huddle together, they sometimes raise their arms, they seem to multiply rapidly, they disappear and return. They live either on dry, rocky terrain or on snowy hillsides. They carry nothing, they do not sing. They move to the left and to the right and sometimes backward. They do not write. They do not drink. But they do bow. Strangely enough, in their peculiar, silhouetted world, they sometimes face each other or the sky, and they bow.

Notes

1 Samuel Beckett, *Stories and Texts for Nothing* (New York: Grove Press, 1967), p. 137.

2 Rovner, in conversation with the author, June 2001.

3 Samuel Beckett, *The Unnamable* (New York: Grove Press, 1958), p. 179.

4 "Filmic" seems a useful word to describe the moving image medium, embracing both video and film. Videotape and 35mm film are both used "to film" images; hence, the word filmic.

5 Stan Brakhage, quoted in P. Adams Sitney, *Visionary Film* (New York: Oxford University Press, 1979), p. 174.

6 This comparison is not casual. Rovner's figures in *Overhanging* do indeed echo Giacometti's in all their existential spareness. For a comparison between Giacometti's sculpture and Beckett's writings, see Matti Megged, *Dialogue in the Void: Beckett and Giacometti* (New York: Lumen Books, 1985).

7 Gene Youngblood, *Expanded Cinema* (New York: E. P. Dutton & Co., 1970), p. 88.

8 Cf. Michael Rush, *New Media in Late Twentieth-Century Art* (New York and London: Thames and Hudson, 1999), p. 88ff.

9 Cf. Lori Zippay, ed., *Artists' Video: An International Guide* (New York: Cross River Press, 1991), pp. 95–97.

10 John Russell, "Mary Lucier," *New York Times*, 10 November 1989; reprinted in Melinda Barlow, ed., *Mary Lucier* (Baltimore: Johns Hopkins University Press, 2000), p. 151.

11 Rovner, in conversation with the author, July 2001.

12 In the text Beckett provided for *Foirades/Fizzles*, his 1976 collaboration with Jasper Johns, one of the characters describes his obsessive movement around his room in terms of repeated steps to the left, then to the right, over and over. See S. E. Gontarski, ed., *Samuel Beckett: The Complete Short Prose: 1929–1989* (New York: Grove Press, 1989), pp. 225–46, which provides only Beckett's text; and *Foirades/Fizzles: Echo and Allusion in the Art of Jasper Johns* (Los Angeles: Wight Art Gallery, University of California, 1987), which reproduces the entire collaboration, including Johns's etchings.

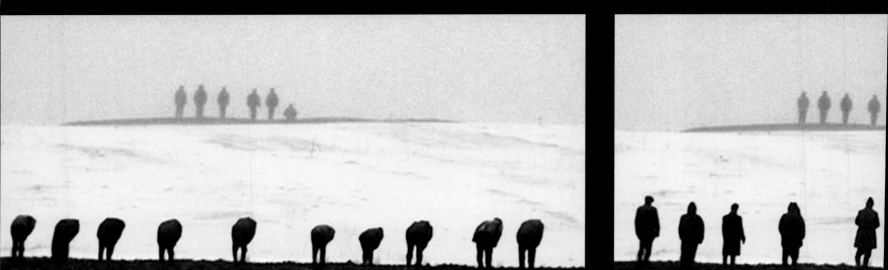

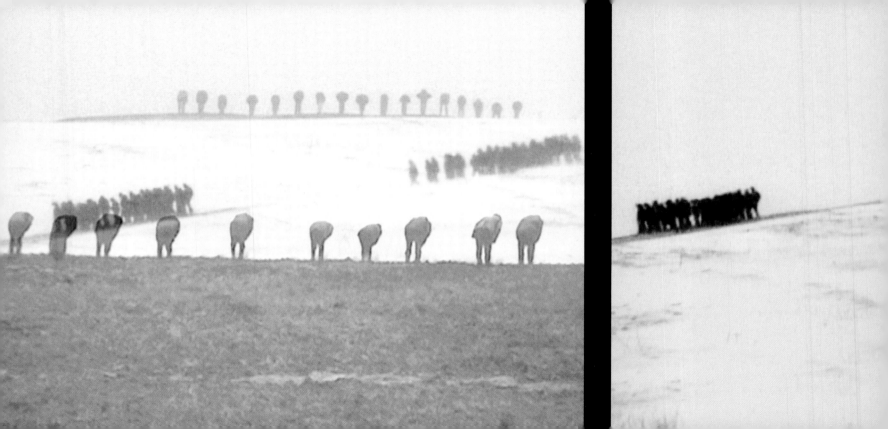

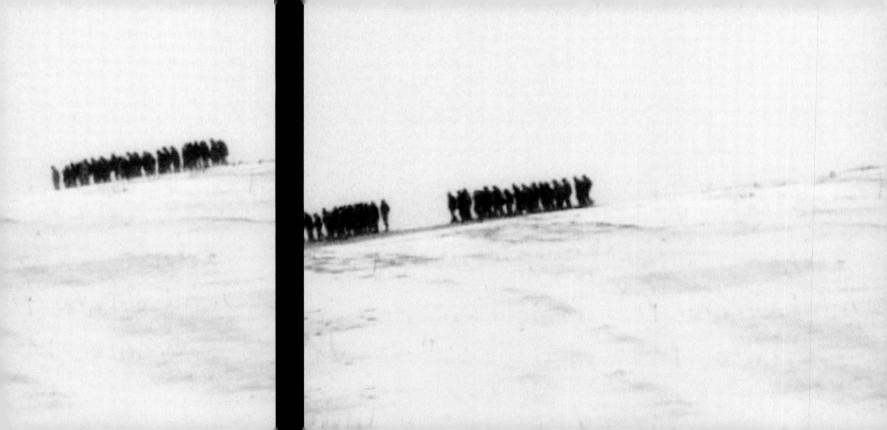

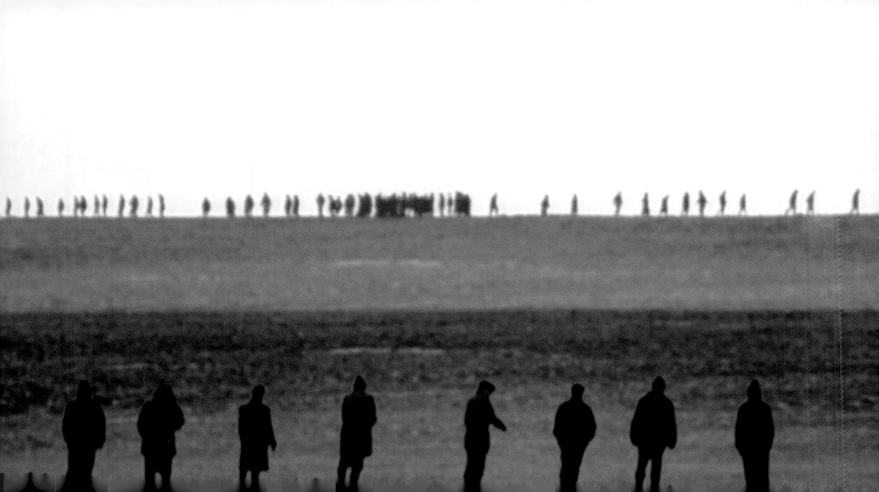

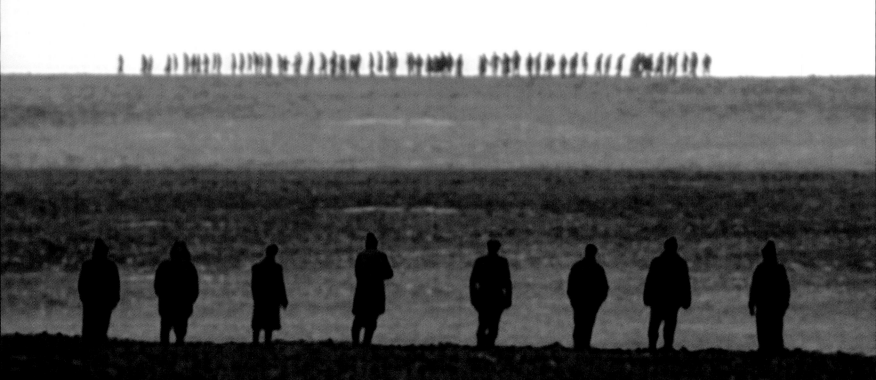

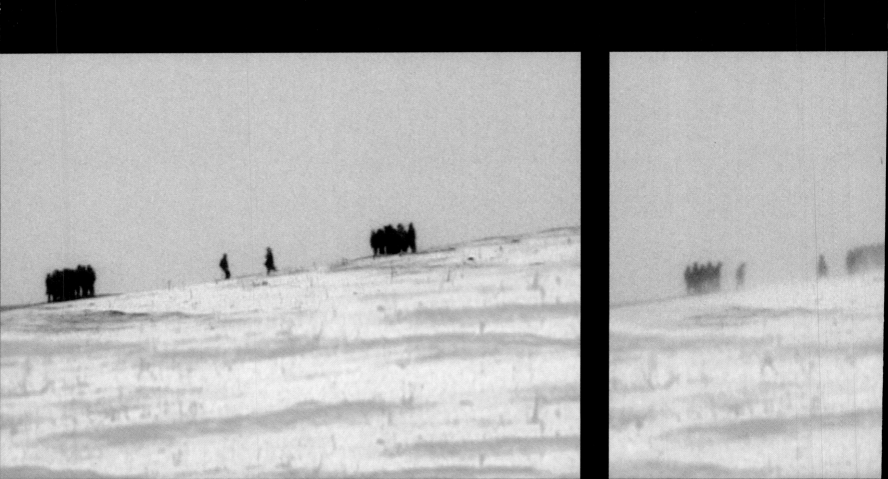

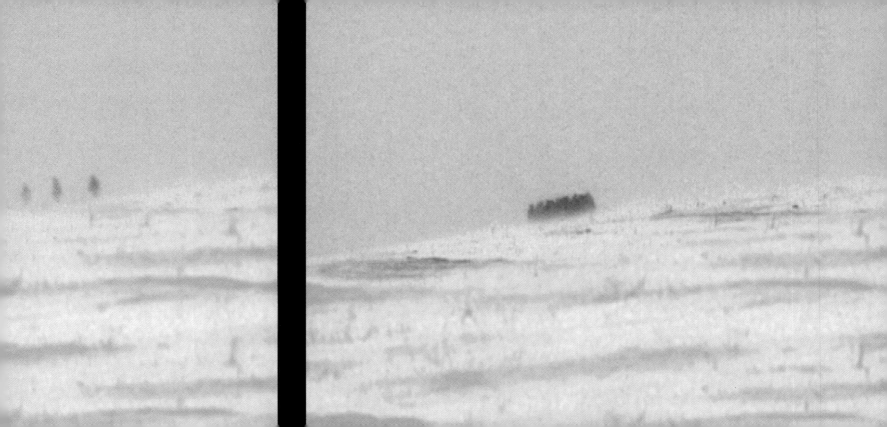

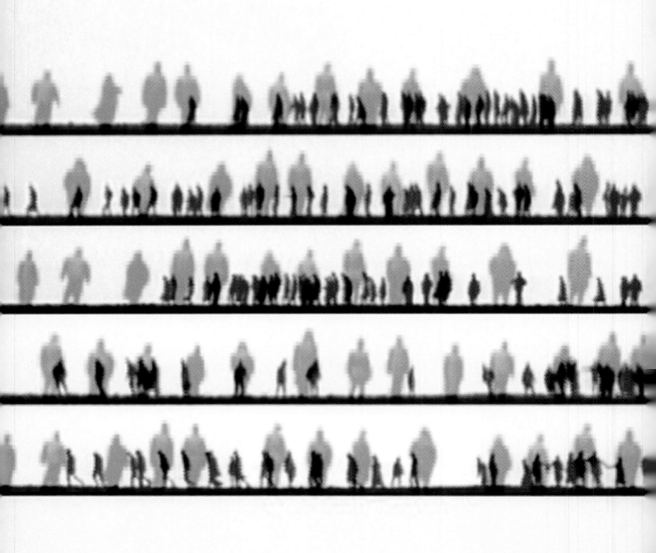

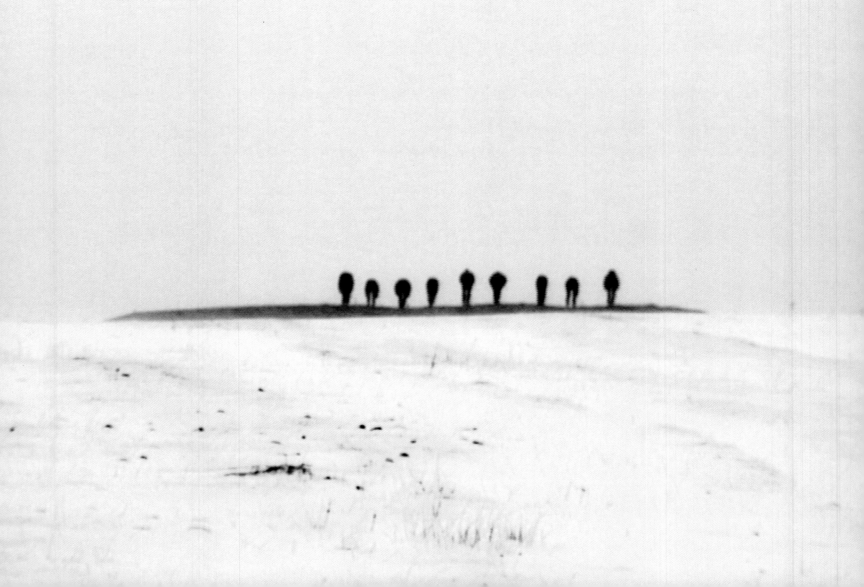

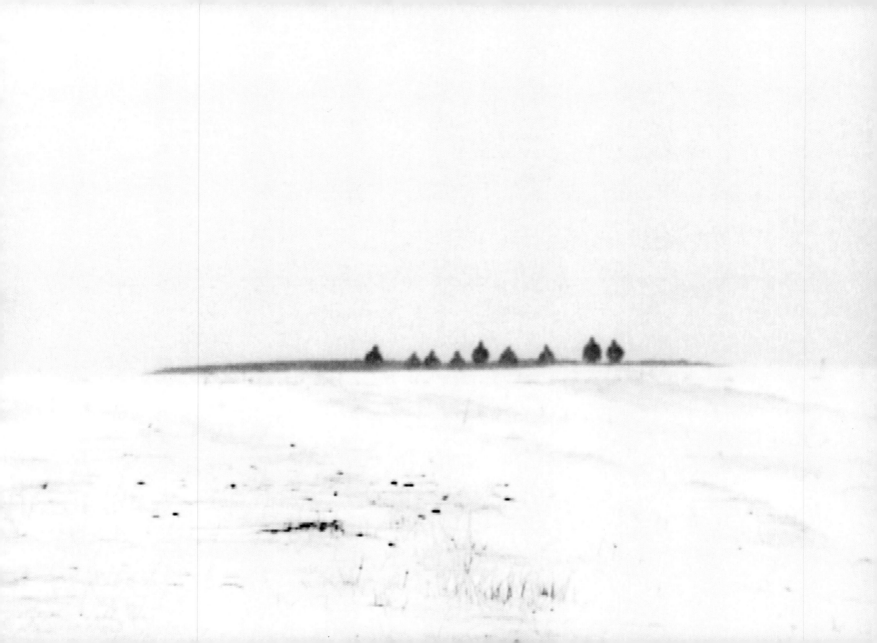

CHRONOLOGY

YUKIKO YAMAGATA

1957

Michal Rovner is born November 7 **in Tel Aviv,** the youngest child of **Jacob** and **Ruth Rovner.** Her sister, **Daphna,** was born in 1950, and her brother, **Oded,** was born in 1953. **Jacob,** a businessman, is a descendant of the first Russians to settle in **Israel** in the late nineteenth century. **Ruth,** a homemaker, had moved to **Israel** from Germany in 1933. **Rovner is raised in Ramat Chen,** a small neighborhood on the outskirts of **Tel Aviv (fig. 1).**

1967

June 5–10 **Israel launches a preemptive attack against Egypt, Syria, and Jordan** in what is known as the **Six-Day War.**

1972

Brother, Oded, is killed in a car accident on the way home from army service.

1973

October 6 **Israel is attacked by Egypt and Syria on Yom Kippur,** the holiest day of the Jewish calendar, marking the beginning of what is known as the **Yom Kippur War.**

1973–75

Trains as a jazz, classical, and modern dancer, with thoughts of a professional career in dance.

1975–77

Holds an administrative position at Kiria army base in Tel Aviv (fig. 2), as part of her two-year mandatory army service in the **Israel Defense Force.**

1978

With boyfriend Arie Hammer, an amateur photographer, **opens Camera Obscura, Israel's first professional darkroom space, in Tel Aviv. Camera Obscura** would later become a school for photography, film, and video.

1979

Takes photography classes at Camera Obscura, while running the school with **Hammer.**

March 26 **Israel and Egypt sign a peace treaty** that ends thirty years of hostilities between the two nations.

1979–81

Studies philosophy, cinema, and television at Tel Aviv University.

1981

July 7 **Marries Arie Hammer. Settles with Hammer in Jerusalem.**

Enrolls at Bezalel Academy of Art and Design in Jerusalem to study photography.

Takes photographs of the desert landscape and of her husband's family farm.

1

2

Figure 1
Rovner and her dog, 1962/63

Figure 2
Rovner in army barracks, 1975/77

1982
First visit to New York, with Hammer.

1983
Robert Frank visits Israel to teach a workshop at Camera Obscura.

1985
Receives bachelor of fine arts degree in photography from Bezalel Academy of Art and Design, Jerusalem.

Moves with Hammer to a farmhouse in Kefar Shemu'el, in the Valley of Ayalon, Israel. Takes photographs in and around the farm.

Travels to Italy and Germany with parents. Takes photographs of rural cottages in the German landscape (fig. 3).

Lee Friedlander visits Israel to teach a workshop at Camera Obscura.

1986–87
Teaches photography at Camera Obscura.

Makes series of color photographs of her black mutt, Stella, and of the tree in her backyard.

1987
Winter **Travels to New York to buy books for a library at Camera Obscura.**

Summer **Moves to New York to live and work.**

1988–89
Rovner and Hammer divorce.

Spring **Travels to Cairo, Egypt. While there, buys taxidermy animals.**

Makes color photographs of plastic, dead, and taxidermy animals in her New York studio apartment, and a series of pictures of an actor in theatrical makeup (fig. 4).

1989
Assists Robert Frank in editing the photographs for the third edition of his book *The Lines of My Hand.*

On a trip to Israel, discovers a Bedouin house on a hill in the Negev Desert, which becomes the subject of the series *Outside*. **The first images in the series are in pastels or bright colors.**

1990
Collaborates on the script and acts as director's assistant for Frank's film *C'est Vrai! (One Hour).*

First solo museum exhibition at the Tel Aviv Museum, accompanied by a catalogue titled *Outside: Michal Rovner, Works, 1987–1990*.

3

4

Figure 3
Michal Rovner
Untitled (Germany), 1985

Figure 4
Michal Rovner
Illuminating Man, 1988/89

234

1991

January 15 **The outbreak of the Persian Gulf War interrupts work on** *Outside* **series. Rovner watches news coverage from her New York studio and photographs television footage with a Polaroid camera. These Polaroid images become the source material for the series** *Decoy.*

February 17 **Cease-fire declared.**

Returns to the *Outside* **series, making images in muted grays and browns.**

Collaborates on the script and acts as director's assistant for Frank's film *Last Supper.*

Parkett/Der Alltag publishes her first book, *Ani-Mal.*

1992–93

Produces a series of photographs of young men floating in the Dead Sea, titled *One-Person Game Against Nature.* **Creates two separate sets of pictures, one made with Polaroid materials, the other recorded by a video camera (fig. 5).**

1993

September 10 **Israel and the Palestinian Liberation Organization sign an agreement of mutual recognition, known as the Oslo Accord.**

First solo museum exhibition outside Israel at the Art Institute of Chicago, accompanied by a catalogue titled *Michal Rovner.*

1994

Included in *New Photography 10* **at the Museum of Modern Art, New York, with Shimon Attie, Abelardo Morell, and Jorge Ribalta.**

Solo exhibition at the Israel Museum, Jerusalem, accompanied by a catalogue titled *Michal Rovner: One-Person Game Against Nature.*

1995

Creates *Tel (Hill).* **Her first site-specific piece,** *Tel (Hill)* **consists of a mural (27 x 147 ft.) wrapped around the Colonnade House, a landmark building in downtown Tel Aviv.**

Creates *Coexistence 1.* **This site-specific project consists of a mural (16 x 64 ft.) hung in Mitzpe Ramon in Israel's Negev Desert. This work is part of a public art project undertaken by the International Artists' Museum, following the 1993 Oslo Accord (figs. 6a–b).**

Autumn **Spends three weeks in China with a group of Chinese and American students of Qigong, a form of martial art.**

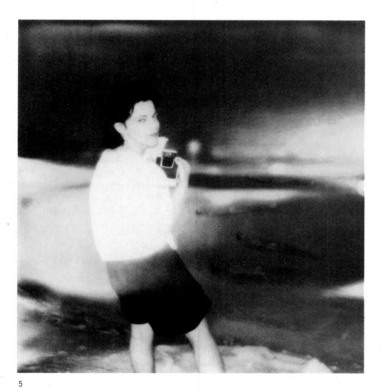

5

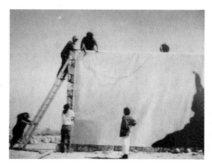

6a

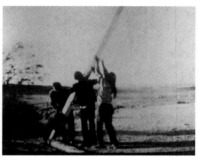

6b

Figure 5
Rovner at the Dead Sea,
August 1993

Figures 6a–b
Stills from video by Michal Rovner
of installation of *Coexistence 1*, 1995

1996

Creates *Dilemmas: The Good Fence*. **This site-specific installation (approximately 137 ft. long) consists of forty-four flags hung above an electric fence at the Israel-Lebanon border, during a time of fire exchange between the two countries. The flags are printed on both sides with an** *X*.

Creates *Edge-Tower*. **This site-specific installation consists of two banners, (each approximately 197 feet long), printed with figures (fig. 7). The banners are stretched from a single guard tower in opposite directions over the Israel-Lebanon border.**

Begins videotaping documentary footage on and around the border of Israel and Lebanon. Footage is edited to create the fictional video *Border* **(1996/97).**

Begins shooting footage of birds in both California and Israel. With this footage, she creates the video *Mutual Interest* **(1997), photographic works (1997–99), and a series of monoprints (1998).**

1997

Border **premieres at the Museum of Modern Art, New York, as part of the museum's Film and Video Program (for a detailed list of the film's screenings, see "Selected Exhibitions").**

Exhibition at the Tate Gallery, London, of murals and the video installation *Mutual Interest*. **Screening of first revision of** *Border*.

Second revision of *Border* **screened at the Los Angeles County Museum of Art.**

1998

Summer **Travels to Athens, Greece, to participate in a group show of Israeli artists. While there, buys waxed paper used in monoprints made the same year.**

1999

Shoots footage in Israel that will result in the video *Overhanging* **and a series of canvas works (fig. 8).**

Creates *Overhanging* **at the Stedelijk Museum Amsterdam. This video installation stretches along two sides of a 130-foot gallery in eighteen floor-to-ceiling sections; it is seen from indoors during the daytime and from outdoors at night.**

Creates *Eagle Butterflies*, **a flat-screen double-image video.**

7

8

Figure 7
Still from video by Ofer Harari of Rovner
preparing for installation of *Edge-Tower*, 1996

Figure 8
Still from video by Ardon Bar-Hama of Rovner
during shooting of *Overhanging*, Israel, 1999

2000

Goes on a retreat to a monastery in Beit Jamal, Israel. The silent nuns in residence are the inspiration for a series of photographs made that same year, titled *Nuns*.

Field 1, from *Overhanging*, is included in the *2000 Biennial Exhibition* at the Whitney Museum of American Art, New York.

Creates *Overhang*, a variation on her video installation *Overhanging*, mounted on seventeen windows of the Chase Manhattan Bank, Park Avenue and Fifty-fifth Street, New York.

Autumn Travels to Russia to shoot video footage for *Coexistence 2*, *Notes*, and *Time Left* (fig. 9).

Third revision of *Border* screened at Tel Aviv Cinematheque.

Creates *Coexistence 2*, a three-screen video installation shown as part of *Media/Metaphor*, a biennial exhibition at the Corcoran Gallery of Art, Washington, D.C.

2001

Spring Travels to Romania to shoot video footage for *Notes* and *Time Left*.

July 26 *Notes*, a video collaboration with Philip Glass, premieres at Lincoln Center, New York, as part of Glass's *Shorts* program.

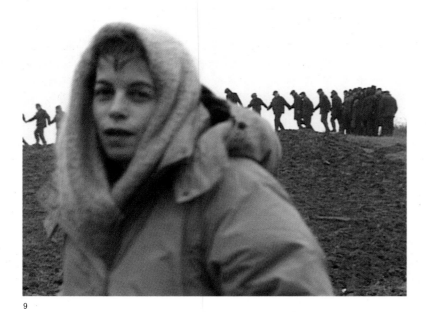

9

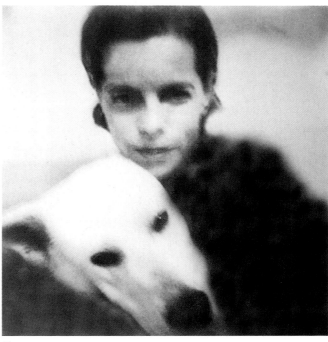

10

Figure 9
Still from video by Dan Itzhaki of Rovner during shooting of preliminary studies for *Time Left*, Russia, 2000

Figure 10
Michal Rovner
Self-Portrait with Tomas, 2000

Selected Exhibition History

The items listed below are organized alphabetically within each year by the name of the exhibiting institution. When an exhibition straddles two years, it is listed under the year it opened. Exhibition titles are not given when they consist simply of the artist's name. The list of solo exhibitions includes shows that featured Michal Rovner and one other artist. Video installations, screenings, and special projects are listed separately after group exhibitions.

Solo Exhibitions

1987

Dizengoff Center, Tel Aviv, *Michal Hammer: Photographic Works.*

1988

Silver Bullet Gallery, Providence, Rhode Island.

1990

Brent Sikkema Fine Art, New York.
Tel Aviv Museum of Art, *Outside: Michal Rovner, Works, 1987–1990* (cat.).

1991

S. Bitter-Larkin, New York (with Yigal Ozeri; cat.).
Grant Gallery, Denver, *Michal Rovner: Decoy.* Traveled to the Ansel Adams Center, San Francisco, 1992, as *Decoy: Michal Rovner, Photographs of the Gulf War.*
La Maison Culture Mercier, Montreal.

1992

Prague House of Photography.
Betsy Rosenfield Gallery, Chicago, *Michal Rovner: "Outside 1990" and "Outside 1991."*
Stephen Wirtz Gallery, San Francisco, *Michal Rovner: "Outside 1990" and "Outside 1991."*

1993

The Art Institute of Chicago (cat.).
Rhona Hoffman Gallery, Chicago.
Peter Kilchmann Galerie, Zurich.

1994

Laura Carpenter Fine Art, Santa Fe, New Mexico.
Galerie Ghislaine Hussenot, Paris (with Adam Fuss).
The Israel Museum, Jerusalem, *Michal Rovner: One-Person Game Against Nature* (cat.).
New Gallery, Houston.

1995

Stephen Friedman Gallery, London.
Rhona Hoffman Gallery, Chicago, *Michal Rovner: New Work.*

1996

The Bohen Foundation, New York, *Michal Rovner: Works, 1991–1995* (brochure).

1997

Pace Wildenstein MacGill, New York, *Michal Rovner: Photographic Works.*
Tate Gallery, London (brochure).
Shoshana Wayne Gallery, Santa Monica, California.
Stephen Wirtz Gallery, San Francisco.

1998

Stephen Friedman Gallery, London.
Rhona Hoffman Gallery, Chicago, *Michal Rovner: Recent Work.*
Studio Stefania Miscetti, Rome, *Michal Rovner: Recall Seeing.*
New Gallery, Houston, *Border.*
The Schmidt Center Gallery, Florida Atlantic University, Boca Raton, *Michal Rovner: Selected Works, 1991–1998* (brochure).

2000

New Gallery, Houston, *Michal Rovner: Between.*
Stephen Wirtz Gallery, San Francisco, *Michal Rovner: New Works.*

2001

Baldwin Gallery, Aspen, Colorado, *Michal Rovner: New Work.*
Kemper Museum of Contemporary Art, Kansas City, Missouri, *Michal Rovner: Works* (brochure).
Shoshana Wayne Gallery, Santa Monica, California.

Group Exhibitions

1985

Camera Obscura Gallery, Tel Aviv.
Mishkan Le'Omanut, Museum of Art, Ein Harod, Israel, *The First Line* (cat.).

1986

Mishkan Le'Omanut, Museum of Art, Ein Harod, Israel, *The Photography Biennale* (cat.).

1987

Photocollect Gallery, New York, *The Animal Show.*

1988

Gallery at Beit Ariela Library, Tel Aviv.
Tel Aviv Museum of Art, *Skyline: Israeli Photographers Contemplate the Landscape* (cat.).

1989

Camera Obscura Gallery, Dizengoff Center, Tel Aviv, *Memory Channels: Imagined and Reimagined Images.*
Janco Dada Museum, Ein Hod, Israel, *Beyond the Frame. Five Photographers* (cat.).

1990

New Gallery, Houston, *Fotofest.*
Paula Cooper Gallery, New York, *Act-Up.*
Tel Aviv Museum of Art, *The Museum as Collector: Selected Acquisitions, 1979–1989.*
Tel Aviv Museum of Art, *Winners of the America-Israel Cultural Foundation Scholarships.*

1991

Haifa Museum of Modern Art, *Selected Art and Design Works by America-Israel Cultural Foundation Scholarship Recipients.*
The Genia Schreiber University Art Gallery, Tel Aviv University, *The Presence of the Absent: The Empty Chair in Israeli Art* (cat.).

1992

New Gallery, Houston, *Fotofest.*
Rose Art Museum, Brandeis University, Waltham, Massachusetts, *Breakdown* (cat.).
The Genia Schreiber University Art Gallery, Tel Aviv University, *Postscripts: "End," Representations in Contemporary Israeli Art* (cat.).

1993

Laura Carpenter Fine Art, Santa Fe, New Mexico, *Image First: Eight Photographers for the '90s.*
Fisher Gallery, University of Southern California, Los Angeles, *Locus: Contemporary Art from Israel* (cat.).
The Jewish Museum, New York, *Collecting from the Twenty-first Century: Recent Acquisitions and Promised Gifts.*
Barbara Mathes Gallery, New York, *On Paper.*
John Stoller Gallery, Minneapolis.
Tel Aviv Museum of Art, *Collection Plus: The Range of Realism.*

1994

Bineth Gallery, Tel Aviv, *Art Focus.*
Castle Gallery, College of New Rochelle, New York, *Toys/Art/US* (cat.).
Marc Jancou Gallery, London, *The Little House on the Prairie.*
The Museum of Modern Art, New York, *New Photography 10: Shimon Attie, Abelardo Morell, Jorge Ribalta, Michal Rovner.*
New Jersey Center for Visual Arts, Summit, *House Sweet House* (cat.).
Wooster Gardens, New York, *Uta Barth, Christopher Bucklow, Jan Henle, Michal Rovner: Photography.*

1995

David Adamson Gallery, Washington, D.C., *Beyond the Looking Glass: Contemporary Women Photographers*.
Pamela Auchincloss Gallery, New York, *Mediated Images: Burt Barr, Peter Campus, Bruce Nauman, Michal Rovner*.
Montage Gallery, Derby Photography Festival, England, *Displacements: Aspects of Change in the Late Twentieth Century*.
San Francisco Museum of Modern Art, *The Photographic Condition*.
Yad-Labanim Museum, Petach Tikva, Israel, *The Myth of Daedalus and Icarus* (cat.).

1996

Corcoran Gallery of Art, Washington, D.C., *From the Collection: Recent Acquisitions of Photography*.
Stephen Friedman Gallery, London, *A Group Show*.
John Hansard Gallery, University of Southampton, England, *Desert* (cat.).
Nicole Klagsbrun, New York, *Making Pictures: Women and Photography, 1975–Now*. A reduced version of this show traveled to the Bernard Toale Gallery, Boston, 1997.
The Light Factory, Charlotte, North Carolina, *A Delicate Balance: Six Israeli Photographers* (cat.). Traveled to the Ashville Art Museum, North Carolina, 1997; the Wellington B. Gray Gallery, East Carolina University, Greenville, North Carolina, 1997; and the St. John's Museum of Art, Wilmington, North Carolina, 1997.
Barbara Mathes Gallery, New York, *The House Transformed*.

1997

Dazibao, Centre de photographies actuelles, Montreal, *De la minceur de l'image/The Tenuous Image* (cat.).
Haifa Museum of Modern Art, *Another Language*.
New Gallery, Houston, *The Thom Conjecture: Michal Rovner, Fran Siegal, Sharon Horvath, Moshe Gershuni*.

1998

Museo de Arte Moderno, Cuenca, Sucre, Mexico, *Borderline Figuration: Digital Art Forms*. Organized by Pan American Cultural Exchange, Houston. Traveled to Museo Nacional del Banco Central del Ecuador, Quito, 1999; and Museo Antropologico del Banco Central, Guayaquil, 1999.
Brunei Gallery, School of Oriental and African Studies, University of London, *Contemporary Israeli Art: Three Generations* (cat.). Organized by the Tel Aviv Museum of Art. Traveled to the National Gallery, Alexandros Soutzos Museum, Athens, 1998.
De Chiara/Stewart, New York, *Back to Back*.
Stephen Friedman Gallery, London, *Group Show of Gallery Artists*.
The Jewish Museum, San Francisco, *50/Fifty: Israeli Art from Bay Area Collections* (brochure).
Jason McCoy, New York, *Summer Group Show*.

Pori Art Museum, Finland, *Animal. Anima. Animus* (cat.). Traveled to Museum voor Moderne Kunst, Arnhem, Holland, 1998–99; P.S. 1, New York, 1999; and Winnipeg Art Gallery, 2000.
Pusan Metropolitan Art Museum, Korea, *Light on the New Millennium: Wind from Extreme Orient* (cat.).
Whitney Museum of American Art, New York, *Hindsight: Recent Work from the Permanent Collection*.

1999

Museum of Contemporary Art, Chicago, *Apposite Opposites: Photography from the MCA Collection*.
John Hansard Gallery, University of Southampton, Highfield, England, *Lie of the Land: Earth, Body, Material* (cat.). Traveled to Arnolfini, Bristol, England, 2000.
Samuel P. Harn Museum of Art, University of Florida, Gainesville, *The Perpetual Well: Contemporary Art from the Collection of The Jewish Museum* (brochure). Organized by the Jewish Museum, New York. Traveled to the Sheldon Memorial Art Gallery and Sculpture Garden, University of Nebraska, Lincoln, 2000; and the Parrish Art Museum, Southampton, New York, 2000.
Whitney Museum of American Art at Champion, Stamford, Connecticut, *Zero-G: When Gravity Becomes Form*.

2000

Applied Materials, Applied Global University, Santa Clara, California, *Looking Ahead: Visions of Israel* (cat.). Traveled to the San Jose Institute of Contemporary Art, 2000.
Stephen Friedman Gallery, London, *Drawing*.
Herbert F. Johnson Museum of Art, Cornell University, Ithaca, New York, *One Man's Eye: Photographs from the Alan Siegel Collection* (cat.).
Tel Aviv Museum of Art, *Exposure: Recent Acquisitions, The Doron Sebbag Art Collection, O.R.S. Ltd.* (cat.).

Video Installations

1997

Mutual Interest, Stedelijk Museum, Amsterdam, as part of *World Wide Video Festival*.
Mutual Interest, Tate Gallery, London.

1999

Overhanging, Stedelijk Museum, Amsterdam, as part of *World Wide Video Festival*.
Mutual Interest, P.S. 1, New York, as part of *Animal. Anima. Animus* (cat.).

2000

Overhang, Chase Manhattan Bank (Park Avenue and Fifty-fifth Street), New York. Organized by Deitch Projects.
Coexistence 2, Corcoran Museum of Art, Washington, D.C., as part of *Media/Metaphor: The Forty-sixth Biennial Exhibition* (brochure).

Field 1, Whitney Museum of American Art, New York, as part of *2000 Biennial Exhibition* (cat.).

2001

Field 1, Ackland Art Museum, The University of North Carolina at Chapel Hill.

Screenings

Border. Video, color, sound; 48 minutes.
Shot on the border of Israel and Lebanon. A fictional story made out of documentary footage.
Premiere: The Museum of Modern Art, New York, 1997.
Later screenings: Stedelijk Museum, Amsterdam, 1997; Tate Gallery, London, 1997, as part of solo exhibition; Los Angeles County Museum of Art, 1997; Museum of Fine Arts, Houston, 1998; Palazzo delle Esposizioni, Rome, 1998; Tel Aviv Cinematheque, 2000; The Israel Museum, Jerusalem, 2000; Museo Nacional Centro de Arte Reina Sofia, Madrid, 2000; Corcoran Gallery of Art, Washington, D.C., 2001; The Fabric Workshop and Museum, Philadelphia, 2002.

Notes. Video, black-and-white, sound; 10 minutes, 37 seconds.
A sound and video collaboration with Philip Glass.
Premiere: *Lincoln Center Festival 2001*, Lincoln Center, New York, 2001, as part of *Shorts*.

Special Projects

1995

Tel (Hill), The Colonnade House, Tel Aviv. Mural (27 x 147 ft.) commissioned to mark the restoration of this historic building.

Coexistence 1, Mitzpe Ramon, Negev Desert, Israel. Mural (16 x 64 ft.) hung on the edge of the Ramon Crater, as part of The International Artists' Museum's *Construction in Process V: Co-Existence*.

1996

Dilemmas: The Good Fence, Israel-Lebanon border. Site-specific project (approximately 137 ft.) of forty-four flags hung above the electric fence along the border during an extensive fire-exchange situation. Each flag has an X-shaped figure printed on both sides.

Edge-Tower, Israel-Lebanon border. Installation consisting of two (3½ x 197 ft. each) banners printed with anonymous figures on semi-transparent plastic mesh material. The banners were stretched from the guard tower in opposite directions across the territorial boundary.

Selected Bibliography

The items listed below are organized chronologically by date of publication. When more than one item bears the same date, the entries are then organized alphabetically within each year. Exhibition catalogues have been included in this list only if they prominently feature the work of Michal Rovner. Additional exhibition catalogues are cited in the "Selected Exhibitions" section of this book.

Books, Exhibition Catalogues, and Brochures

1990

Rovner, Michal. *Ani-Mal*. New York and Zurich: Walter Keller, Parkett/Der Alltag, 1990.
Tel Aviv Museum of Art. *Outside: Michal Rovner, Works, 1987–1990* (exh. cat.). Tel Aviv: Tel Aviv Museum of Art, 1990.

1991

Friedman, Lori, and James Young. *Decoy: Yigal Ozeri and Michal Rovner* (exh. cat.). New York: S. Bitter-Larkin, 1991.

1993

Shakked, Shlomit. *Locus: Contemporary Art from Israel* (exh. cat.). Los Angeles: Fisher Gallery, University of Southern California, 1993.
Wolf, Sylvia. *Michal Rovner* (exh. cat.). With an essay by Steven Henry Madoff. Chicago: The Art Institute of Chicago, 1993.

1994

Perez, Nissan N. *Michal Rovner: One-Person Game Against Nature* (exh. cat.). Jerusalem: The Israel Museum, 1994.

1996

Hanhardt, John G. *Michal Rovner: Works, 1991–1996* (brochure). New York: The Bohen Foundation, 1996.

1997

Morris, Frances. *Michal Rovner* (brochure). London: Tate Gallery, 1997.

1998

Faulds, W. Rod. *Michal Rovner: Selected Works, 1991–1998* (brochure). Boca Raton, Fla.: The Schmidt Center Gallery, Florida Atlantic University, 1998.

2001

Inselmann, Andrea. *Michal Rovner: Works* (brochure). Kansas City, Mo.: Kemper Museum of Contemporary Art, 2001.

Articles, Essays, and Reviews

1987

Goldfine, Gil. "Poetry from Polaroids." *Jerusalem Post*, 4 September 1987.

1990

Creative Camera 304 (June/July 1990): front cover.
"Portfolio: Michal Rovner's Polaroids." *Creative Camera* 305 (August/September 1990): 39–42.

1991

Aletti, Vince. "Choices." *New York Village Voice*, 9 July 1991.
Gray, Alice. "Decoy: S. Bitter-Larkin." *Art News* 90 (October 1991): 132.

1992

McCracken, David. "Gallery Scene." *Chicago Tribune*, 24 January 1992, p. 64.
Porges, Maria. "Michal Rovner: Friends of Photography/Ansel Adams Center." *Artforum* 30 (April 1992): 103.
Watten, Barrett. "Michal Rovner." *Artweek* 23 (20 February 1992): 14.

1993

Foerstner, Abigail. "Rovner Draws on the Commonplace to Create the Surreal." *Chicago Tribune*, 12 November 1993, pp. 77–78.
"Michal Rovner." *Creative Camera* 321 (April/May 1993): 66–67.

Woll, Johanna. "Image First: Eight Photographers for the 90's." *Galeries Magazine* (Summer 1993): 139.

1994

Armitage, Diane. "Michal Rovner: Photographs." *Magazine of the Arts* (May 1994): 45.
Chadwick, Susan. "Photographer's Exhibit Evokes Powerful Images of Isolation." *Houston Post*, 26 November 1994, pp. F1, F3.
Hagen, Charles. "Group Show: Wooster Gardens." *New York Times*, 28 January 1994, sec. C, p. 19.
Johnson, Patricia C. "Artist Manipulates Photographs to Create Images of Isolation." *Houston Chronicle*, 29 November 1994, p. 3D.
Karmel, Pepe. "Out of the Ghetto?" *Art News* 93 (April 1994): 144–49.
Rosen, Roee. "Illuminating Eerie Images of Past and Present." *New York Forward*, 21 October 1994, p. 9.
Snodgrass, Susan. "Michal Rovner at the Art Institute of Chicago and Rhona Hoffman." *Art in America* 82 (May 1994): 124–25.

1995

Camper, Fred. "View Finders." *Chicago Reader*, 29 September 1995, pp. 30, 32–33.
"Last Chance." *Chicago Tribune*, 27 October 1995, p. 64.
Levine, Angela. "Library without Books." *Jerusalem Post*, 1 September 1995, p. 30.
Riddell, Jennifer L. "Michal Rovner: Rhona Hoffman Gallery." *New Art Examiner* 23 (November 1995): 35.
Vidal, Christine. "Michal Rovner." *La Recherche Photographique* 19 (Fall 1995): 15–19.

1996

Morrissey, Simon. "Derby Photography Festival: Michal Rovner." *Creative Camera* 337 (December 1995/January 1996): 41–42.

1997

Aquin, Stéphane. "De la minceur de l'image: Taille fine."
Voir (Montreal), 15 August 1997, p. 50.

Côté, Mario. "De la minceur de l'image." *Parachute* 88
(October-December 1997): 54–55.

Kandel, Susan. "Exploring Power of Three Among Friends."
Los Angeles Times, 4 July 1997, p. 18.

Lamarche, Bernard. "Le regard tel un fantôme."
Le Devoir (Paris), 29–30 March 1997, p. D9.

Lamarche, Bernard. "Dissolution de l'image." *Le Devoir*
(Paris), 24–25 May 1997, p. D8.

Langlois, Monique. "Juste des images." *Cinébulles* 16,
2 (1997): 58–59.

Lofting, Claire. "Ambiguous Images: Reflections
on Michal Rovner's *Border*." *Coil: Journal of the
Moving Image* 5 (Fall 1997): 25–30.

"Michal Rovner." *La Recherche photographique* 20
(Spring 1997): 52–53.

Philp, Hunter Drohojowska. "From Dislocation, Artistic
Direction." *Los Angeles Times*, 15 June 1997, pp. 54, 56.

1998

Artner, Alan G. "Rovner's Photoworks Take a More
Abstract Turn." *Chicago Tribune*, 6 November 1998,
p. 60.

Coleman, Sarah. "'50/Fifty': Through July 26,
Jewish Museum." *San Francisco Bay Guardian* 32
(27 May–2 June 1998).

Di Genova, Arianna. "L'arte spericolata." *Il Manifesto*
(Rome), 26 March 1998.

Dykstra, Jean. "Michal Rovner at Stephen Friedman."
Art and Auction 21 (21 September–4 October 1998): 67.

"Michal Rovner." *Palm Beach Jewish Times*, 30 October
1998.

"Michal Rovner: Stills from Her 1997 Film, *Border*."
Creative Camera 353 (August/September 1998): 16–17.

Schmidt, Steve. "Image Is Everything." *New Times*

Broward/Palm Beach, 26 November 1998.

Van Proyen, Mark. "Michal Rovner: Stephen Wirtz Gallery."
New Art Examiner 25 (March 1998): 57–58.

Weinstein, Michael. "Rhona Hoffman Gallery: Michal
Rovner." *New City* (November 1998).

1999

Van de Velde, Paola. "Mystieke installatie in Amsterdam:
Michal Rovner blikvanger op 17 de Video Festival."
De Telegraaf (Amsterdam), 17 September 1999, p. T15.

2000

Hambourg, Maria Morris. "Michal Rovner." *Metropolitan
Museum of Art Bulletin: Recent Acquisitions, a Selection:
1999–2000* 57 (Fall 2000): 69.

Leffingwell, Edward. "Michal Rovner at 410 Park Avenue."
Art in America 88 (November 2000): 169.

Lewis, Jo Ann. "The Biennial's Grand Illusions."
Washington Post, 10 December 2000, pp. G1, G6.

Merritt, Raymond, and Miles Barth. *A Thousand Hounds*.
Cologne: Taschen, 2000, p. 497.

Nahas, Dominique. "Overhang: Michal Rovner at the
Whitney Biennial." *Dart International* 3 (Fall 2000):
31-32.

Nessel, Jennifer. "Ghostly Visions." *Art News* 99 (Summer
2000): 138, 140.

Rogoff, Irit. *Terra Infirma: Geography's Visual Culture*.
London: Routledge, 2000, pp. 137–43.

"Rovner at Deitch." *Flash Art* 33 (May/June 2000): 56.

Rush, Michael. "New Media Rampant." *Art in America* 88
(July 2000): 41, 43.

Vogel, Carol. "Chase's Art Plans." *New York Times*,
14 April 2000, sec. E, p. 38.

2001

Nessel, Jennifer. "Michal Rovner: Art Crossing
Boundaries." *Jewish Woman* (Fall 2001): 18.

List of Illustrations

All plates are works by Michal Rovner. Those listed from institutions or private collections correspond to works in the Whitney Museum of American Art's mid-career survey exhibition. All others are from the collection of the artist.

Page 1
Merging #14, 1997. Pigmented ink-jet on canvas, 41¾ x 45¼ in. (106 x 114.9 cm)

Pages 2–3
Mutual Interest #2, 1998. Chromogenic color print, 34 x 49 in. (86.4 x 124.5 cm). Collection of Steven and Ann Ames

Pages 4–8
Michal Rovner, studies for *Time Left*, 2002. Multi-channel video installation, dimensions variable. Collection of the artist

Page 10
Michal Rovner, still from *Coexistence 2*, 2000. Multi-channel video installation, dimensions variable. Collection of the artist

Pages 12–15
Michal Rovner, studies for *Time Left*, 2002. Multi-channel video installation, dimensions variable. Collection of the artist

Wolf Essay

Plate 1
Untitled 1981. Gelatin silver print, 24 x 36 in. (61 x 91.4 cm)

Figure 1
Frances Frith, *The North Shore of the Dead Sea*, 1857. Print from bound album, *Sinai and Palestine*, vol. 2. Albumen silver print, 6 x 8⁷⁄₁₆ in. (15.3 x 21.5 cm). The Metropolitan Museum of Art, New York; Rogers Fund, 1908, transferred from the Library, 1991 (1991.1073.91)

Figure 2
Shmuel Yosef Schweig, *Ha-Noar Ha-Oved* (*Working Youth*), 1926. Gelatin silver print. Courtesy Keren Kayemeth Leisrael-Jewish National Fund Photo Archive, Jerusalem

Figure 3
Monitin (Reputation), cover of first issue, September 1978. Collection of Nissan N. Perez

Figure 4
Michal Rovner, *Untitled*, 1981. Gelatin silver print, 5¾ x 8¾ in. (14.6 x 22.2 cm). Collection of the artist

Figure 5
Michal Rovner, *Untitled*, 1983. Gelatin silver print, 7 x 10¾ in. (17.8 x 27.3 cm). Collection of the artist

Figure 6
Michal Rovner, *Untitled (Nahalal)*, 1984/85. Gelatin silver print, 8³⁄₁₆ x 12⅜ in. (20.8 x 31.4 cm). Collection of the artist

Figure 7
Michal Rovner, *Untitled (Nahalal)*, 1984/85. Gelatin silver print, 8³⁄₁₆ x 12⁵⁄₁₆ in. (20.8 x 31.3 cm). Collection of the artist

Figure 8
Michal Rovner, *Untitled*, 1985. Gelatin silver print, 8¹³⁄₁₆ x 13¼ in. (22.4 x 33.7 cm). Collection of the artist

Figure 9
Michal Rovner, images from a photographic album of Rovner's farmhouse in Kefar Shemu'el, 1985/86. Eight gelatin silver prints, various dimensions. Collection of the artist

Figure 10
Michal Rovner, *Untitled*, 1985/86. Gelatin silver print, 5⅝ x 8¼ in. (14.3 x 21 cm). Collection of the artist

Figure 11
Michal Rovner, *The Tree*, 1985/86. Gelatin silver print, 7⅛ x 10¹¹⁄₁₆ in. (18.1 x 27.1 cm). Collection of the artist

Figure 12
Michal Rovner, *The Tree*, 1986/87. Chromogenic color print, 19½ x 19 in. (49.5 x 48.3 cm). Collection of the artist

Figure 13
Michal Rovner, *The Tree*, 1986/87. Chromogenic color print, 19½ x 19 in. (49.5 x 48.3 cm). Collection of the artist

Figure 14
Michal Rovner, *The Tree*, 1986/87. Chromogenic color print, 19½ x 19 in. (49.5 x 48.3 cm). Collection of the artist

Figure 15
Michal Rovner, *Sinking Dog*, 1987. Chromogenic color print, 28 x 27¾ in. (71.1 x 70.5 cm). The Metropolitan Museum of Art, New York; Purchase, The Horace W. Goldsmith Foundation Gift, 1999 (1999.238.2)

Figure 16
Michal Rovner, *Rising Dog*, 1987. Chromogenic color print, 28 x 27¾ in. (71.1 x 70.5 cm). The Metropolitan Museum of Art, New York; Purchase, Jennifer and Joseph Duke, 1999 (1999.238.1)

Figure 17
Michal Rovner, *Arie's Shirt*, 1987. Gelatin silver print, 16¾ x 21 in. (42.5 x 53.3 cm). Collection of the artist

Figure 18
Michal Rovner, *My Donkey*, 1987. Gelatin silver print, 15 x 20 in. (38.1 x 50.8 cm). Collection of the artist

Figure 19
Michal Rovner, *People in the Earth*, 1987. Chromogenic color print, 17 x 17½ in. (43.2 x 44.4 cm). Collection of the artist

Figure 20
Michal Rovner, *Woman and Airplane*, 1987. Chromogenic color print, 18¾ x 18½ in. (47.6 x 47 cm). Collection of the artist

Figure 21
Michal Rovner, *Me and the Bird*, 1988. Chromogenic color print, 10¼ x 10 in. (25 x 25.4 cm). Collection of the artist

Figure 22
Michal Rovner, *Flying Lamb*, 1988. Chromogenic color print, 18¾ x 18¼ in. (47.6 x 46.4 cm). Collection of the artist

Figure 23
David Levinthal, *Untitled*, 1977, from the series *Hitler Moves East: A Graphic Chronicle 1941–43*. Kodalith print, 9¾ x 7¹¹⁄₁₆ in. (24.8 x 19.5 cm). Whitney Museum of American Art, New York; Purchase, with funds from The Sondra and Charles Gilman Jr. Foundation, Inc. (93.59)

Figure 24
Laurie Simmons, *First Bathroom/Woman Standing*, 1978. Silver dye bleach print (Cibachrome), 3³⁄₁₆ x 5 in. (8.1 x 12.7 cm). Collection of the artist

Figure 25
Robert Capa, *D-Day, Omaha Beach, near Colleville-sur-Mer, Normandy Coast, June 6, 1944*, 1944, from the series *Images of War*. Gelatin silver print, 8¹⁵⁄₁₆ x 13⁵⁄₁₆ in. (22.7 x 34.4 cm). Whitney Museum of American Art, New York; Gift of Mr. And Mrs. Aaron Rose (91.79.1)

Figure 26

Huynh Cong (Nick) Ut, *Children Fleeing a Napalm Strike*, 8 June 1972. Courtesy AP/Wide World Photos

Plate 2

Outside #3, 1990. Chromogenic color print, 29½ x 30 in. (74.9 x 76.2 cm). Collection of Joseph M. Cohen

Plate 3

Outside #13, 1990. Chromogenic color print, 29½ x 29½ in. (74.9 x 74.9 cm)

Plate 4

Outside #5, 1990. Chromogenic color print, 29½ x 29½ in. (74.9 x 74.9 cm). Collection of Joseph M. Cohen

Plate 5

Decoy #2 (Target), 1991. Chromogenic color print, 48⅛ x 47 in. (122.2 x 119.4 cm). The Museum of Fine Arts, Houston; Gift of Michael A. Caddell and Cynthia Chapman (98.236.27)

Plate 6

Decoy #3, 1991. Chromogenic color print, 49½ x 48½ in. (125.7 x 123.2 cm). Whitney Museum of American Art, New York; Purchase, with funds from the Harriett Ames Charitable Trust (97.88)

Plates 7a–c

Decoy #7, 1991. Three chromogenic color prints, each 19½ x 19 in. (49.5 x 48.3 cm)

Plate 8

Decoy #6, 1991. For chromogenic color print, overall 19¼ x 76 in. (48.9 x 193 cm)

Plate 9

Decoy #1 (Man 1), 1991. Chromogenic color print, 24 x 20 in. (61 x 50.8 cm). The Metropolitan Museum of Art, New York; Purchase, Frances Dittmer Gift, 2000 (2000.250)

Plate 10

Decoy #29 (Map), 1991. Chromogenic color print, 28 x 28 in. (71.1 x 71.1 cm)

Plate 11

China, 1995. Four chromogenic color prints, overall 45½ x 164½ in. (115.6 x 417.8 cm). Solomon R. Guggenheim Museum, New York; partial and promised Gift, The Bohen Foundation, 2001 (2001.250)

Plates 12a–c

Decoy #16, 1991. Three chromogenic color prints, each 19 x 19 in. (48.3 x 48.3 cm)

Plate 13

Outside #11, 1990/91. Chromogenic color print, 19½ x 19½ in. (49.5 x 49.5 cm). The Metropolitan Museum of Art, New York; Purchase, The Horace W. Goldsmith Foundation Gift, 1992 (1992.5040)

Plate 14

Outside #1, 1990/91. Chromogenic color print, 19¼ x 18¹⁵⁄₁₆ in. (48.9 x 48.1 cm). The Art Institute of Chicago; Gift of Jeanne and Richard S. Press (1996.584)

Plate 15

Outside #3, 1990/91. Chromogenic color print, 19½ x 19½ in. (49.5 x 49.5 cm). The Metropolitan Museum of Art, New York; Purchase, Rosalind Solomon Gift, 1992 (1992.5157)

Plate 16

Outside #4, 1990/91. Chromogenic color print, 19 x 19 in. (48.3 x 48.3 cm)

Plate 17

Outside #20, 1990/91. Chromogenic color print, 19⅞ x 19⅝ in. (50.5 x 49.8 cm). The Metropolitan Museum of Art, New York; Purchase, Anonymous Gift, 2000 (2000.248)

Plate 18

Outside #9, 1990/91. Chromogenic color print, 19⁹⁄₁₆ x 19³⁄₁₆ in. (49.7 x 48.8 cm). The Art Institute of Chicago; Gift of Jeanne and Richard S. Press (1996.586)

Plate 19

Outside #10, 1990/91. Chromogenic color print, 19 x 19 in. (48.3 x 48.3 cm)

Plate 20

Outside #12, 1990/91. Chromogenic color print, 19½ x 19 in. (49.5 x 48.3 cm). Solomon R. Guggenheim Museum, New York; Partial and promised gift, The Bohen Foundation, 2001 (2001.241)

Figures 27–28

Michal Rovner, *Untitled*, 1985/87. Two gelatin silver prints, each 3⅛ x 4¾ in. (7.9 x 12.1 cm). Collection of the artist

Figure 29

Edward Steichen, *The Pool*, 1900. Platinum print with hand-darkened edges, 10¾ x 6⁵⁄₁₆ in. (27.3 x 16.1 cm). The Art Institute of Chicago; Alfred Stieglitz Collection (1949.873)

Figure 30

Allan McCollum, *#73A* and *#73B*, 1985, from the series *Perpetual Photo*. Two gelatin silver prints, each 9¾ x 11½ in. (24.8 x 29.2 cm). Private collection, New York

Figure 31

Robert Heinecken, *Connie Chung*, 1986. Photogram, ink-jet print, 21⅞ x 22 in. (55.5 x 66 cm). The Metropolitan Museum of Art, New York; Purchase, Charina Foundation Inc. Gift, 1986 (1986.1192)

Figure 32

Ellen Brooks, *Garden Slice*, 1987. Silver dye bleach print (Cibachrome), 87 x 44 in. (221 x 111.8 cm). Whitney Museum of American Art, New York; Purchase, with funds from the Photography Committee (2001.256)

Figure 33

Uta Barth, *Ground #42*, 1994. Chromogenic color print on panel, 11¼ x 10½ x 1⅞ in. (28.6 x 26.7 x 4.8 cm). Whitney Museum of American Art, New York; Purchase, with funds from the Photography Committee (95.162)

Figure 34

Gerhard Richter, *Waterfall*, 1997. Oil on linen, 64⅞ x 43⅜ in. (164.8 x 110.2 cm). Hirshhorn Museum and Sculpture Garden, Smithsonian Institution, Washington, D.C.; Joseph H. Hirshhorn Purchase Fund, 1998 (HSMG 98.28)

Plate 21

One-Person Game Against Nature #5, 1992. Chromogenic color print, 30⁹⁄₁₆ x 30⁹⁄₁₆ in. (77.6 x 77.6 cm). The Art Institute of Chicago; Restricted gift of O. R. S. Ltd., and Michael Caddell and Tracey Conwell (1994.48)

Plate 22

One-Person Game Against Nature #6, 1992. Chromogenic color print, 28¾ x 28¼ in. (73 x 71.8 cm). The Museum of Fine Arts, Houston; Gift of Michael A. Caddell and Cynthia Chapman (98.236.16)

Plate 23

One-Person Game Against Nature #7, 1992. Chromogenic color print, 28¾ x 28⅛ in. (73 x 71.4 cm). The Museum of Fine Arts, Houston; Gift of Michael A. Caddell and Cynthia Chapman (98.236.15)

Plate 24
One-Person Game Against Nature #22, 1992/93.
Chromogenic color print, 28½ x 28½ in. (72.4 x 72.4 cm)

Plate 25
One-Person Game Against Nature #45, 1993. Chromogenic
color print, 29½ x 28⁹⁄₁₆ in. (75 x 72.5 cm). The Art Institute of
Chicago; Gift of Jeanne and Richard S. Press (1996.592)

Plate 26
One-Person Game Against Nature #30V, 1993. Chromogenic
color print, 40 x 40 in. (101.6 x 101.6 cm)

Plate 27
One-Person Game Against Nature #6V, 1992. Chromogenic
color print, 30³⁄₁₆ x 40³⁄₁₆ in. (76.6 x 102.1 cm). The Art
Institute of Chicago; Restricted gift of O. R. S. Ltd.,
and Michael Caddell and Tracey Conwell (1994.47)

Plate 28
One-Person Game Against Nature #10V, 1993. Chromogenic
color print, 30³⁄₁₆ x 40³⁄₁₆ in. (76.6 x 102.1 cm) The Art Institute
of Chicago; Restricted gift of O. R. S. Ltd., and Michael
Caddell and Tracey Conwell (1994.46)

Plate 29
One-Person Game Against Nature #9V, 1993.
Chromogenic color print, 30³⁄₁₆ x 40¼ in. (76.7 x 102.2 cm).
Collection of Emily Fisher Landau

Plate 30
All That, 1995. Pigmented ink-jet on canvas, 40 x 95 in.
(101.6 x 241.3 cm)

Plates 31a–c
Red Field, 1995. Pigmented ink-jet on canvas triptych,
overall 39 x 165 in. (99.1 x 419.1 cm). Whitney Museum
of American Art, New York; Purchase, with funds from
the Harriett Ames Charitable Trust (97.77a-c)

Plate 32
Force, 1997. Chromogenic color print, 40³⁄₁₆ x 41½ in.
(102.1 x 105.4 cm). Collection of Gabriela Brown

Plate 33
Heat #1, 1997. Chromogenic color print (Duraflex),
96 x 50 in. (243.8 x 127 cm). Collection of Orit P. Freedman

Plate 34
Land, 1997. Pigmented ink-jet on canvas, 71 x 109 in.
(180.3 x 276.9 cm)

Figure 35
Michal Rovner, *Labyrinth*, 1997. Pigmented ink-jet on can-
vas, 26¾ x 139¼ in. (67.9 x 353.7 cm). Collection of the artist

Figure 36
Michal Rovner, *Tel (Hill)*, 1995. Linoleum mural wrapped
around the Colonnade House, Tel Aviv, 27 x 147 ft.
(8.2 x 44.8 m). Collection of the artist

Figure 37
Michal Rovner, *Coexistence 1*, 1995. Pigmented ink-jet
on plastic (Panaflex), 16 x 64 ft. (4.9 x 19.5 m). Collection
of the artist

Figure 38
Michal Rovner, *Dilemmas: The Good Fence*, 1996. Forty-four
flags hung above an electric fence at the Israel-Lebanon
border, approximately 137 ft. (42 m). Collection of the artist

Figure 39
Michal Rovner, *Edge-Tower*, 1996. Two semi-transparent
plastic mesh banners, stretched from a guard tower
in opposite directions over the Israel-Lebanon border,
each 3½ x 197 ft. (1.1 x 60 m). Collection of the artist

Plate 35
Border #8, 1997/98. Pigmented ink-jet on canvas,
50¾ x 66¾ in. (128.9 x 169.5 cm). The Metropolitan Museum
of Art, New York; Purchase, The Horace W. Goldsmith
Foundation Gift, 1999 (1999.240)

Plate 36
Border (Jeep), 1997/2000. Pigmented ink-jet on canvas,
39 x 51 in. (99.1 x 129.5 cm)

Plate 37
Border (Topography 1), 1997/2001. Pigmented ink-jet
on canvas, 23½ x 43 in. (59.7 x 109.2 cm)

Figures 40a–d
Michal Rovner, stills from *Border*, 1996/97. Video, color,
sound; 48 minutes. Solomon R. Guggenheim Museum,
New York; Partial and promised gift, The Bohen
Foundation, 2001 (2001.253)

Figure 41
Installation view of Michal Rovner's *Mutual Interest*, 1997,
at the Stedelijk Museum, Amsterdam. Multi-channel video
installation, dimensions variable. Collection of the artist

Figures 42a–c
Michal Rovner, stills from *Mutual Interest*, 1997.
Multi-channel video installation, dimensions variable.
Collection of the artist

Figure 43
Ross Bleckner, *Birds Falling*, 1994-95. Oil on canvas,
84 x 60 in. (213.4 cm x 152.4 cm). National Gallery
of Art, Washington, D.C.; Gift of Anthony T. Podesta,
Washington, D.C. (1998.106.1)

Figure 44
Felix Gonzalez-Torres, *Untitled*, 1995. Billboard as installed
at Roosevelt Avenue and Seventieth Street, Queens,
New York, for "Felix Gonzalez-Torres" (2 December 1999-13
January 2000), an outdoor project organized by Creative
Time. Courtesy Andrea Rosen Gallery, New York, in repre-
sentation of The Estate of Felix Gonzalez-Torres

Plate 38
Mission, 1999. Pigmented ink-jet on canvas, 47 x 48¾ in.
(119.4 x 123.8 cm)

Plate 39
Crosses, 1999. Pigmented ink-jet on canvas, 56⅞ x 43 in.
(144.5 x 109.2 cm)

Plate 40
While in the Air II, 1999. Pigmented ink-jet on canvas,
40¼ x 39¼ in. (102.2 x 99.7 cm)

Plate 41
While in the Air III, 1999. Pigmented ink-jet on canvas,
40¼ x 39¼ in. (102.2 x 99.7 cm)

Plate 42
Echo, 1998. Pigmented ink-jet on canvas, 39 x 32 in.
(99.1 x 81.3 cm). Whitney Museum of American Art, New
York; Gift of the artist in honor of Sylvia Wolf (2000.81)

Plate 43
Mutual Interest #1, 1997. Chromogenic color print
(Fujiflex), 48 x 93 in. (121.9 x 236.2 cm). Collection
of Nechami and Arnold Druck

Plate 44
Descent, 1998. Pigmented ink-jet on canvas, 85¼ x 39 in. (216.5 x 99.1 cm)

Plate 45
Mutual Interest #2, 1998. Chromogenic color print, 34 x 49 in. (86.4 x 124.5 cm). Collection of Steven and Ann Ames

Plate 46
Untitled #1 (Athens), 1998. Acrylic on waxed paper, 27 x 19½ in. (68.6 x 49.5 cm)

Plate 47
Untitled #8 (Athens), 1998. Acrylic on waxed paper, 27 x 19½ in. (68.6 x 49.5 cm)

Plate 48
Untitled #6 (Athens), 1998. Acrylic on waxed paper, 27 x 19½ in. (68.6 x 49.5 cm)

Plate 49
Untitled #4 (Athens), 1998. Acrylic on waxed paper, 19½ x 27 in. (49.5 x 68.6 cm)

Plate 50
Untitled #11 (Athens), 1998. Acrylic on waxed paper, 19½ x 27 in. (49.5 x 68.6 cm)

Plate 51
Untitled #9 (Athens), 1998. Acrylic on waxed paper, 27 x 19½ in. (68.6 x 49.5 cm)

Plate 52
Untitled #12 (Athens), 1998. Acrylic on waxed paper, 19½ x 27 in. (49.5 x 68.6 cm)

Plate 53
Untitled #2 (Athens), 1998. Acrylic on waxed paper, 19½ x 27 in. (49.5 x 68.6 cm)

Plate 54
Merging P#1, 1997. Chromogenic color print, 41½ x 43½ in. (105.4 x 110.5 cm). Whitney Museum of American Art, New York; Gift of Barbara Schwartz in honor of Evelyn and Leonard Lauder (T.2002.160)

Plate 55
Adama (Earth), 1999. Pigmented ink-jet on canvas, 35¼ x 49½ in. (89.5 x 125.7 cm)

Plate 56
Merging #6, 1997. Pigmented ink-jet on canvas, 41¾ x 45¼ in. (106 x 114.9 cm)

Plate 57
Merging in the Wind, 1997. Pigmented ink-jet on canvas, 36 x 46⅝ in. (91.4 x 118.4 cm)

Plate 58
Blur, 1998. Pigmented ink-jet on canvas, 49 x 63 in. (124.5 x 160 cm)

Plate 59
Pull, 1999. Chromogenic color print, 20 x 20 in. (50.8 x 50.8 cm). Collection of Kathryn Fleck

Plate 60
Soil, 1999. Chromogenic color print, 30 x 30 in. (76.2 x 76.2 cm)

Plate 61
In the Presence of, 1999. Pigmented ink-jet on canvas, 31½ x 61½ in. (80 x 156.2 cm)

Plate 62
Falling in the Field, 2000. Chromogenic color print, 42 x 49 in. (106.7 x 124.5 cm)

Plate 63
Shalosh (Three), 2001. Pigmented ink-jet on canvas, 40½ x 41¼ in. (102.9 x 104.8 cm)

Figure 45
Indoor installation view of Michal Rovner's *Overhanging*, 1999, at the Stedelijk Museum, Amsterdam. Multi-channel video installation, dimensions variable. Collection of the artist

Figure 46
Outdoor nighttime view of Michal Rovner's *Overhanging*, 1999, at the Stedelijk Museum, Amsterdam. Multi-channel video installation, dimensions variable. Collection of the artist

Figures 47–49
Michal Rovner, stills from *Overhanging*, 1999. Multi-channel video installation, dimensions variable. Collection of the artist

Figure 50
Michal Rovner, *Overhang #5*, 2000. Five chromogenic color prints, each 30 x 30 inches (76.2 x 76.2 cm). Collection of the artist

Figure 51
Michal Rovner, still from *Eagle Butterflies*, 1999. Single-channel video, dimensions variable. Collection of the artist

Figure 52
Michal Rovner, stills from *Coexistence 2*, 2000. Multi-channel video installation, dimensions variable. Collection of the artist

Figure 53
Michal Rovner and Philip Glass, still from *Notes*, 2001. Video, black-and-white, sound; 10 minutes, 37 seconds. Collection of Michal Rovner

Figure 54
Michal Rovner, still from *Time Left*, 2002. Multi-channel video installation, dimensions variable. Collection of the artist

Figure 55
Michal Rovner, *Untitled #7*, 2000. Chromogenic color print, 20 x 20 in. (50.8 x 50.8 cm). Collection of the artist

Figure 56
Michal Rovner, *Untitled #2*, 2000. Chromogenic color print, 20 x 20 in. (50.8 x 50.8 cm). Collection of the artist

Figure 57
Vija Celmins, *T.V.*, 1964. Oil on canvas, 26 x 36 in. (66 x 91.4 cm). Collection of Steve Tisch

Figure 58
Vija Celmins, *Untitled (Ocean)*, 1970. Pencil on paper, 14⅛ x 18⅞ in. (35.9 x 47.9 cm). The Museum of Modern Art, New York; Mrs. Florene M. Schoenborn Fund (585.1970)

Figure 59
Shirin Neshat, *Untitled (Rapture)*, 1999. Gelatin silver print, 43¼ x 68¼ in. (109.9 x 173.4 cm). Whitney Museum of American Art, New York; Purchase, with funds from Kathryn Fleck in honor of Maxwell L. Anderson (2000.106)

Pages 145–55
Michal Rovner, stills from *Mutual Interest*, 1997. Multi-channel video installation, dimensions variable. Collection of the artist

Rovner/Golub Conversation

Figure 1
Leon Golub, *White Squad I*, 1982. Acrylic on canvas, 120 x 184 in. (304.8 x 467.4 cm). Whitney Museum of American Art, New York; Gift of the Eli Broad Family Foundation and purchase, with funds from the Painting and Sculpture Committee (94.67)

Figure 2
Michal Rovner and Leon Golub, 1 April 2001

Pages 173–83
Michal Rovner, stills from *Border*, 1996/97. Video, color, sound; 48 minutes. Solomon R. Guggenheim Museum, New York; Partial and promised gift, The Bohen Foundation, 2001 (2001.253)

Pages 184–87
Michal Rovner, stills from *Coexistence 2*, 2000. Multi-channel video installation, dimensions variable. Collection of the artist

Rush Essay

Figure 1
Michal Rovner, stills from *Border*, 1996/97. Video, color, sound; 48 minutes. Solomon R. Guggenheim Museum, New York; Partial and promised gift, The Bohen Foundation, 2001 (2001.253)

Figure 2
Installation view of Michal Rovner's *Overhanging*, 1999, at the Stedelijk Museum, Amsterdam. Multi-channel video installation, dimensions variable. Collection of the artist

Figure 3
Outdoor installation view of Michal Rovner's *Overhang*, 2000, at the Chase Manhattan Bank, Park Avenue and Fifty-fifth Street, New York. Multi-channel video installation, dimensions variable. Collection of the artist, courtesy Deitch Projects

Figures 4–9
Michal Rovner, stills from *Overhanging*, 1999. Multi-channel video installation, dimensions variable. Collection of the artist

Figure 10
Michal Rovner, still from *Field 1*, 2000. Video, color and black-and-white, sound; 14 minutes. Collection of the artist

Pages 197–204
Michal Rovner, stills from *Overhanging*, 1999. Multi-channel video installation, dimensions variable. Collection of the artist

Figure 11
Stan Brakhage, stills from "Part One" of *Dog Star Man*, 1962. Film, color, silent; 30 minutes. Anthology Film Archives, New York

Figure 12
Installation view of Mary Lucier's *Wilderness*, 1986, at the Henry Art Gallery, University of Washington, Seattle. Three-channel video installation for seven twenty-five-inch video monitors mounted on faux classical pedestals in a stepped colonnade, color, sound; 21 minutes. Private collection, New York

Figure 13
Installation view of Michal Rovner's *Mutual Interest*, 1997, at the Stedelijk Museum, Amsterdam. Multi-channel video installation, dimensions variable. Collection of the artist

Figures 14a–b
Michal Rovner, stills from *Mutual Interest*, 1997. Multi-channel video installation, dimensions variable. Collection of the artist

Figure 15
Installation view of Michal Rovner's *Coexistence 2*, 2000, at the Corcoran Gallery of Art, Washington, D.C. Multi-channel video installation, dimensions variable. Collection of the artist

Figure 16
Michal Rovner, stills from *Coexistence 2*, 2000. Multi-channel video installation, dimensions variable. Collection of the artist

Figure 17
Michal Rovner and Philip Glass, stills from *Notes*, 2001. Video, color, sound; 10 minutes, 37 seconds. Collection of Michal Rovner

Pages 217–32
Michal Rovner and Philip Glass, stills from *Notes*, 2001. Video, black-and-white, sound; 10 minutes, 37 seconds. Collection of Michal Rovner

Chronology

Figure 1
Rovner and her dog, 1962/63

Figure 2
Rovner in army barracks, 1975/77

Figure 3
Michal Rovner, *Untitled (Germany)*, 1985. Gelatin silver print, 5 11/16 x 8 5/16 in. (14.4 x 21.1 cm). Collection of the artist

Figure 4
Michal Rovner, *Illuminating Man*, 1988/89. Chromogeric color print, 19 x 19 in. (48.3 x 48.3 cm). Collection of the artist

Figure 5
Rovner at the Dead Sea, August 1993

Figures 6a–b
Stills from video by Michal Rovner of installation of *Coexistence 1*, 1995

Figure 7
Still from video by Ofer Harari of Rovner preparing for installation of *Edge-Tower*, 1996

Figure 8
Still from video by Ardon Bar-Hama of Rovner during shooting of *Overhanging*, Israel, 1999

Figure 9
Still from video by Dan Itzhaki of Rovner during shooting of preliminary studies for *Time Left*, Russia, 2000

Figure 10
Michal Rovner, *Self-Portrait with Tomas*, 2000

Pages 257–63
Michal Rovner, studies for *Time Left*, 2002. Multi-channel video installation, dimensions variable. Collection of the artist

ACKNOWLEDGMENTS

SYLVIA WOLF

I first came to know Michal Rovner over a decade ago during our work together on an exhibition of her photographs at the Art Institute of Chicago. Since then, Rovner has expanded her repertoire to include video installation and pigment printing on canvas, and her work has been shown in galleries and museums throughout the United States and Europe. As is often the case in the first decades of an artist's career, exhibitions have featured Rovner's most recent works. Consequently, no exhibition or publication to date has presented the full range of her artistic accomplishments. This book and the exhibition it accompanies provide a mid-career survey of Rovner's art. By tracing Rovner's creative development and placing her imagery in the context of contemporary artistic production, we hope to set the foundation for viewing the decades of work to come.

I owe a debt of gratitude to the Israel National Lottery Council for the Arts for their extraordinary contribution to this project at a crucial time. This book was also supported, in part, by a generous grant from the Elizabeth Firestone Graham Foundation. The project was made possible with public funds from the New York-Israel Cultural Cooperation Commission, a joint venture of the State of New York, George E. Pataki—Governor, and the State of Israel. Special thanks go to Edmund G. Glass, Commission Chairman, and Sarah Jarkow, Commission Coordinator, who assisted in the application process. This project was supported as well by the National Committee of the Whitney Museum of American Art, and by the Israel Ministry of Foreign Affairs, Cultural and Scientific Relations Division; and the Office of Cultural Affairs in the U.S.A., Consulate General of Israel in New York. Special thanks go to Ofra Ben-Yaacov and Rafi Gamzou for their enthusiasm for the project from its outset. Several individuals contributed their support at a critical moment in the funding process, and have become true guardian angels to this project. Deep appreciation is extended to Jill and Jay Bernstein, the Brandes Family Art Collection, Tel Aviv, Gabriela and Amiel Brown, Melva Bucksbaum and Raymond Learsy, Larry and Marilyn Fields, Giza Venture Capital, Israel, Susan and Leonard Nimoy, Ami Oren, Paul and June Schorr, and Roselyne C. Swig. Special thanks go to Shlomo and Nira Nechama, who have championed Rovner's career throughout the preparations for this exhibition. Without the commitment of all those mentioned above, this project would surely not have gone forward.

This publication and the exhibition it accompanies were realized through the efforts of many individuals at the Whitney Museum of American Art. I am indebted, first and foremost, to Maxwell L. Anderson, Alice Pratt Brown Director, for his support of this project from the beginning and for his steadfast advocacy throughout every stage of this endeavor. Christie Putnam, Associate Director for Exhibitions and Collections Management, guided all budgetary and administrative tasks with efficiency, sensitivity, and good humor. In the Department of Registration, I would like to thank Suzanne Quigley, Head Registrar; Barbi Spieler, Senior Registrar; Tara Eckert, Assistant Registrar; and Kelley Loftus, Assistant Paper Preparator. For their creative thinking and their determination to secure funds

for this project, I am grateful to Terri Coppersmith, Director of Corporate Partnerships; J. Lennox Hannan, Director of Foundation and Government Relations; Alexander Villari, Grants Writer/Researcher; Tess O'Dwyer, Director of Major, Planned and Individual Giving; and Barbara Bantivoglio, Associate Director for External Affairs. In addition, Betsy Jacks, Director of Marketing; Mary Haus, Director of Communications; Stephen Soba, Senior Publicist; and Susan Galvani, Communications Coordinator, ensured that the exhibition and this publication would be known to the broadest possible audience. Countless other colleagues in the museum have enhanced this project with their support, including Maura Heffner, Assistant Curator and Manager, Touring Exhibitions Program; Tracy Tucker, Curatorial Assistant, Touring Exhibitions Program; Curatorial Interns Nicole Schreiber, Susanna Cole, and Tami Thompson; Glenn Phillips, former Assistant Curator for Special Projects, Holly Davey, Audio Visual Coordinator, and Richard Bloes, Projectionist, who consulted on the film and video installations; Mark Steigelman and Keith Crippen, the current and former Manager of Construction/Design, respectively, who consulted on the installation design.

This book is published on the occasion of Rovner's mid-career survey exhibition at the Whitney Museum of American Art. I would like to express my sincere thanks to those individuals who loaned works from their private collections for inclusion in the exhibition. For deepening my appreciation of Rovner's career through the study of works in their possession, I am grateful to Steven and Ann Ames, Gabriela Brown, Joseph M. Cohen, Arnold Druck, Kathryn Fleck, and Orit P. Freedman. I am equally grateful to my colleagues and friends at lending institutions: Anne Tucker, Linda Wilhelm, Katie Heinlein, Julie Bobb, Elena John, and George Zombakis at the Museum of Fine Arts, Houston; David Travis, Douglas Severson, Kristin Merrill, James Iska, Lisa D'Acquisto, and Martha Sharma at the Art Institute of Chicago; Maria Hambourg, Malcolm Daniel, Mia Fineman, Lisa Hostetler, and Pedrag Dimitrijevic at the Metropolitan Museum of Art, New York; and Lisa Dennison at the Solomon R. Guggenheim Museum, New York.

Several additional colleagues and patrons made their collections available during my research, and many of Rovner's champions and friends offered support and assistance. Those who contributed to specific aspects of this project are mentioned individually in the book's endnotes. Others deserving of thanks and recognition include Debbi Berman, Michael Caddell, Carolyn Cohen, Tracey Conwell, Fred Henry, Sarah Hermanson, Corey Keller, Kathleen Lamb, Ya'el Lotan, Annie Ohayan, Mordechai Omer, Susan Paine, Kate Palmer, Richard and Jeanne Press, David C. Ruttenberg, Eve Schillo, Barbara Schwartz, Robert Sobieszek, and Joan Weakley. Over the years, I have relied on the gallery representatives that have championed Rovner's art, including Thom Andriola in Houston; Stephen Friedman in London; Rhona Hoffman in Chicago; Peter MacGill in New York; Shoshona Wayne in Santa Monica; and Stephen and Connie Wirtz in San Francisco. I am equally grateful to Rovner's studio assistants for their steadfast devotion to Rovner's art and their many contributions to this project: Michele Fliegler, Cecily Marbach, Karin Bar, Amy Hopwood, Elisabeth Hauser, and Angela Livermore. I owe a particular debt of gratitude to Doron Sebbag, a long-time supporter of Rovner's career, with whom I have had numerous insightful and rewarding conver-

sations about contemporary art. Rovner's parents, Ruth and Jacob, and her sister, Daphna, made me feel welcome in their homes and, through their generosity with their recollections, furthered my understanding of Rovner's early development.

The content of the book was greatly enhanced by Michael Rush's essay, which not only sheds light on Rovner's video production, but also places her work in the context of contemporary video production. Leon Golub was exceptionally generous during our work on his dialogue with Rovner for this book. When an artist of long experience and one in mid-career speak as frankly as Golub and Rovner have done here, all readers benefit from the liveliness of the exchange. I owe special thanks to those readers who lent their time and critical thought to my essay. For strengthening the text with their suggestions and expertise, I am grateful to Nissan N. Perez, Curator of Photography at the Israel Museum; Adam Weinberg, Director of the Addison Gallery, Phillips Academy, Andover; and at the Whitney Museum, Lawrence Rinder, Joel and Anne Ehrenkranz Curator of Contemporary Art; Garrett White, Director of Publications and New Media; and Yukiko Yamagata, Senior Curatorial Assistant in Photography. By compiling the selected bibliography and exhibition history, and carefully researching the artist's chronology, Yukiko Yamagata has added invaluable resource material for current and future scholars of Rovner's art. Lucie Haskins is thanked for creating a useful index. Margherita Andreotti edited this publication with characteristic intelligence and rigor. An insightful and trusted editor, her presence can be felt on every page.

This book was produced by the Whitney Museum of American Art's Department of Publications and New Media under the direction of Garrett White, who, with former Managing Editor Susan Richmond, guided every aspect of its production with a sure hand and keen eye for artistic excellence. Garrett White's predecessors, Kate Norment and Mary E. DelMonico, are also gratefully acknowledged for lending their support and expertise to the very early stages of the project. For the elegant design of the book, which so beautifully complements Rovner's art, I am indebted to the talent and sensitivity of Lorraine Wild, Robert Ruehlman, and Jessica Fleischmann. In the Whitney's Department of Rights and Reproductions, Anita Duquette, Manager, orchestrated the photographing of works by Matt Flynn, and the compilation of visual material with speed, efficiency, and good cheer. Gerhard Steidl and his gifted staff at Steidl Verlag applied extraordinary artistry and the highest level of craftsmanship to the translation of Rovner's work to the printed page.

My partner in every aspect of the Rovner publication and exhibition has been Yukiko Yamagata, Senior Curatorial Assistant in Photography at the Whitney Museum. It is with pleasure and profound thanks that I acknowledge her countless efforts on behalf of this endeavor, and recognize the professionalism and grace she brought to all of our work together. I have benefited immeasurably from conversations about this project with Rita Frankiel and Elisa Lapine. Duane Schuler's underlying support and insight into the creative process have contributed to all facets of this book and exhibition. Finally, deep thanks go to Rovner herself. For the art that is at the core of this study and for the friendship that has emerged, I am filled with appreciation and gratitude.

ACKNOWLEDGMENTS

MICHAL ROVNER

Thanks to all of my editors and video professionals for working with me day and night and for their devotion. For *Border* (1996/97), I thank my additional cameramen Yoav Dagan, Ofer Harrary, Eitan Harris and Noam Teich. Special thanks to Brigadier General Giora for his High-8 video filming and his important participation in the project. Thanks to Dan Itzhaki, editor; to Alex Claude and Jane Steward for their contributions to the sound design; and to Gravity Post Production for their generous support with online editing. For *Mutual Interest* (1997), thanks to Mickey Kovler, editor, and to Jane Stewart for her work on the sound design.

For *Overhanging* (1999) and *Overhang* (2000), many thanks to Dan Itzhaki, editor; to Ronen Sharabani, online chief editor; to Avi Bello, Ahron Peer, Dan Tomer, and Quentin, online editors; to Michal Hirsch and Boris Levinson, digital editors; and to Effi Wizen, special advisor. Thanks to Rea Mochiach for creating music for the pieces. Thanks to Tom Van Vliet, World Wide Video Festival; to Eyal Ofer and the Chase Manhattan Bank of New York City; and to Jeffrey Deitch at Deitch Projects, New York. For their help and generous support, I thank Aviv Giladi, and Judith and Rami Nussbaum.

For *Eagle Butterflies* (1999), thanks to Avi Bello, online editor; and to Rea Mochiach, who produced the music for the piece. For *Coexistence 2* (2000), I thank my additional cameramen Adron Bar-Hama and Yoav Dagan. Thanks to Dan Itzhaki, editor; to Ronen Sharabani and Yoni Tzruya, online editors; and to Jane Stewart for her contribution to the sound design. For *Notes* (2001), I thank my additional cameraman Ardon Bar-Hama. Thanks also to Dan Itzhaki, editor; Aharon Peer and Yoni Tzruya, online editors; and most of all, Philip Glass for his music and for a wonderful collaboration.

For *Time Left* (2002), I thank my cameraman Ardon Bar-Hama. Many thanks also to Dan Itzhaki and Avi Mussel, editors; to Aharon Peer, online editor; to Ronen Tapiro, video technician; and to Doron Fitterman and Avi Mussel, post-production supervisors. Doron Fitterman also served as production coordinator. Support for the video server was provided by Disk-in. Special thanks to Gravity Post Production.

Special thanks to Yoram Altman, Roni Brown, Doron Fitterman, and Effi Wizen at Gravity Post Production for assisting and supporting many of my video projects. Without them, the projects would not have come to life. I also thank Asaf Roet at Draco for assisting and supporting with editing equipment, Loni Herzikowitz and Dagan Sade at Ishfar for equipment support, and Gil Mitrani at Opus.

Many thanks to Jerry Lewis and Neo Pena at New York Mounting; to Daniel Barbosa, Chia Chen, and Danny Rodriguez at Color Edge; to Bark Frameworks and Courier Network; and to Tara Beall, Ron Krell, Alicja Ostrowska, and Ofra Pizante.

Thanks to Sasha Klein; to Julia and Arcadi, producers of filming sessions in Russia; to Anatoli Yurkov of the Russian Embassy; and to Dan Oryan, cultural attaché in Moscow. Thanks to Shlomo Yaul, manager of the Even Vesid Quarry at Moddin; and to Mano at Derech Eretz.

Many thanks to Bank Leumi and Yona Fogel, Vice President, for supporting the project *Time Left*. Special thanks to the Israel National Lottery Council for the Arts for their generous support for this exhibition. Thanks to the Israel Consulate for Cultural Affairs, and to Ofra Ben-Yaacov, Rafi Gamzou, and Renee Schreiber. Thanks to Bank Hapoalim for helping me when I began working on the exhibition.

Thanks to my assistants in New York: Karin Bar, Elizabeth Hauser, Amy Hopwood, Angela Livermore. Thanks to my other assistants: Tomer Gefen, Shira Goren, Gad Gubran, Ninel Koren, Mali, Eran Rapatzki, Yaniv Tamam, and Rita Zaher. Many thanks to Michele Fliegler, my financial assistant, for her stability, her presence, and for helping the studio in good times and hard times. Special thanks to my chief assistant, Cecily Marbach, for her commitment and for doing her utmost to allow me to concentrate and to protect my time and energy. Thanks to all of my galleries.

Many thanks to Nadir Arber, Aya Azrielant, Adiv Baruch, Uzi Beller, Hanina and Gil Brandes, Gabriela and Amiel Brown, Danny and Shosh Dankner, Gili and Rafi Gidron, Dan Giron, Moshe Goldberg, Joseph Hackmey, Oded Halaf, Arie Hammer, Zeev Holtzman, Giora Inbar, Bernard Kruger, Steven Henry Madoff, Eyal Ofer, Idan Ofer, Annie Ohayon, Professor Mordechai Omer, Hubbard Ron, Rivka Saker and Sotheby's Israel, Ludwig Schudt, Doron Sebbag, Uri and Jasmine Segal, Yoram and Anat Turbowicz, Michele Yankielowicz, Zvi Yemini, Michal and Mickey Zelemayer, and Moshe Ziv.

My thanks to Robert Frank for his inspiration and help; many thanks to Judith and Rami Nussbaum; many thanks to Orit P. Freedman for her support and care; much gratitude to Serge and Limor Tirosh for their sincere concern and their major help with this project; thanks to Aviv Giladi for being there, and for his ideas and support. My thanks to Ya'el Lotan for her help throughout the years with all my projects; to Yigal Ozeri for his ongoing support, and for being an artist with unique admiration for other artists. So many thanks to Nira and Shlomo Nechama for their friendship and generosity; without them this project would not have been possible.

Sincere thanks and respect go to Robert Sobieszek, Los Angeles County Museum of Art, for his intelligent work. Thanks to Fred Henry and Joan Weakley at The Bohen Foundation for their commitment to my work; to Maria Morris Hambourg, Metropolitan Museum of Art, New York, for her insight and caring; to John G. Hanhardt, Solomon R. Guggenheim Museum, New York; to Adam Weinberg, Addison Gallery of American Art, Andover, Massachusetts; to Frances Morris, Tate Gallery, London; to Philip Brookman, Corcoran Gallery of Art, Washington, D.C.; to Valerie Cassel, Contemporary Arts Museum, Houston; to Matthew Drutt, The Menil Collection, Houston; to Jane Farver, Queens Museum of Art; to Anne Wilkes Tucker, The Museum of Fine Arts, Houston; and to Bob Fitzpatrick, Museum of Contemporary Art, Chicago.

Thanks to Gerhard Steidl, my printer and copublisher, for his high standards and refusal to compromise; to Garrett White, Director of Publications and New Media at the Whitney, for accompanying the project with a special vision; to Michael Rush and Leon Golub for their vivid interest and their words; and to Lorraine Wild and her studio for their creative and thoughtful design.

Thanks to Jack and Ruth Rovner, my parents, to my sister, Daphna, and to Tomas for keeping me safe.

Special thanks to Maxwell L. Anderson, Director of the Whitney Museum of American Art, for his efforts in supporting this exhibition in these challenging times. Finally, I thank Sylvia Wolf, Sondra Gilman Curator of Photography at the Whitney, for her commitment all these years to a deep look at what I've been doing, for her professionalism, and for her great encouragement. I'm glad I had the honor and the pleasure to work with Sylvia.

Photography and Reproduction Credits

In the majority of cases, photographs of works of art
have been provided by owners. The following list applies
to photographs for which an additional acknowledgment
is due.

Sylvia Wolf, "The Space Between":
© 2001 The Art Institute of Chicago, All Rights Reserved:
Plates 13, 21, 27–28; courtesy of the artist: Figures 35–38,
40–42, 45–54; courtesy of the artist/photograph by Matt
Flynn: Figures 30, 39; courtesy the Bohen Foundation:
Plate 11 Geoffrey Clements: Plate 31; Sheldan C. Collins:
Figures 23, 33, 59, Plates 6, 42; Sheldan C. Collins/©
Magnum Photos, Inc.: Figure 25; Lorene Emerson/© 2001
Board of Trustees, National Gallery of Art, Washington,
D.C.: Figure 43; Matt Flynn: Figures 3–14, 17–22, 27–28,
55–56, Plates 1–4, 7–8, 10, 12, 16, 19–20, 24, 26, 29–30, 32–34,
36–41, 44–63; courtesy McKee Gallery, New York: Figure 57;
© 1988 The Metropolitan Museum of Art, New York: Figure
31; © 1993 The Metropolitan Museum of Art, New York:
Plates 13, 15; © 2000 The Metropolitan Museum of Art, New
York: Figure 16, Plate 35; © 2001 The Metropolitan Museum
of Art, New York: Figures 1, 15, Plates 9, 17; © The Museum
of Fine Arts, Houston: Plates 5, 22–23; © 2001 The Museum
of Modern Art, New York: Figure 58; Orcutt & Van Der
Putten/courtesy Andrea Rosen Gallery, New York: Figure
44; © 1997 Michal Rovner/courtesy Arnold & Nechami
Druck and Pace/MacGill Gallery, New York: Plate 43;
Laurie Simmons: Figure 24; Lee Stalsworth: Figure 34;
Courtesy Leslie Tonkonow Artworks + Projects: Figure 32;
Greg Williams/© 2001 The Art Institute of Chicago, All
Rights Reserved: Plates 14, 25; Greg Williams/© 2001 The
Art Institute of Chicago, All Rights Reserved/reprinted
with permission of Joanna T. Steichen: Figure 29.

"Michal Rovner and Leon Golub in Conversation":
D. James Dee: Figure 1. Courtesy of the artist: Figure 2.

Michael Rush, "'There Will Be Silence': The Video Art
of Michal Rovner":
Courtesy of the artist: Figures 1–10, 13–17; Arunas
Kulikauskas: Figure 11; Richard Nicol: Figure 12.

Yukiko Yamagata, "Chronology":
Courtesy of the artist: Figures 4, 6–9; courtesy of the
artist/photograph by Matt Flynn: Figures 1–2; Matt Flynn:
Figures 3, 10; Amit Goren: Figure 5..

This book was published on the occasion of the exhibition
Michal Rovner: The Space Between at the Whitney Museum
of American Art, New York, July 11–October 13, 2002.

Michal Rovner: The Space Between is supported by grants
from the Israel National Lottery, Council for the Arts,
and the Elizabeth Firestone Graham Foundation.
Additional support was provided by the New York-Israel
Cultural Cooperation Commission, a joint venture
of the State of New York, George E. Pataki—Governor,
and the State of Israel.

**ISRAEL NATIONAL LOTTERY
COUNCIL FOR THE ARTS**

Research for Museum publications is supported
by an endowment established by The Andrew W. Mellon
Foundation and other generous donors.

A portion of the proceeds from the sale of this book
benefits the Whitney Museum of American Art
and its programs.

This exhibition and catalogue were organized by Sylvia
Wolf, Sondra Gilman Curator of Photography, with the
assistance of Yukiko Yamagata, senior curatorial assistant,
Whitney Museum.

This publication was produced by the Publications
and New Media Department at the Whitney Museum
of American Art:

Director: Garrett White
Editorial: Rachel Wixom, Managing Editor; Thea Hetzner,
Assistant Editor; Libby Hruska, Assistant Editor
Design: Makiko Ushiba, Senior Graphic Designer;
Christine Knorr, Graphic Designer
Production: Vickie Leung, Production Manager
Rights and Reproductions: Anita Duquette, Manager,
Rights and Reproductions; Jennifer Belt, Photographs
and Permissions Coordinator
Assistant: Carolyn Ramo

Text editor: Margherita Andreotti
Design: Lorraine Wild with Robert Ruehlman
and Jessica Fleischmann
Printing and color separations: Steidl, Göttingen, Germany
Printed and bound in Germany
Cover: Michal Rovner, Still from *Overhanging*, 1999.
Multi-channel video installation, dimensions variable.
Collection of the artist.

Library of Congress Cataloging-in-Publication Data

Wolf, Sylvia, 1957-
Michal Rovner : the space between / Sylvia Wolf ;
with an essay by Michael Rush and a conversation
between Michal Rovner and Leon Golub.
p. cm.
Includes bibliographical references and index.
ISBN 3-88243-828-2
1. Photography, Artistic. 2. Video art. 3.
Rovner, Michal, 1957- I. Rovner, Michal, 1957- II.
Whitney Museum of American Art. III. Title.
TR654 .W6363 2002
779'.092--dc21 2002004796

© 2002 Whitney Museum of American Art
945 Madison Avenue at 75th Street
New York, NY 10021
www.whitney.org

Copublished by the Whitney Museum of American Art
and Steidl Verlag, Göttingen, Germany

Distribution: Steidl, Düstere Str. 4,
D-373073 Göttingen

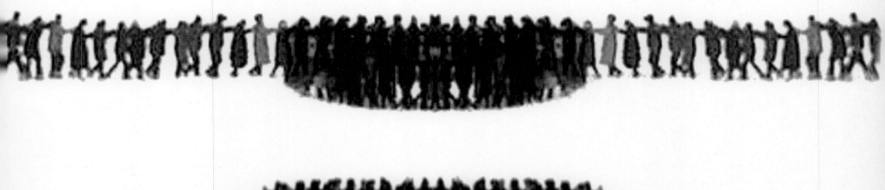

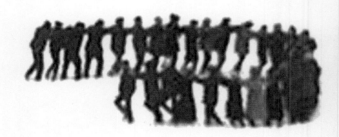

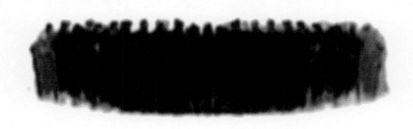

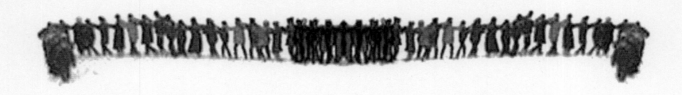
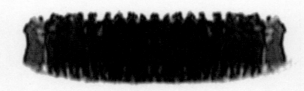
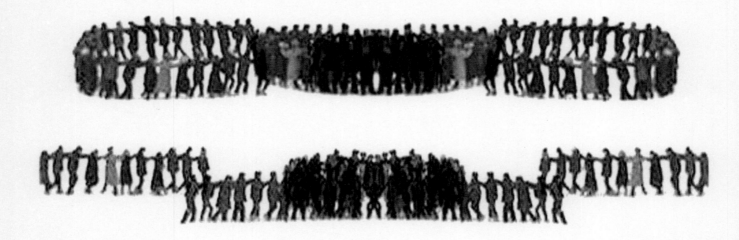
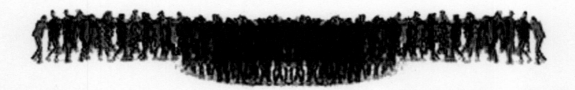

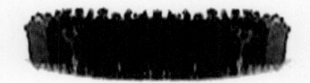

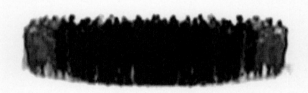

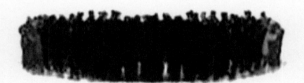

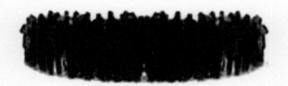

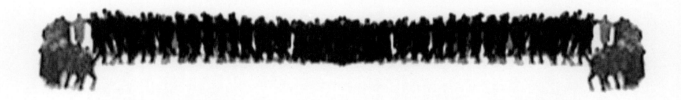

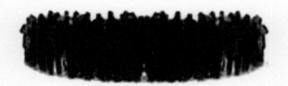

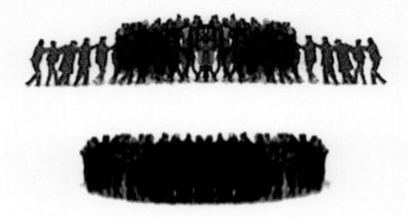

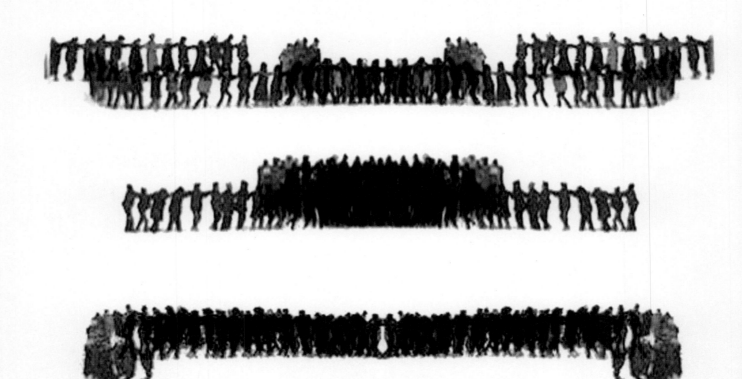

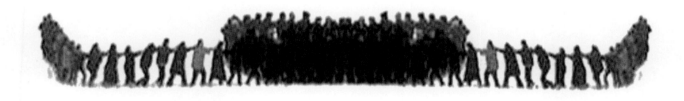

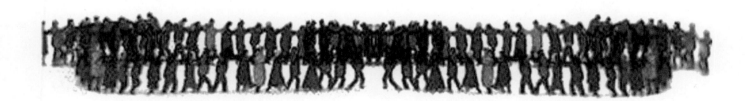